} FOR THE
?BETH BIOLOGIST.

' KEEP FISH FREE

Peter Miller

Carl Safina

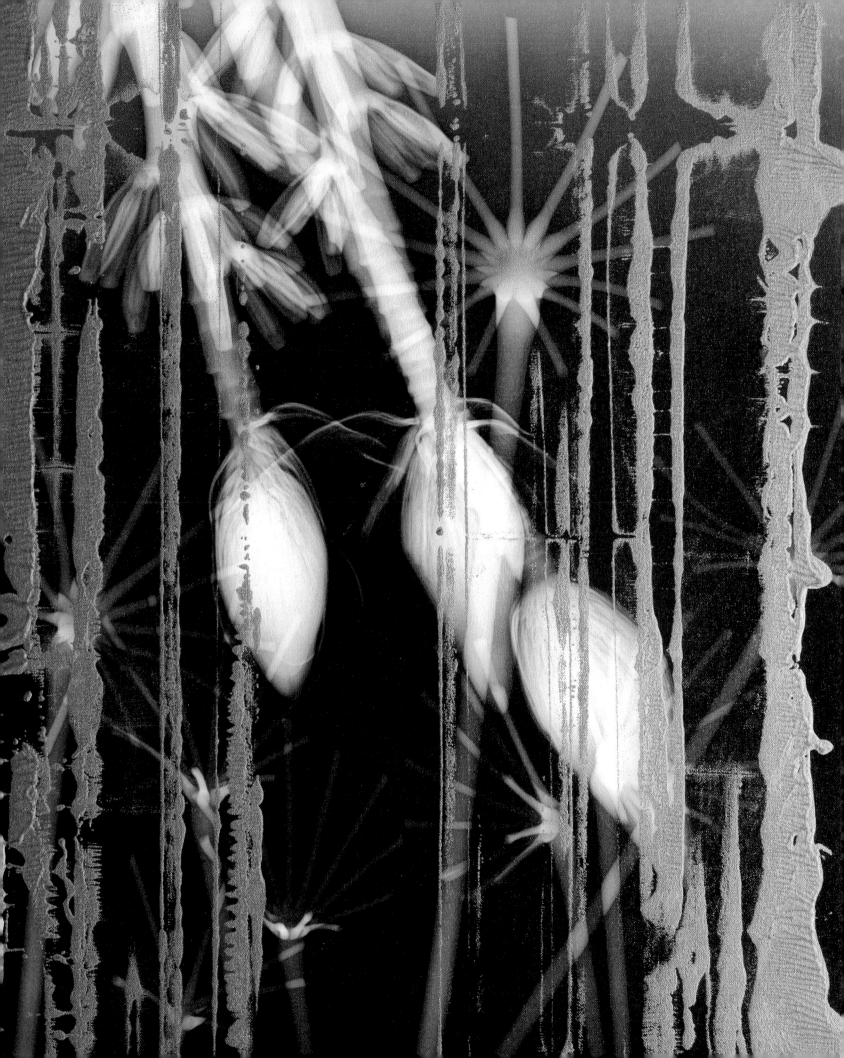

RADIOGRAPHIC

X-Ray Photo Inventions

Steve Miller

Foreword by Carl Safina

Preface by Marvin Heiferman

Glitterati
INCORPORATED

New York | London

First published in 2017 by

Gl*itter*at*i*
INCORPORATED

New York | London

New York Office:
630 Ninth Ave, Ste 603
New York, NY 10036
Telephone: 212 362 9119

London Office:
1 Rona Road
London NW3 2HY
Tel/Fax +44 (0) 207 267 9739

www.GlitteratiIncorporated.com
media@GlitteratiIncorporated.com for inquiries

First edition, 2017

Library of Congress Cataloging-in-Publication data
is available from the publisher.

Editor: Phil Columns
Design: Liz Trovato

Hardcover edition
ISBN: 978-1-943876-45-7
Printed and bound in China

10 9 8 7 6 5 4 3 2

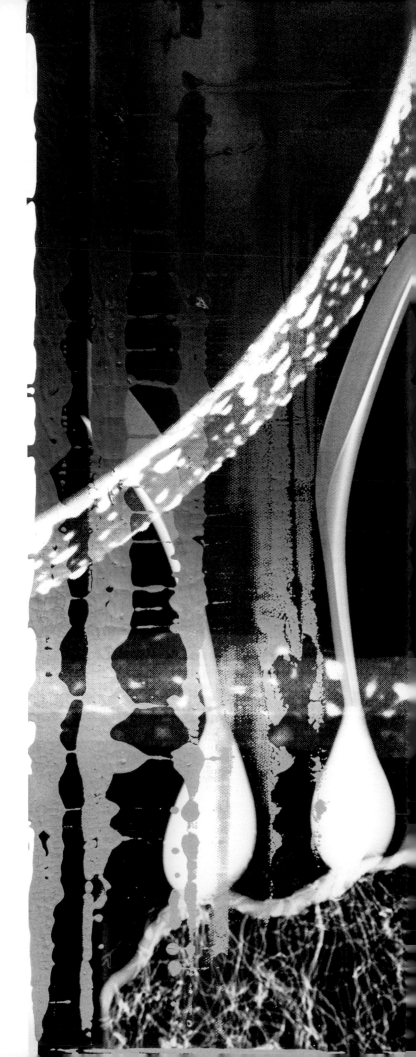

Previous spread: *Flaming Shade*, 2009 | Carbon inkjet, acrylic and
silkscreen on canvas | 26.5 x 22 in.

Right: *Earth Changes*, 2009 | Carbon inkjet, acrylic and silkscreen
on canvas | 22.25 x 26.5 in.

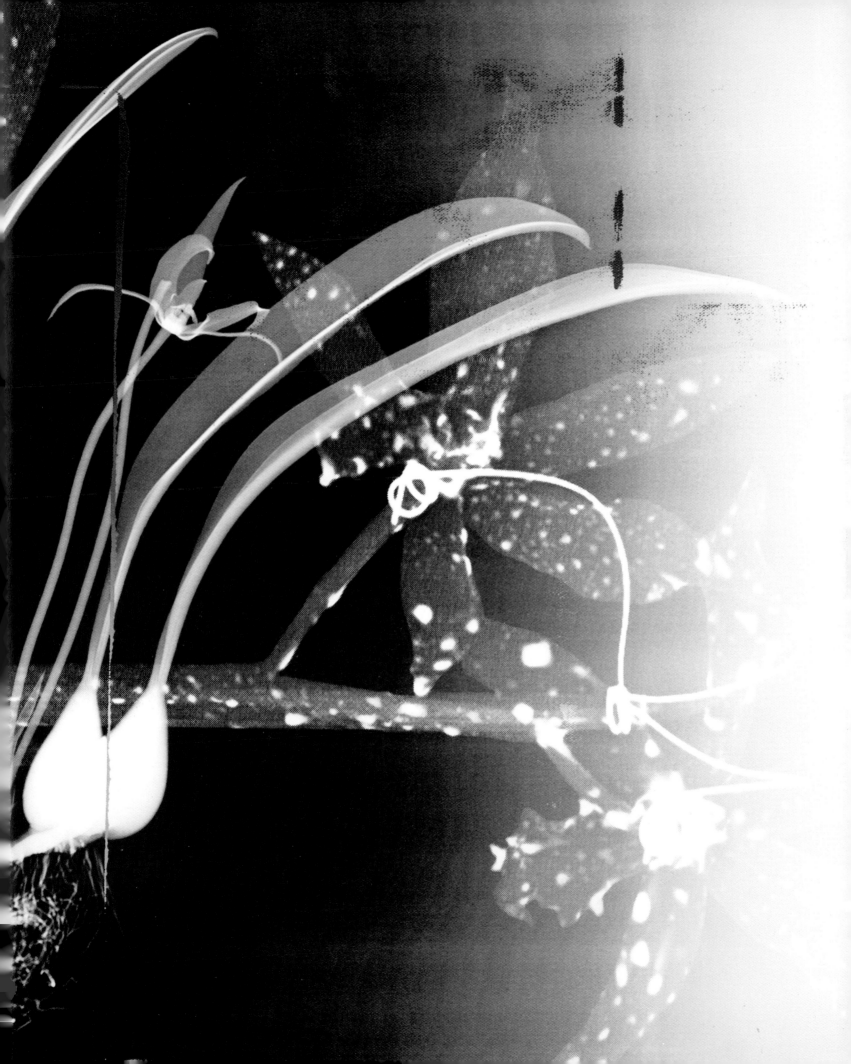

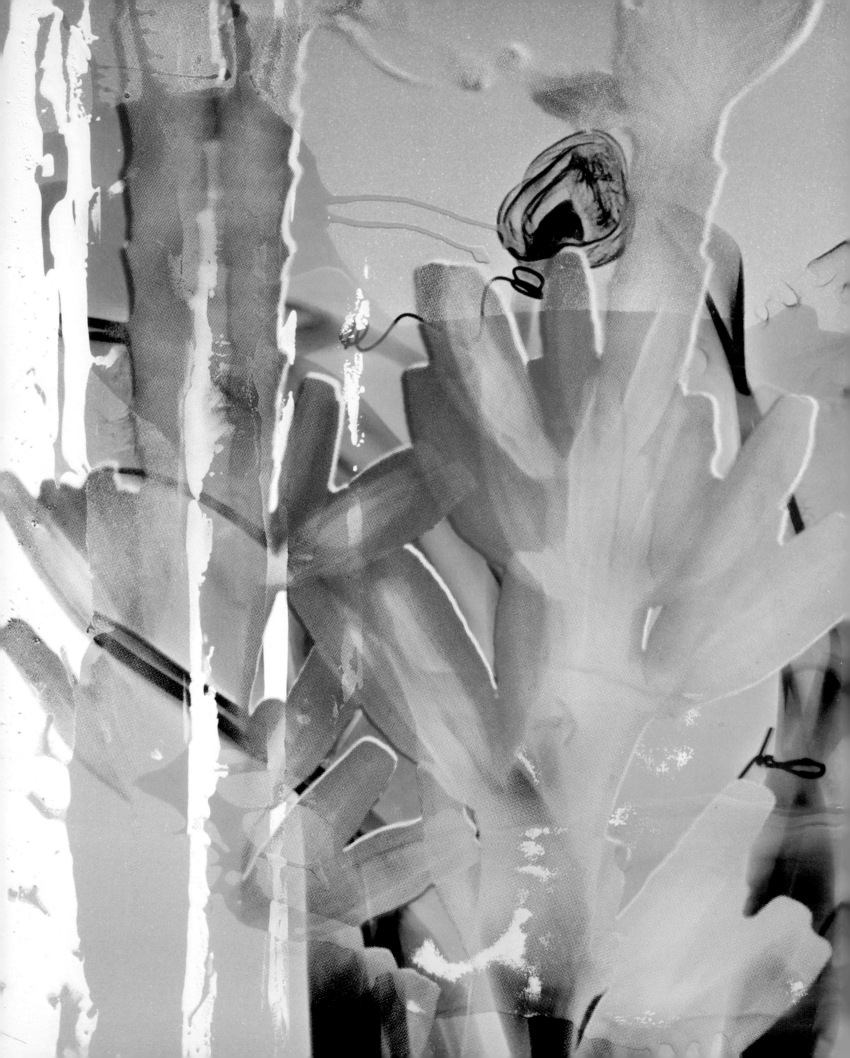

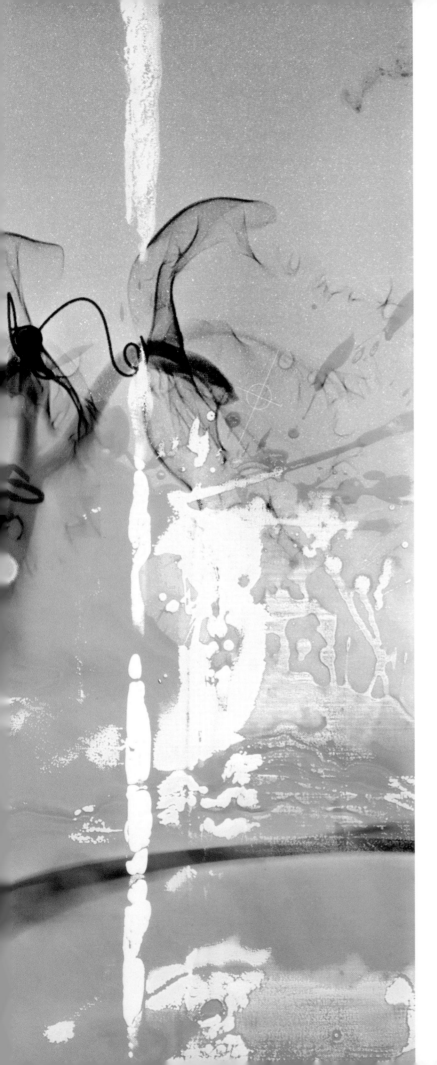

Mown into Softness, 2009 | Inkjet, enamel
and silkscreen on canvas | 24 x 26.5 in.

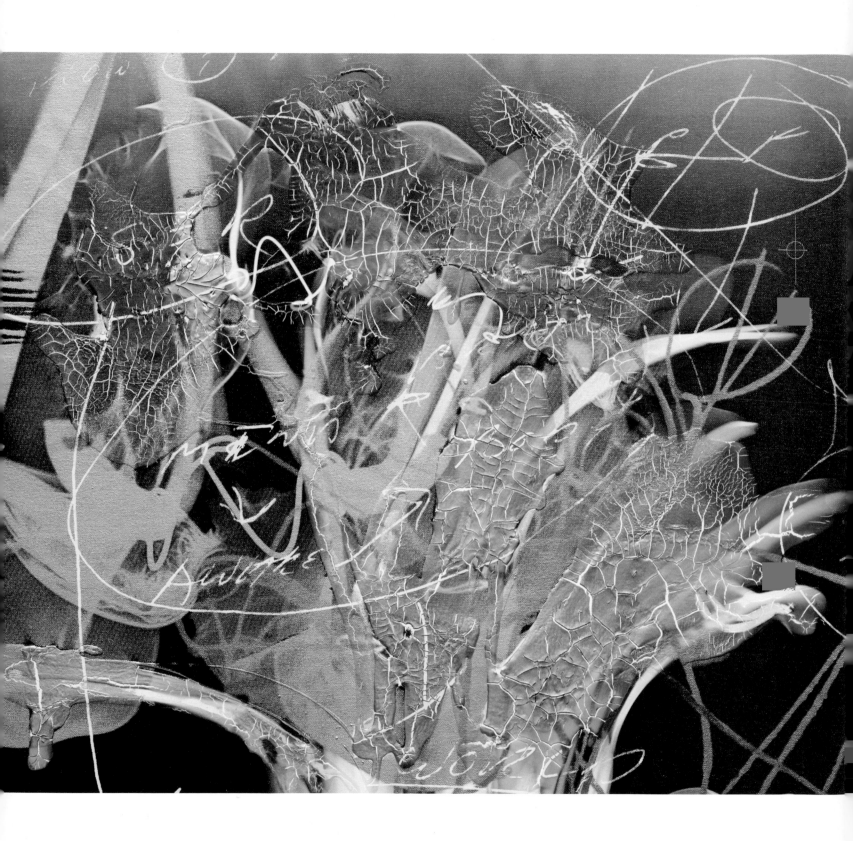

Fragmentary Traces, 2009 | Carbon inkjet, acrylic and silkscreen on canvas | 21.5 x 25.75 in.

FOREWORD

ALL IS MIRACULOUS

Carl Safina

Attraction. Repulsion. Vision. Division. We cannot bear to look. We cannot look away. Visibility, indivisibility. What divides, unites. One nation invisible. We stare and cannot see. Or glance and see right through.

Lightning never strikes twice. Once is quite enough to make a point. You cannot step into the same river twice. Is a river, then, just an idea? Can you drown in an idea? What we all have in common is that we are neither here nor there. The right place, the right time. Or maybe just unlucky.

The population grows. And the withering world shrinks. If the physics was different our expansion might make the world expand. Like eating too much. The whole universe is "expanding," but only because we are all getting farther and farther from one another. Our marooned and tentatively tethered little planet cannot grow. We grow; it doesn't. The biggest slices of pie get cut at the least crowded table. Our table is more and more crowded. Termites don't make the house bigger, don't set the wood a-growin'. Nor we. Planetary termites.

Speaking of which. If ever I felt at home, forget it. Never quite did. Certainly never will. Not now. Would if humans could get from civilized to humanized. Less and less likely looking. Trending the wrong way for that, for all appearances.

The snake eats rats whole. Piranhas rove ever-hungering. Each rat, each snake, each piranha, and each of us is of course a living, acting, self-interested individual. Living things are generally capable of growth, reproduction and repair—but an individual isn't as distinct an entity as it seems. No life is an island.

We, the living, must be continually plugged into flowing energy and flowing materials. Animals such as us are like bonfires. Stop providing energy and material (food, fluid, and air), and we not only go out, we cease to exist. We're not like a motor or computer that can be restarted. We're much more networked, much more fragile, more ephemeral.

Biophysicist Harold Morowitz questions whether individuals are even real, "because they do not exist per se but only as local perturbations in this universal energy flow." He uses the analogy of a whirlpool in a river. The whirlpool does not exist as a separate entity, but rather is made of an ever-changing collection of water molecules, facilitated by the energy of moving water. "It exists only because of the flow of water through the stream. If the flow ceases the vortex disappears." In the same sense, living things like blackbirds and you and I "are transient, unstable entities with constantly changing molecules dependent on a constant flow of energy to maintain form." You don't just go with the flow—you live by it. The loss of the inbound flow is death. Death is merely life unplugged.

While we live, we shimmer. We are almost

mirages. What appears solid is mere molecules, made of atoms, composed of subatomic particles and energy. Ultimately mostly space. We are made of flows through emptiness. We wage our struggles and passions over literally nothing. Yet have a closer look. Don't just look at. Look in. There is something there. It's a big step from nothing to just a little something. A little something is what we have. It's all there is.

While an individual is a real entity in some meaningful ways, blurring the edges of our sense of self is a more accurate picture. We're less like crisp photographs and more like impressionist paintings. Our material makeup is constantly changing. We are made individuals by our DNA—makes us each a bit different—and especially by our unique actions, memories, and histories.

But our histories are largely shared, having started long before we were born. Inconceivably long before. Our lines of descent blend to distant shared ancestors who were, as all living things are, kin.

Albert Einstein said, "A human being is part of the whole, called by us 'Universe,' a part limited in time and space. He experiences himself, his thoughts and feelings as something separate from the rest—a kind of optical delusion of his consciousness. This delusion is a kind of prison for us, restricting us to our personal desires and to affection for a few persons nearest to us. Our task must be to free ourselves from this prison."

If you still believe you are distinct from your surroundings, try reading three pages while holding your breath. The point is: you are not just an entity; you are an interchange.

A living thing is a knot of passing time, flowing material, and continuous energy. From dust, energy assembles for itself the wood, leaves, bone, and muscle that we recognize as living. We are these dynamic processes in relationship to each other. All lives depend on how energy pushes matter through plants and animals. Often the matter itself, such as carbon, nitrogen, and water, cycles through the whole community. We are a relationship to the world. We're a tapestry of relationships.

Ecology—a term coined by the German Ernst Haeckel in 1866 from the Greek word for "household"—blurs the individual. Ecology investigates how all living things depend on other living things, and on that flow of energy and materials.

Ecology reveals a world where each individual seed, each creature, is an experiment, testing the waters with its own uniqueness, striving for a fit. But chances of surviving to adulthood range from under ten percent for most mammals and birds with highly developed parental care, to as low as one in millions for big fish that lay immense numbers of eggs.

How can so harsh a world brim with life? The whole thing works because nature preserves not individuals, but the enterprise by which life struggles to survive, and adapts to

changes. In other words, individuals disappear, species disappear—what survives is the process. The living enterprise continues because the process continues.

The big take-home message, so far, of a century and a half of biology and ecology: life is—more than anything else—a process; it creates, and depends on, relationships among energy, land, water, air, time, and various living things. It's not just about human-to-human interaction. It's about all interaction. We're bound with the rest of life in a network, a network including not just all living things but the energy and non-living matter that flows through the living, making and keeping us all alive as we make it alive. And unless we embrace the reality we're in—and reality's implications—we'll face big problems. To keep life alive, what's important is: preserve the process.

All is miraculous. But now the theme of the story a kind of heartbreak for a world of miracles that remains so vitally unaware of how imperiled it is. The more we sense the miracle, the more intense the tragedy appears. We, the planet's termites, whittle and whittle and whittle. You can almost hear us chewing.

One note is not music. It is what lies between notes that makes the music. And what is between them is: their relationship. Relationships are the music life makes. Asking, 'What is the meaning of life?' is the wrong question; it makes you look in the wrong places. The question is, 'Where is the meaning in life?' The place to look is: Between. And so what we see as the shimmering surfaces, we would do better to see into. For aeons the world mattered to our ancestors and for hundreds of millennia it mattered to human beings. Now and faster, human beings matter to the world. There is more here than first meets the eye.

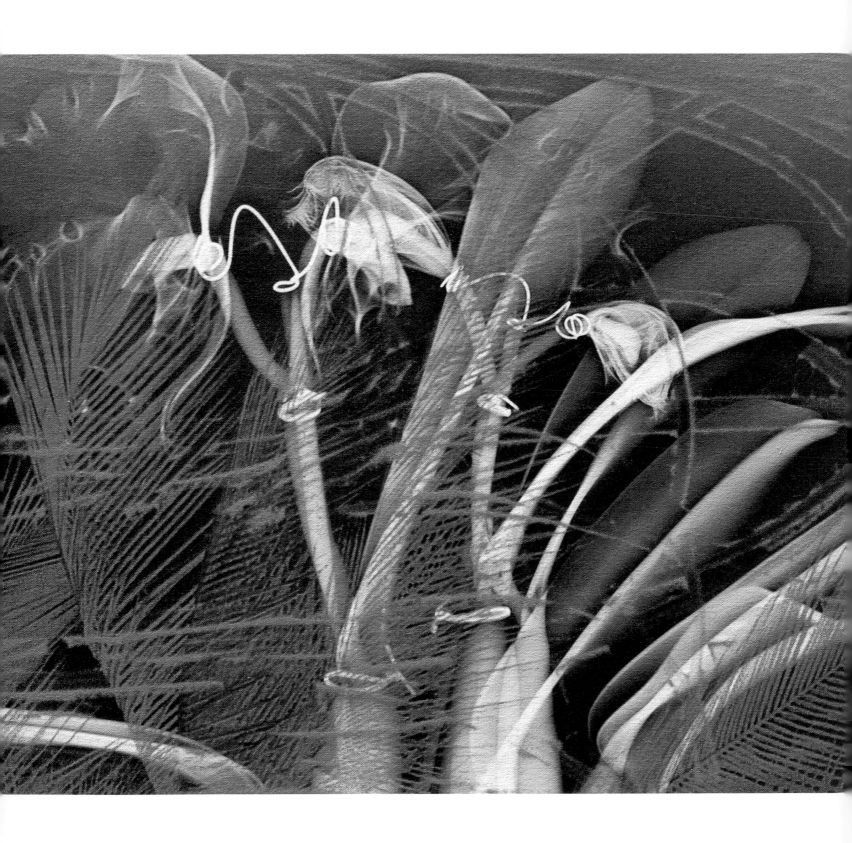

The Universe Begins, 2010 | Carbon inkjet and silkscreen on canvas | 21.75 x 26 in.

SEEING THROUGH THE WORLD WE KNOW

Marvin Heiferman

It was in late November 1895 that Wilhelm Conrad Röntgen, a German physicist, detected the previously unknown, highly charged electromagnetic rays that he called X-rays. Weeks later and a few days before Christmas, he harnessed those rays to capture an image of his wife's left hand, which revealed the bones beneath her skin and so startled her that she was said to have exclaimed, "I have seen my death."

Almost a century later, Steve Miller—tired of art world exclamations about the "death" of painting—began to incorporate science-based imaging into his artworks. Using X-rays and more advanced imaging options, as well—CT scans, MRIs, sonograms, scanning electron microscopy, and satellite imaging—one of his goals was to explore if there was still health and life left in a medium many left for dead in an increasingly photographic and mediated world.

In the 1980s, Miller's work addressed the growing impact of digital technology and the devastation triggered by the AIDS virus. In the 1990s, the juggling of life and death issues led Miller to use X-rays to look at and literally through luxury goods, as a way to produce still lifes that updated the 17th-century tradition of *vanitas* paintings, using contemporary objects to reflect upon the lushness and transitory nature of life.

But eventually Miller's curiosity and imaging options pulled him in a different direction. He began conversations with researchers at Brookhaven National Laboratory, and Rockefeller University and a unique and productive visual partnership with Rod MacKinnon who, like Röntgen in 1901, was awarded a Nobel Prize in 2003 for his pioneering work on the structure and movement of proteins.

On a trip to Brazil in 2005, fascinated by the beauty and complexity of the country's tropical environment, Miller began to conceptualize and produce much of the imagery featured in this book. The visuals and facts he encountered in Brazil were, and still are, overwhelming. One-third of the world's rainforests are located in the Amazon River basin, which is, in turn, home to one-third of all known animal species in the world. The diverse plant matter, density, and scale of the rainforest there is staggering. So much carbon dioxide is taken in, so much oxygen is released back into the earth's atmosphere through the process of transpiration, that the Amazon rainforest is often called the earth's air conditioner or the "lungs of the world."

In recent decades, however, radical deforestation—the leveling of large swaths of land to cultivate cash crops, raise cattle, sell off timber, and bio-prospect for plant extracts used in the production of chemicals, cosmetics,

and breakthrough medicines—has decimated the Amazon basin. A fifth of the rainforest is already gone.

During subsequent visits to Brazil and obsessed with the country's biodiversity and environmental challenges, Miller once again partnered with scientists, this time in São Paulo and Belém, to access the radiology equipment necessary to picture and catalog local species, flora, and fauna. *Health of the Planet* evolved into a dense and multilayered project, and Miller's compulsive desire to see, know, collect, and save has something of a Noah's ark quality about it.

All the bright color and painterly exuberance, all the high-tech diagnostic imagery featured in Miller's silkscreens, paintings, sculptures, and works on paper and printed on surfboards are dazzling to explore and take in. Photography was widely used in the 19th century to collect specimens and create picture atlases of the natural world. In works that explore health and environmental stewardship, Miller uses scientific images, too, but to a different end, not only to catalog and celebrate the natural world, but to make us acknowledge our place in and the consequential nature of our interactions with it.

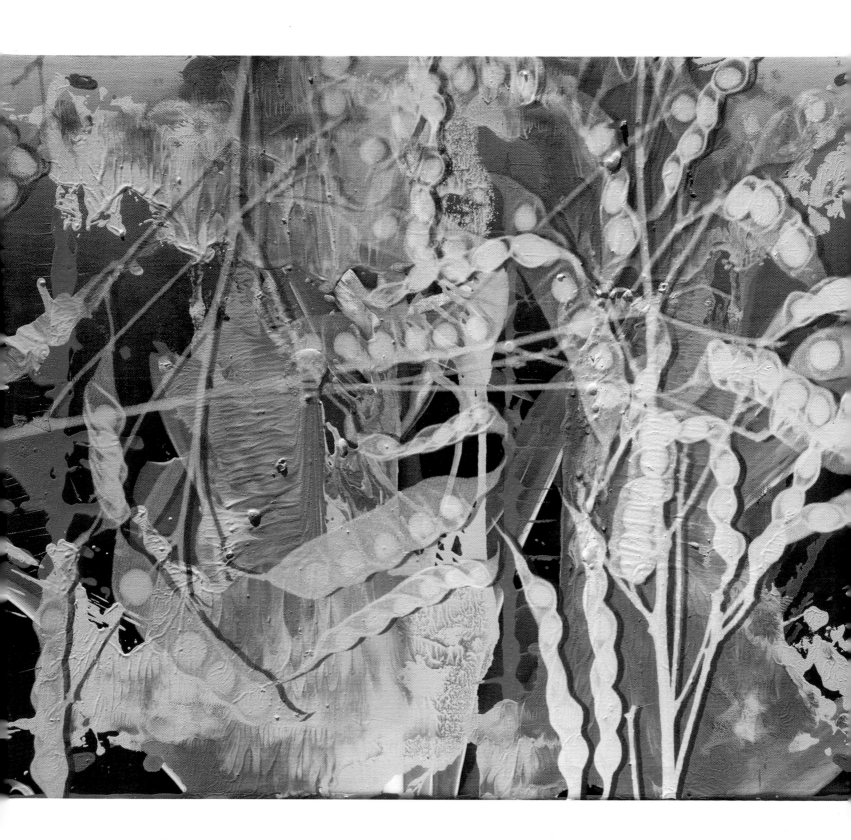

Vast Timespan, 2010 | Carbon inkjet, oil and silkscreen on canvas | 22 x 26 in.

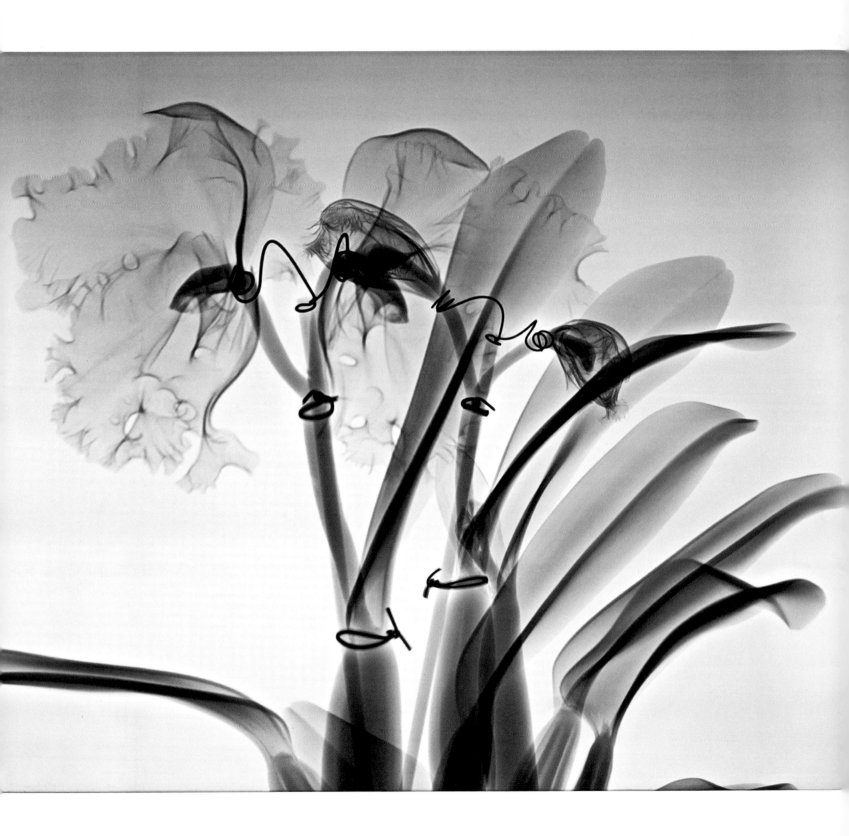

Glass, 2008 | Carbon inkjet on cotton rag | 24 x 28.75 in.

WHAT LIES BENEATH OUR GLOBAL RIBS

The use of X-rays in my art practice had started in 1992 after enduring another anachronistic conversation about the death of painting. Conceiving of a way to reinvent the notion of a portrait, I began to use medical technology to look beyond the surface and beneath the flesh. I continued this exploration with CT scans, MRIs, sonograms, echocardiograms, electron microscopes and X-ray photography—taking photos of other mysteries including women's shoes and musical instruments. This same lens of technology that could be used to understand the human body could also be used to gain insight into the natural world.

In 2005 a long-term project started with the seed of a thought on a tropical island. I traveled to Brazil and was overwhelmed by the natural environment. My environmental curiosity was stimulated by the beauty of the Ilha Grande,

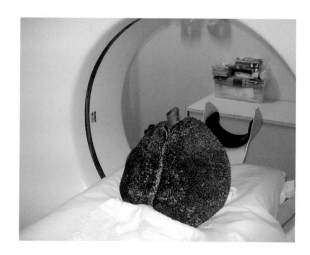

an island with untouched beaches at the edge of the Atlantic rainforest in the area of Angra dos Reis. This astounding encounter with the exotic natural land included looking up into a tree and seeing an unusual fruit, the size of a football, with spikes all over the surface. It was my first sighting of the jackfruit, called *jaca* in Portuguese. Eventually, I found a jaca with two fruits occupying one stem that looked like a giant pair of lungs. Curious about this new discovery, I decided that an X-ray could answer some questions.

This strange jaca tree made me think that if the Amazon is called the "lungs" of our planet, I could x-ray the flora and fauna of the rainforests to give the world a metaphorical checkup. It seemed obvious to want to know what lies beneath our global ribs. So, I took my jaca "lungs" to a local hospital and initiated what was to become an expansive project, *Health of the Planet*.

In Brazil, the greatest accumulation of animals was in Belém, in Pará, the Amazon's northernmost state. Flying over the Amazon in a small plane at 2,000 feet and finding no relief from the vast green was astonishing, as well as riding the river in a small boat viewing a resolutely uninhabited shore line. In another adventure, a sense of danger welled up as I strolled the Atlantic rainforest in Bahia as the sun was setting. Panic arrived from losing the trail that didn't look familiar. Walking where there is no

horizon and no direction as the light source dipped below the tree line induced an adrenaline rush. I read a statistic that we could not last a day without being engulfed by bugs and predators.

In Belém, I was automatically interested in x-raying the sloth. These critically endangered tree-dwelling mammal species are being stressed by the deforestation and burning of the rainforest. They live in the canopy of the forest and can move freely in any direction above the forest floor for their safety and survival. With the land clearing, their lungs are susceptible to smoke and pollution as they become trapped in islands of trees. When an island no longer supports their habitat, they must escape and make their way across a clearing. This journey makes them an easy, slow-moving target for predators. My work *Sloth Pieta* is the canary in the coal mine, foreshadowing an increasingly bleak ecological future.

When looking at the shapes and designs of Amazon land-clearing from a satellite, one distinctive pattern that appears is called a "fish bone." A long spine emerges with ribs. In the rivers below, piranhas swim: as seen by the

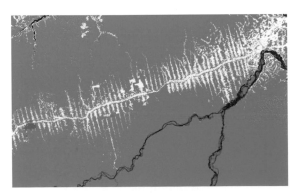

miracle of radiology, one can see their tight, efficient design from tooth to tail. In predatory packs, these creatures clean the river and serve their function in the energy exchange that defines a dynamic fluid system.

When one observes this critical conversation between resources and needs, there is no human who is exempt.

Telephone and electrical lines (called "cat whiskers") found in the favela create exquisite communal drawings when seen from above or below, speaking to the chaotic need for resources, in contrast to the aerial geometry of deforestation.

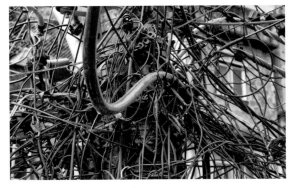

The Amazon flora and fauna are resources in dwindling supply. No need to capture the swimming alligator, stuff it and mount it on your wall for ego and vanity. In Brazil, I see the surfboard as a metaphoric connection to water. The surfboard is a trophy that can be found in a favela or in a home of the famous. Mount an X-ray of a live alligator onto a surfboard to create the eco-trophy. Lay a python on a skateboard and make the same shape with your moving feet to samba with science.

Opposite: *Sloth Pieta*, 2011 | Carbon inkjet on cotton rag | 26 x 24 in.

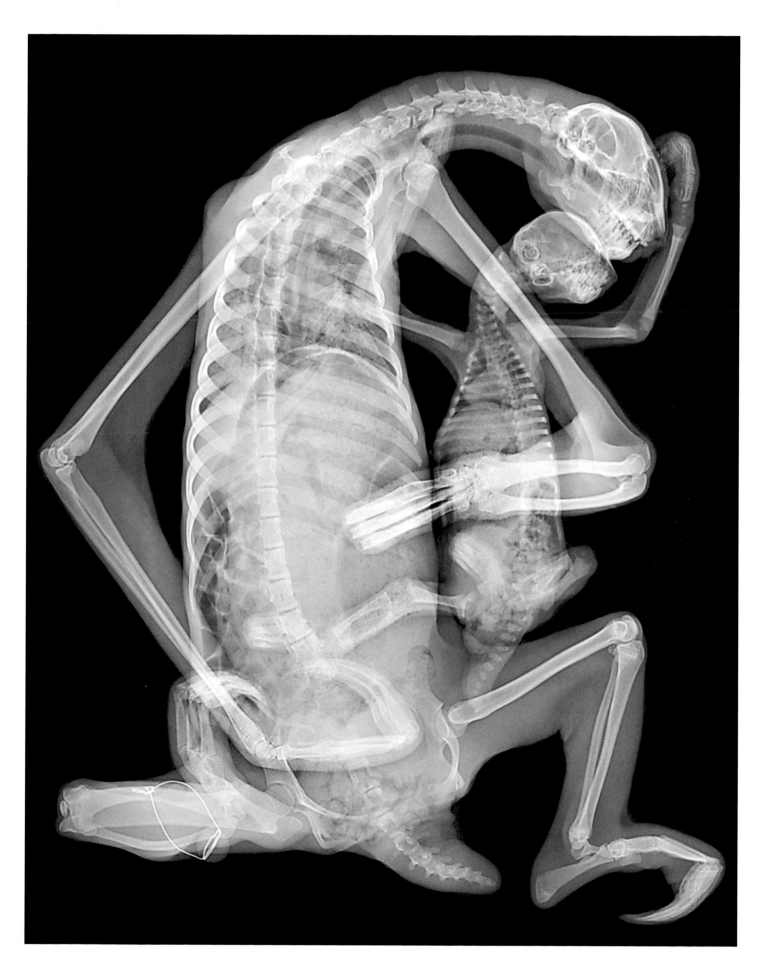

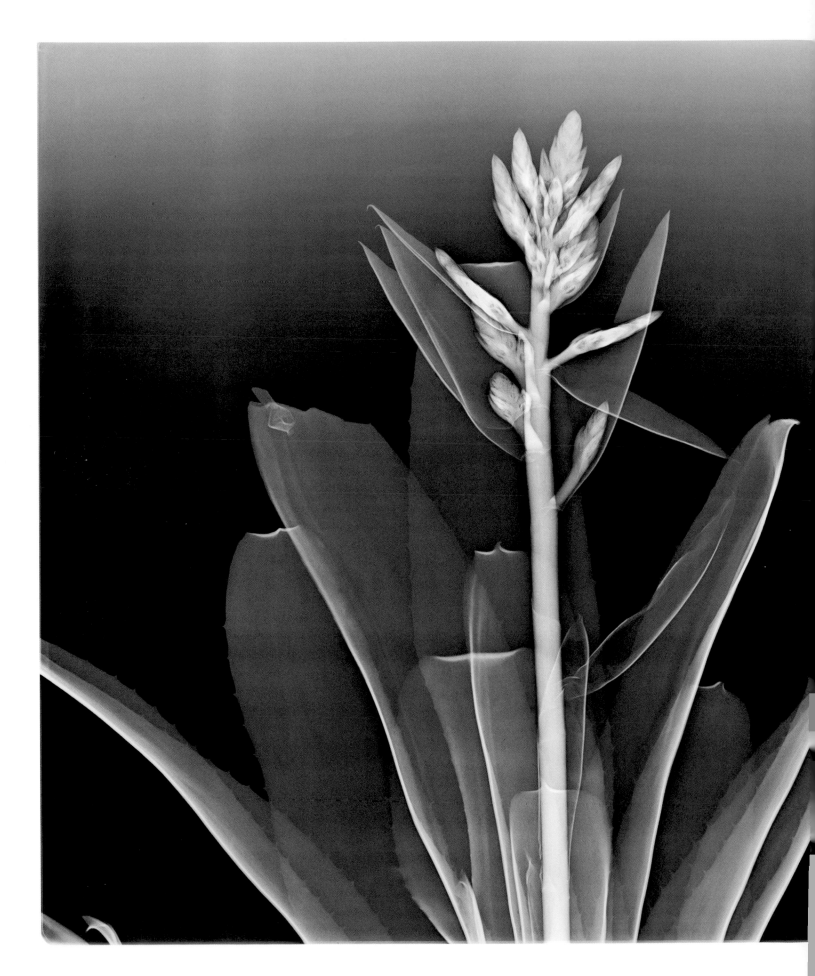

Torch, 2010 | Carbon inkjet on cotton rag | 24 × 28.75 in.

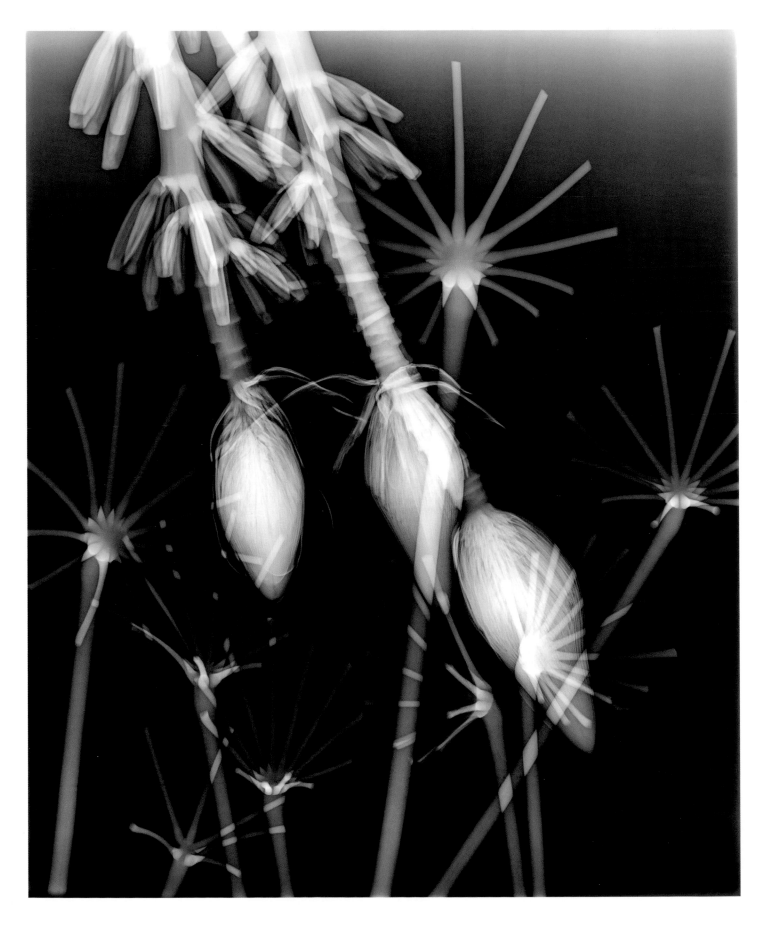

Fireworks, 2010 | Carbon inkjet on cotton rag | 28.75 x 24 in.

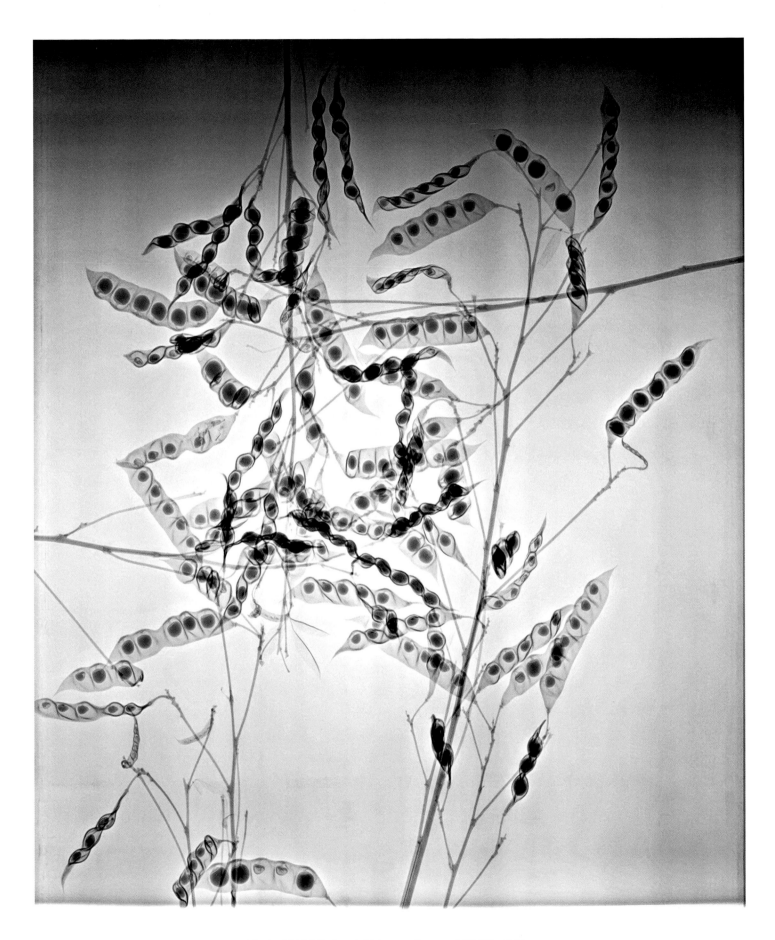

Pods, 2010 | Carbon inkjet on cotton rag | 28.75 x 24 in.

Greenhouse Effect, 2009 | Carbon inkjet, acrylic and silkscreen on canvas | 26.5 x 22 in.

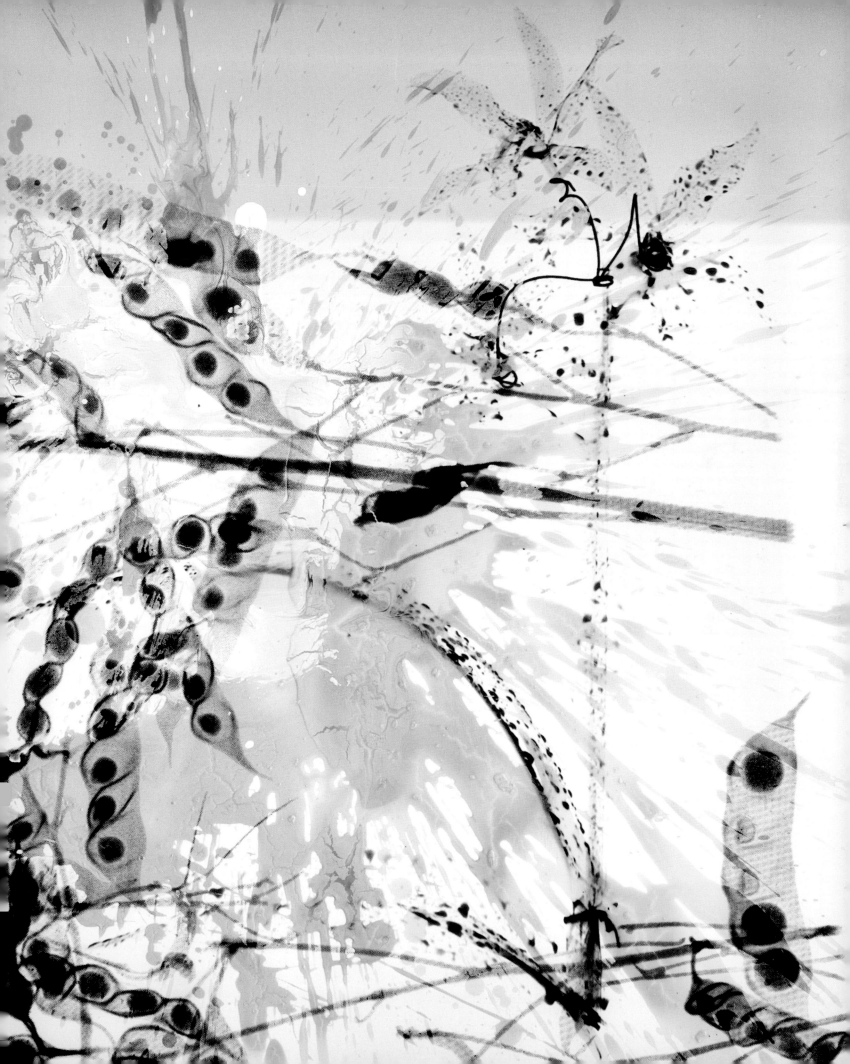

Health of the Planet #525, 2009 | Carbon inkjet, enamel and silkscreen on cotton rag | 25.5 x 24 in.

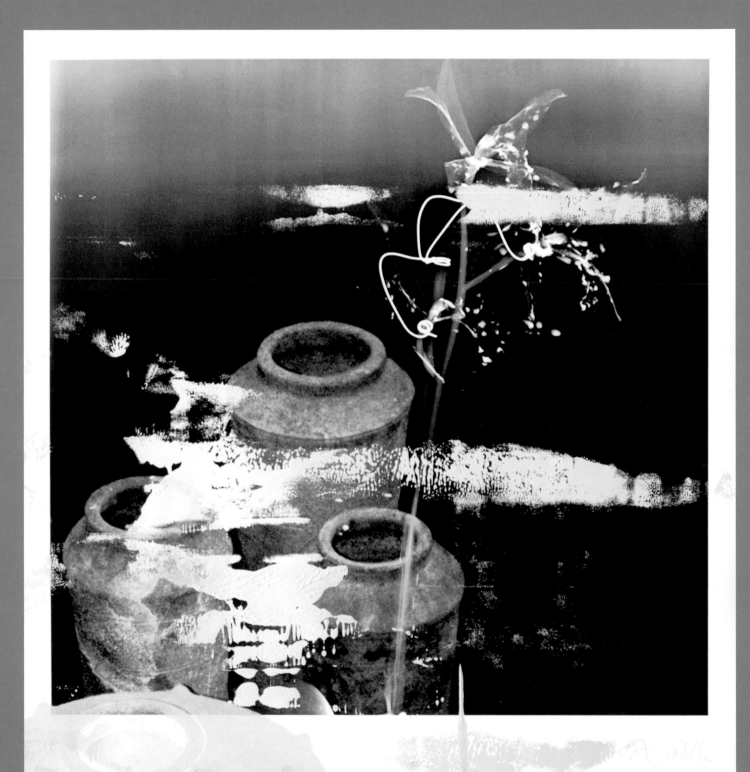

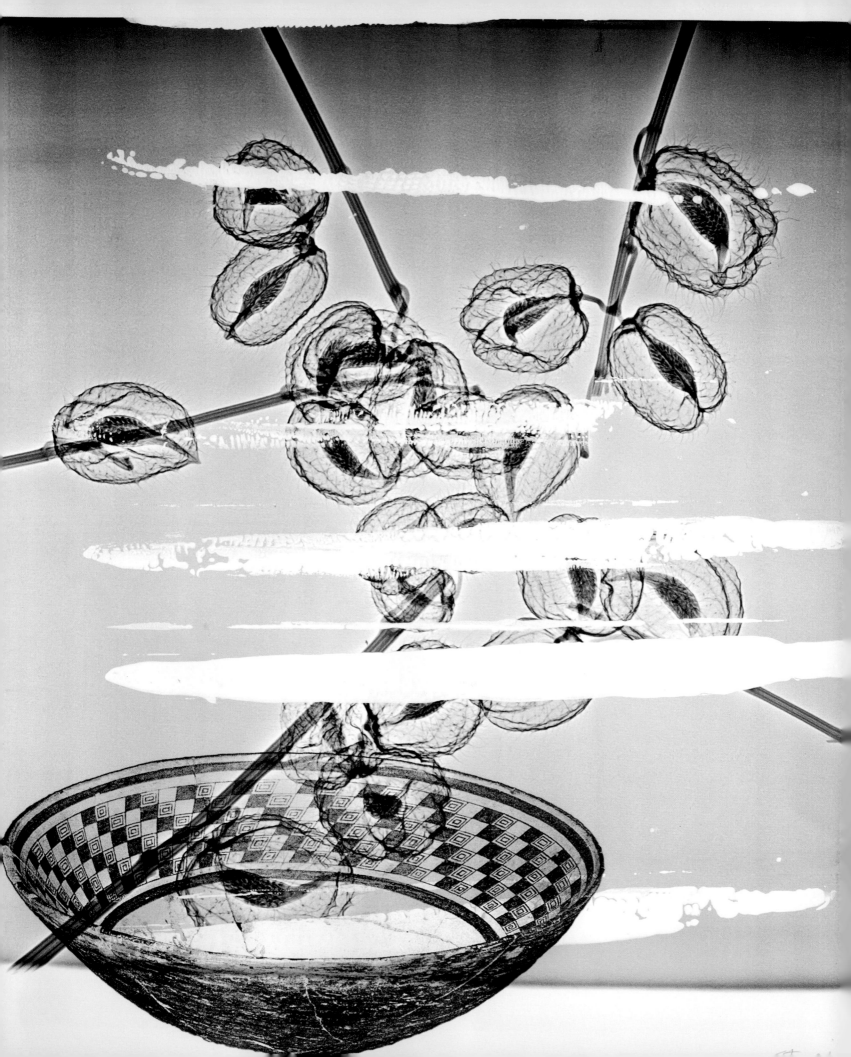

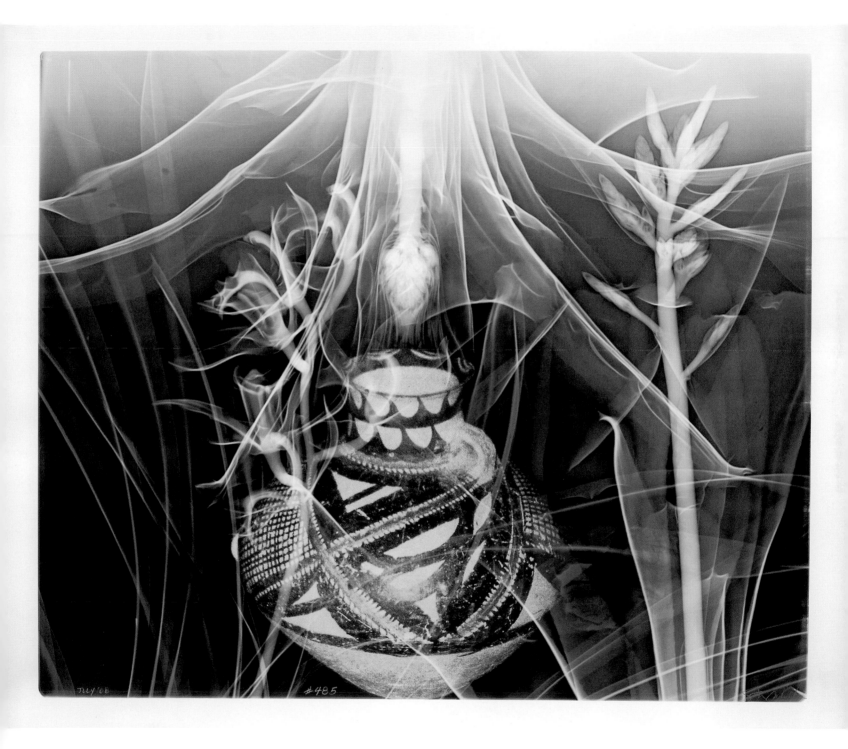

Opposite: *Health of the Planet #480*, 2008 | Carbon inkjet, enamel and silkscreen on cotton rag | 31 x 24 in.

Above: *Health of the Planet #485*, 2008 | Carbon inkjet and silkscreen on cotton rag | 24 x 30.83 in.

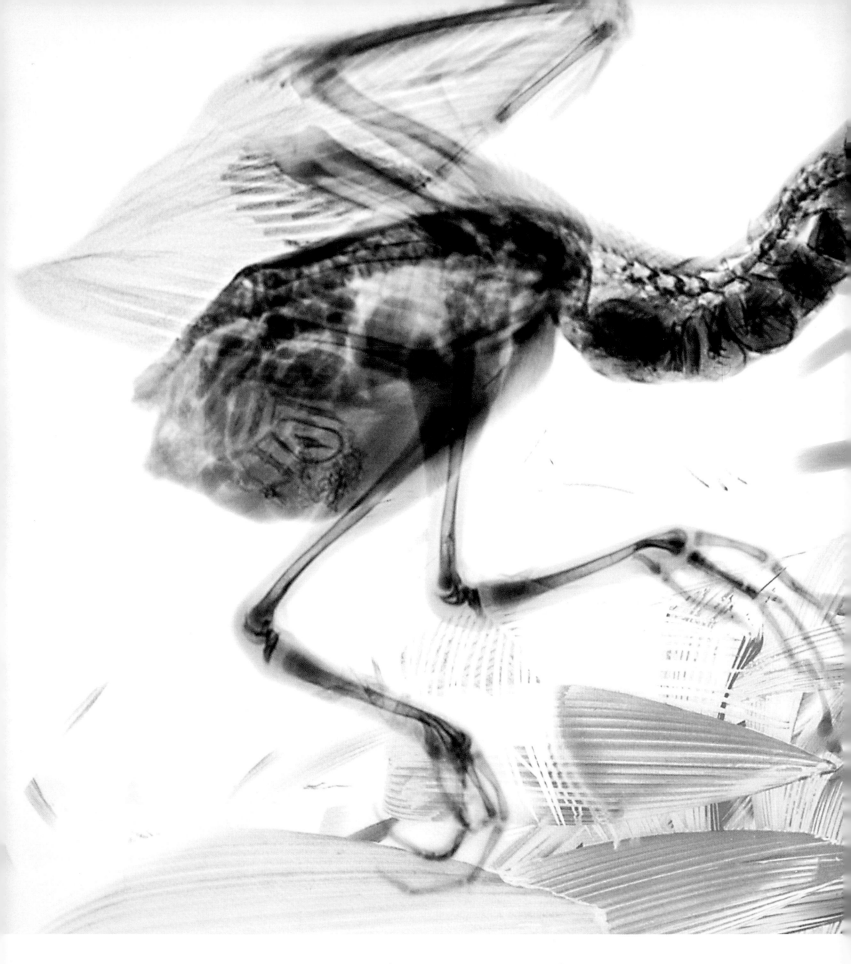

The Kingdom of Instinct, 2015 | Inkjet and silkscreen on canvas | 40.5 x 74 in.

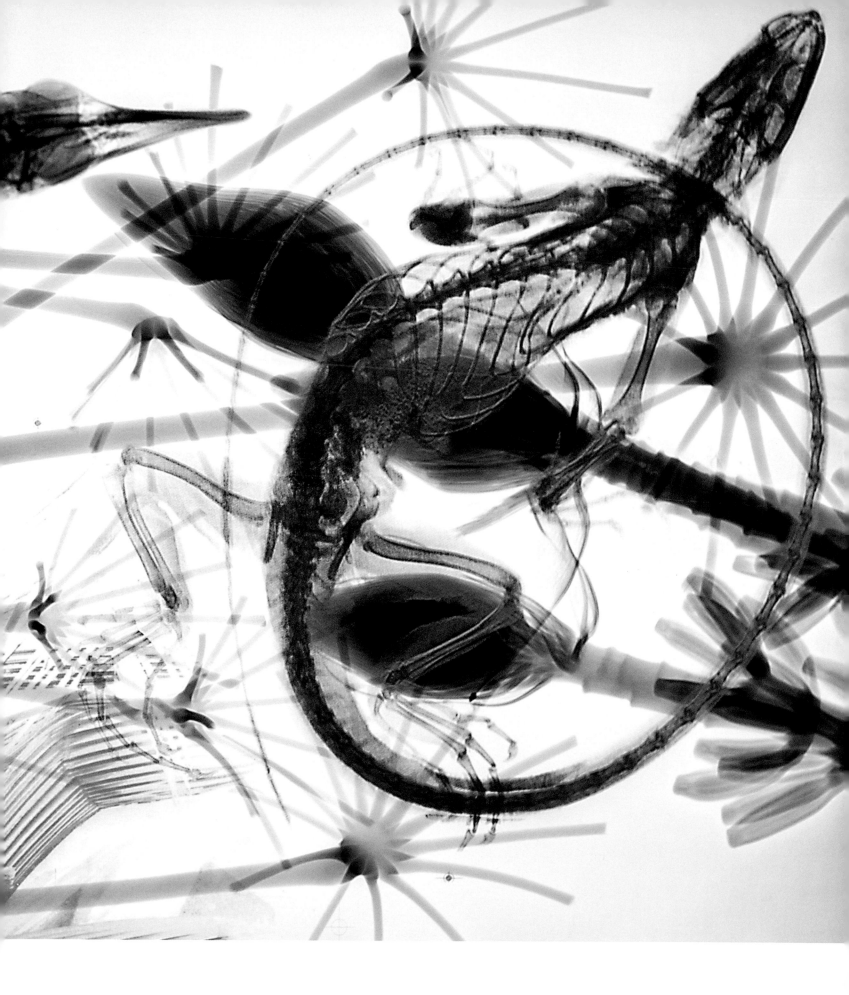

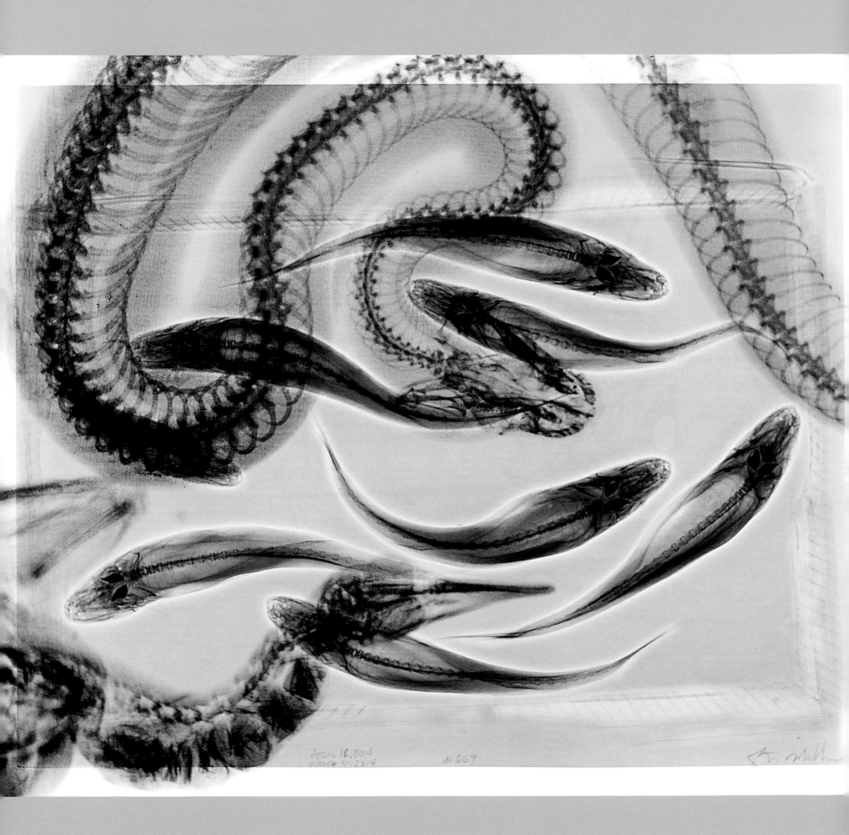

Health of the Planet #669, 2014 | Carbon inkjet and silkscreen on cotton rag | 24 x 28.75 in.

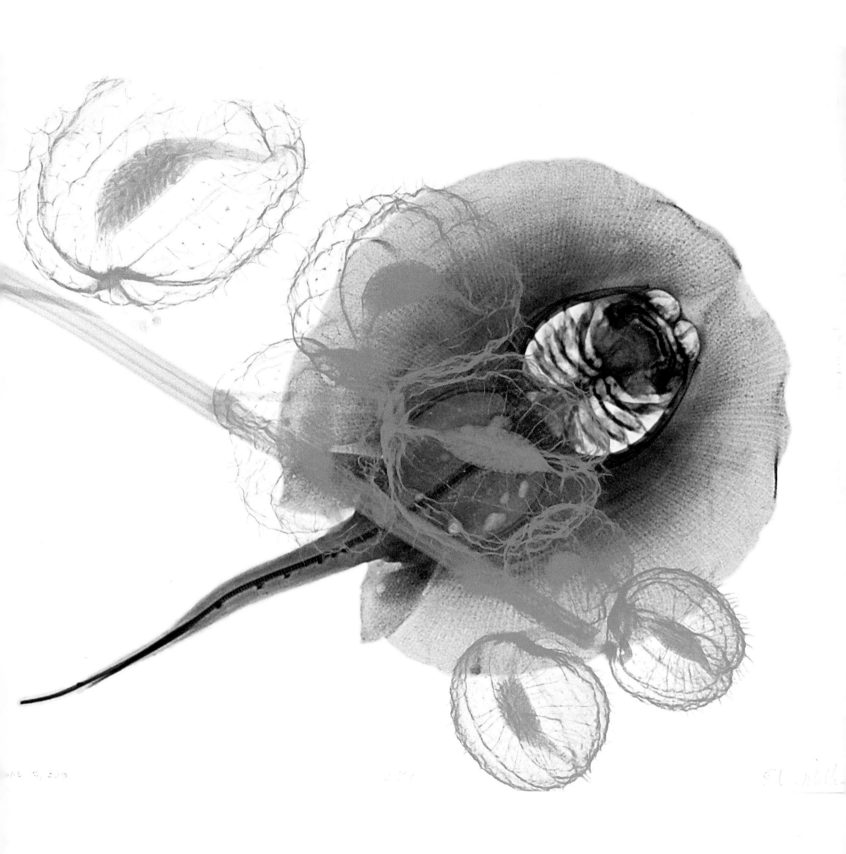

Health of the Planet #638, 2013 | Carbon inkjet and silkscreen on cotton rag | 24 x 28.5 in.

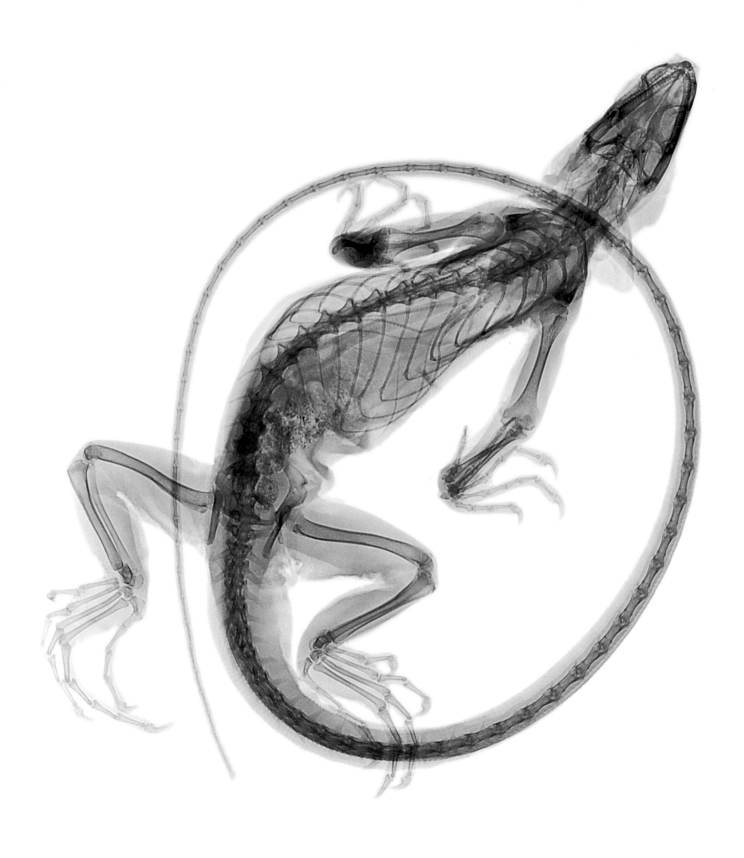

Iguana, 2011 | Carbon inkjet on cotton rag | 24.13 x 24 in.

Turtle Lungs, 2012 | Carbon inkjet on cotton rag | 23.68 x 24 in.

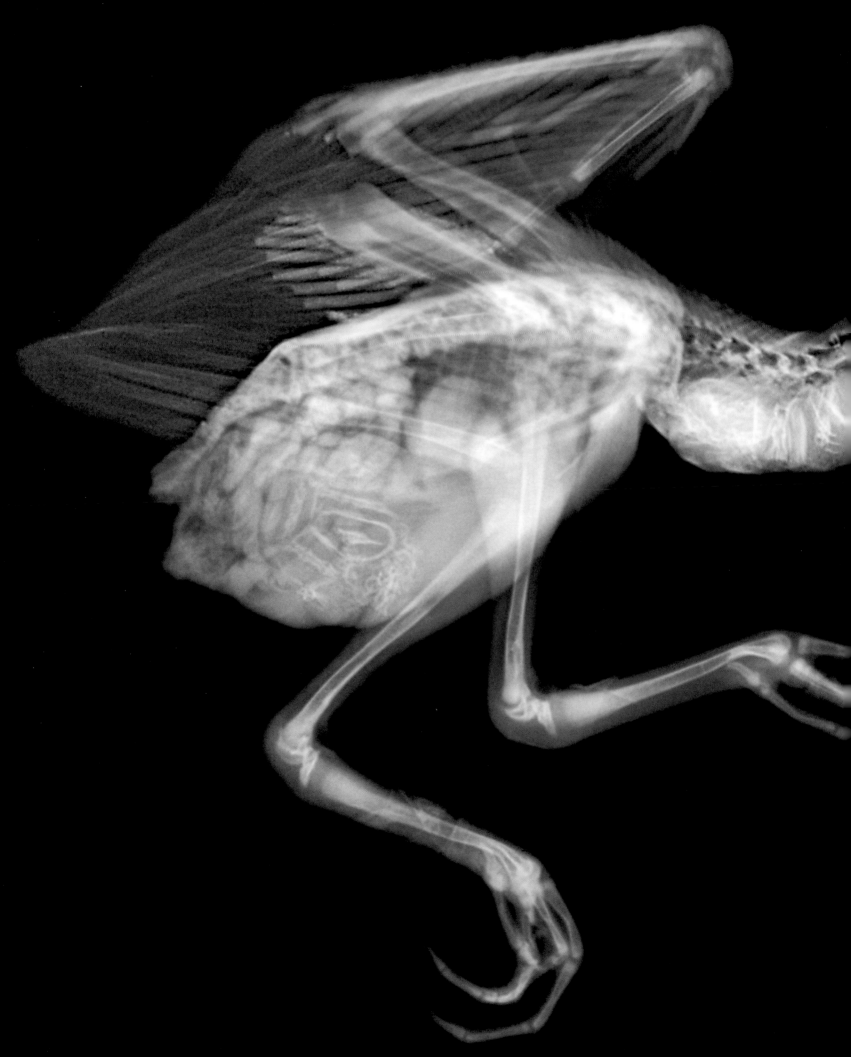

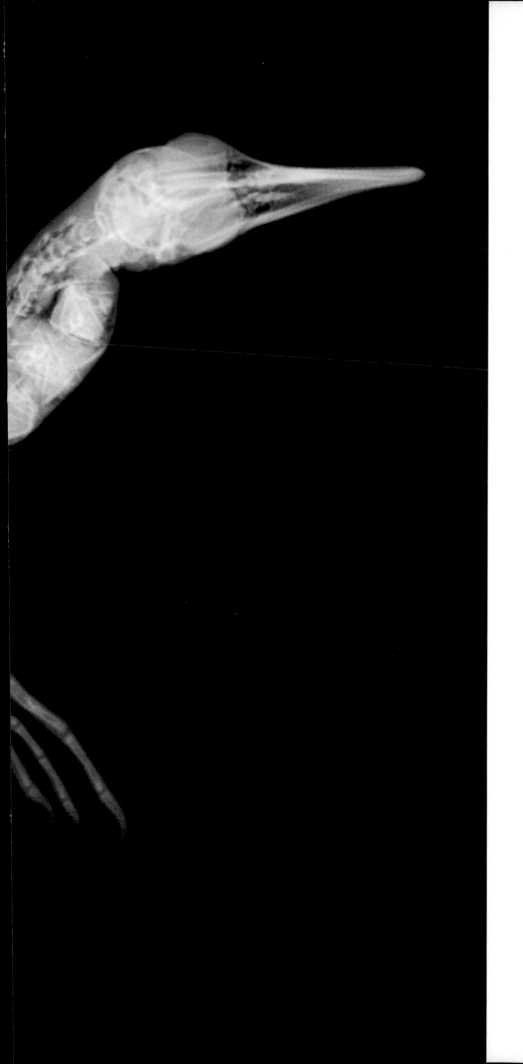

Running Bird, 2011 | Carbon inkjet on cotton rag | 24 x 30 in.

Vanitas #120, 2000 | Silkscreen on museum board | 50 x 38 in.

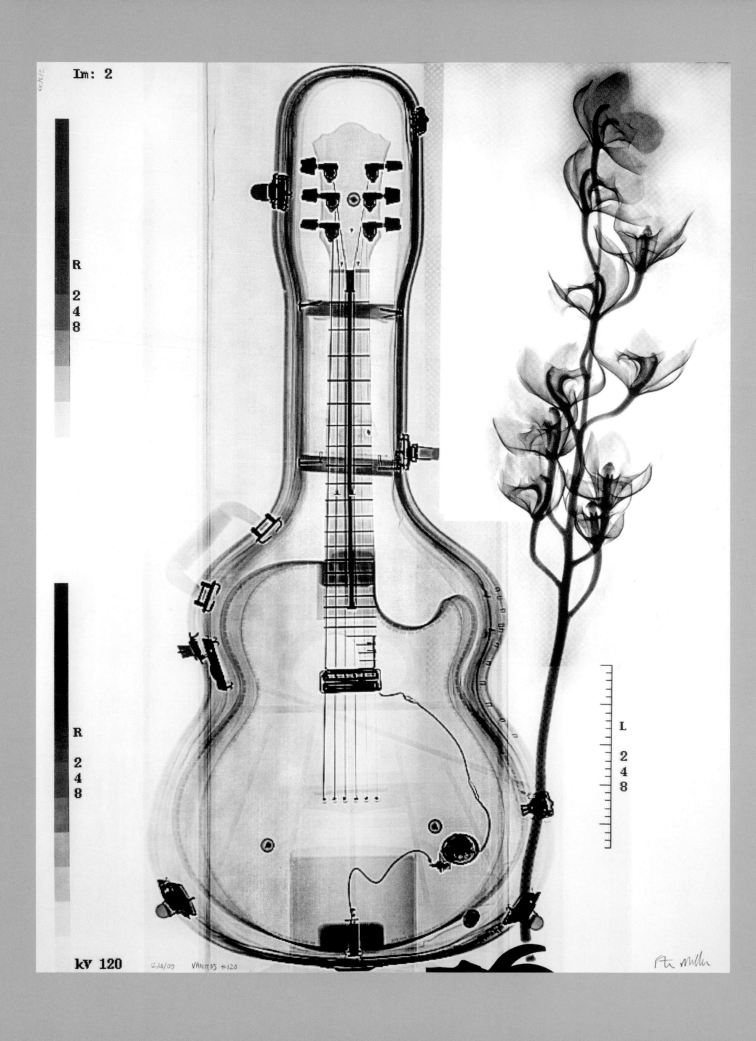

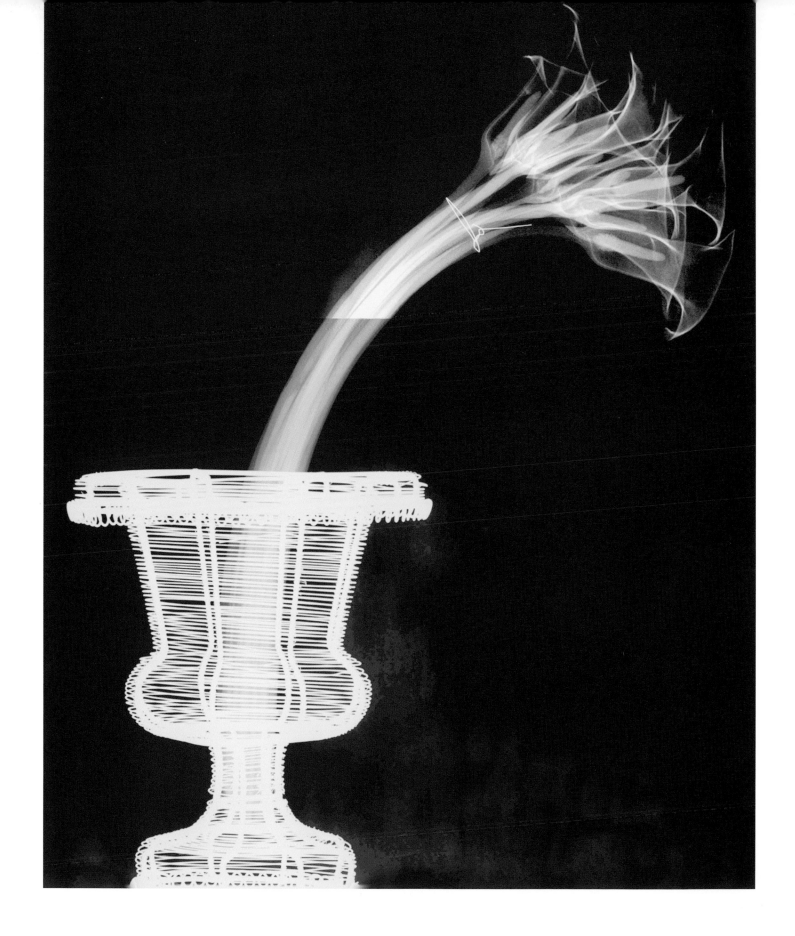

Above: *Calla Lily* from the X-ray flower portfolio, 2000 | Iris print | 30.75 x 22.5 in.

Opposite: *Amaryllis* from the X-ray flower portfolio, 2000 | Iris print | 30.75 x 22.5 in.

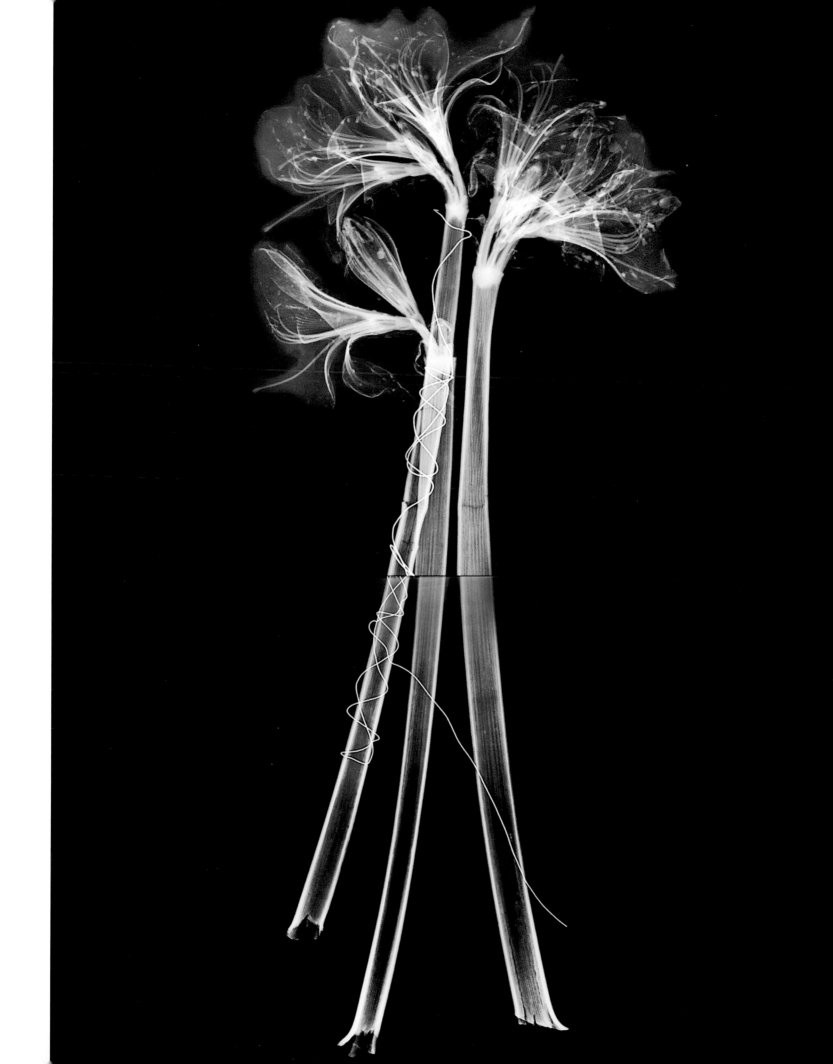

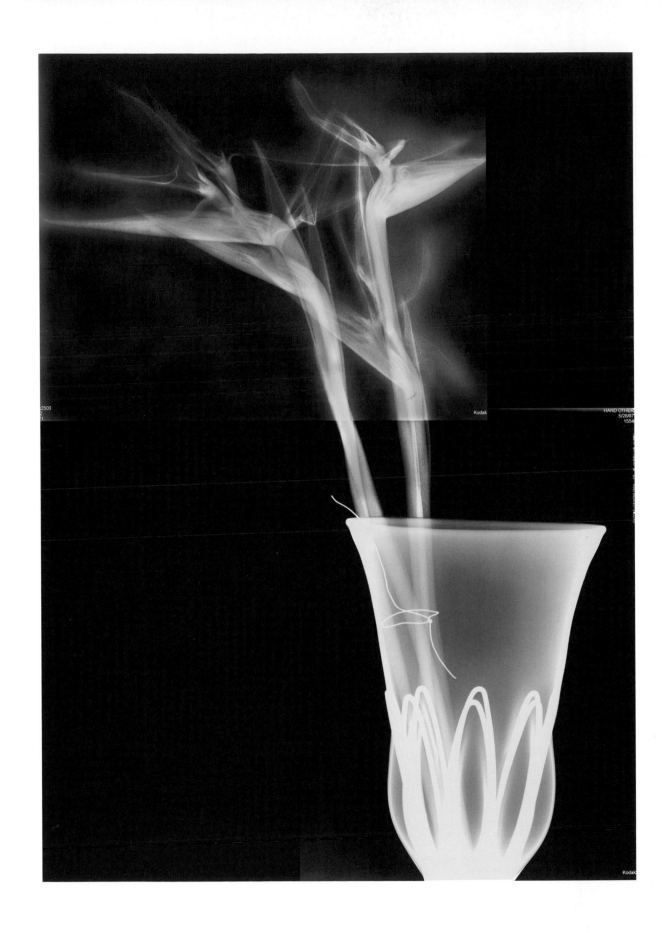

Above: *Bird of Paradise* from the X-ray flower portfolio, 2000 | Iris print | 30.75 x 22.5 in.

Opposite: *Daisy* from the X-ray flower portfolio, 2000 | Iris print | 30.75 x 22.5 in.

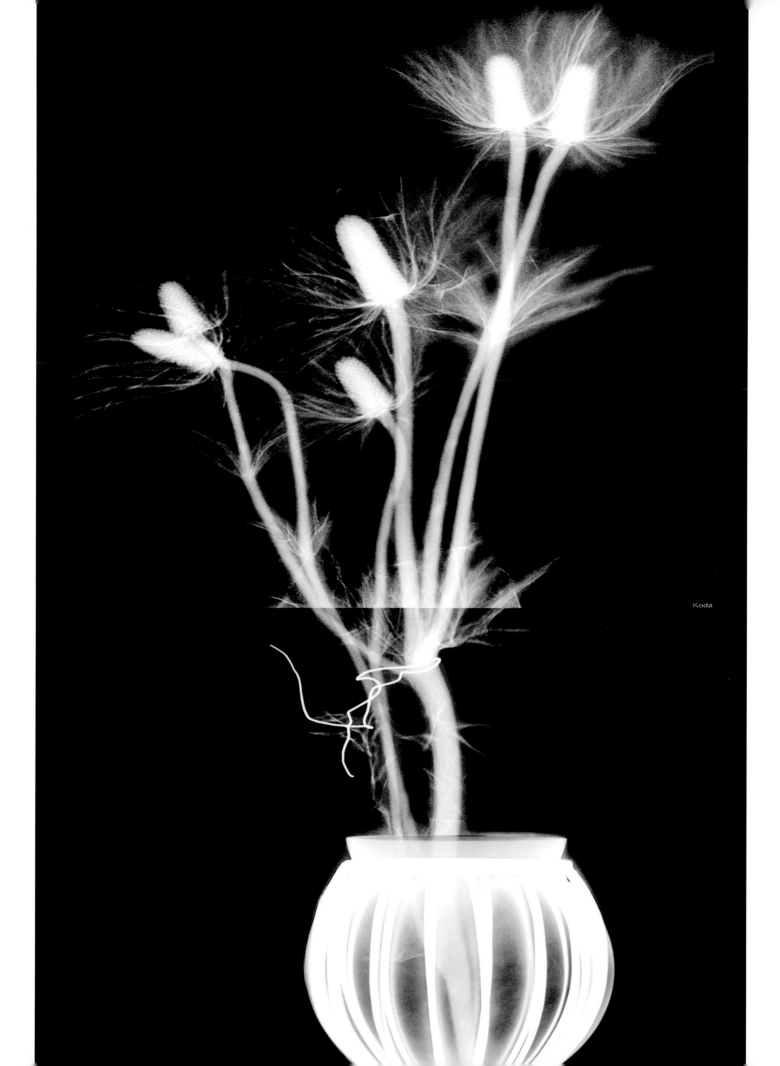

Self-Portrait Vanitas with Tulips, 1997 | Pigment dispersion and silkscreen on canvas | 55 x 45 in.

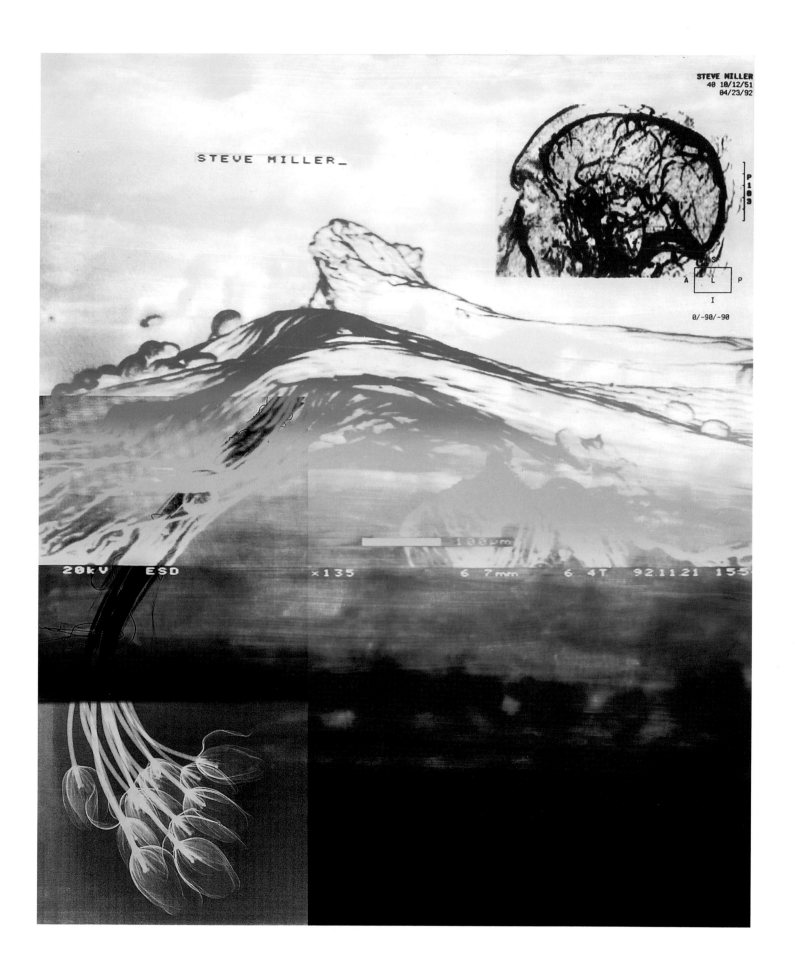

STEVE MILLER_

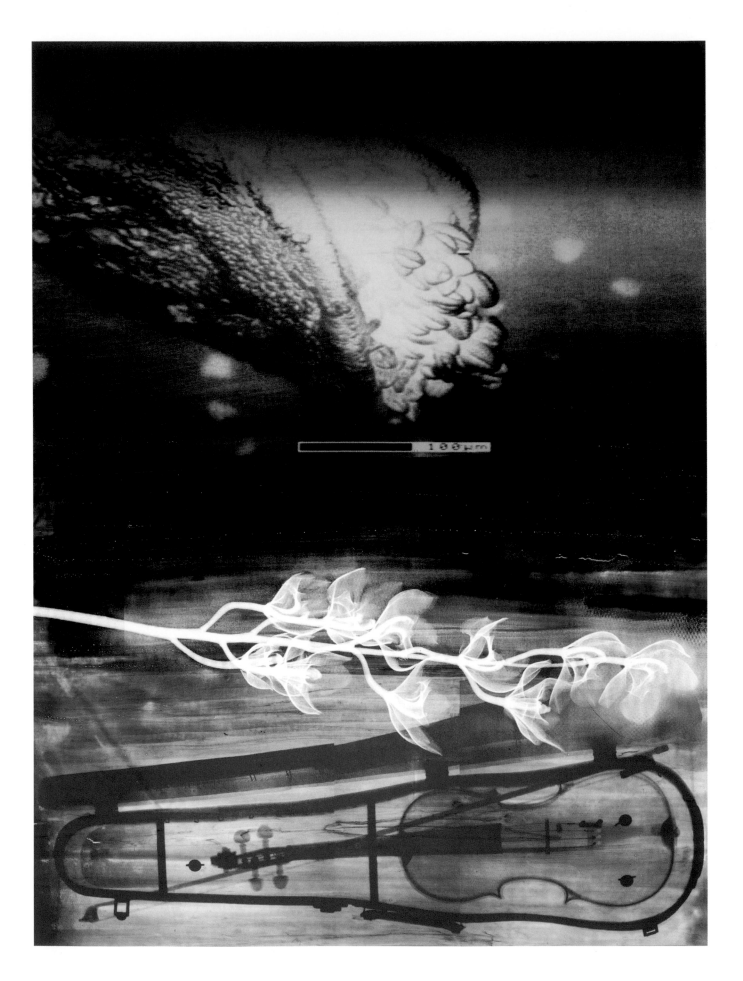

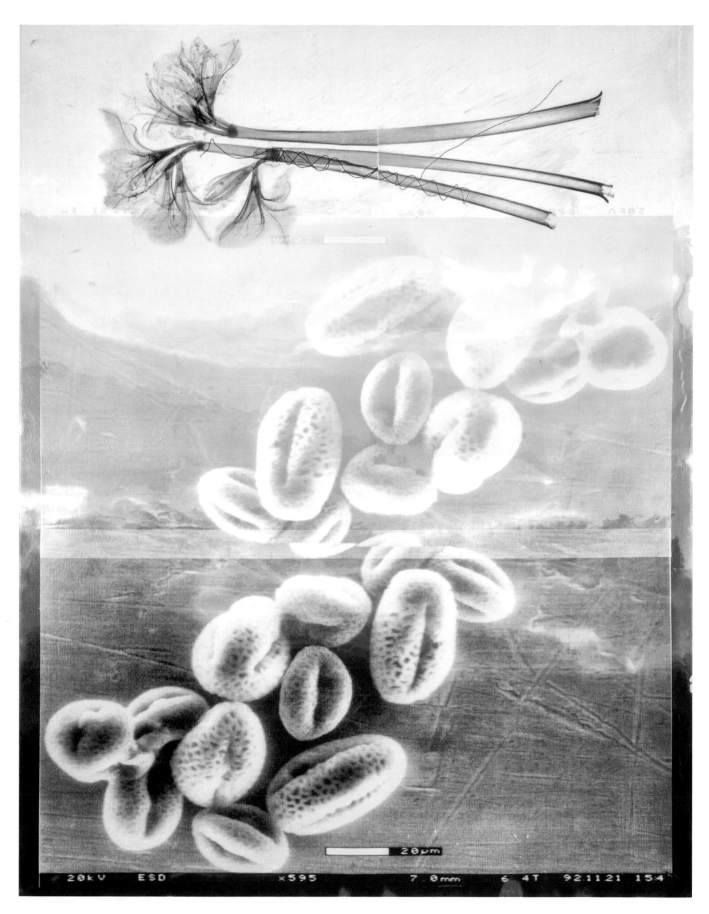

Opposite: *Body Music*, 2000 | Pigment dispersion and silkscreen on canvas | 56 x 39 in.

Above: *Source Material*, 2000 | Pigment dispersion and silkscreen on canvas | 62 x 48 in.

Against Ideas, 2000 | Pigment dispersion and
silkscreen on canvas | 50 x 65 in.

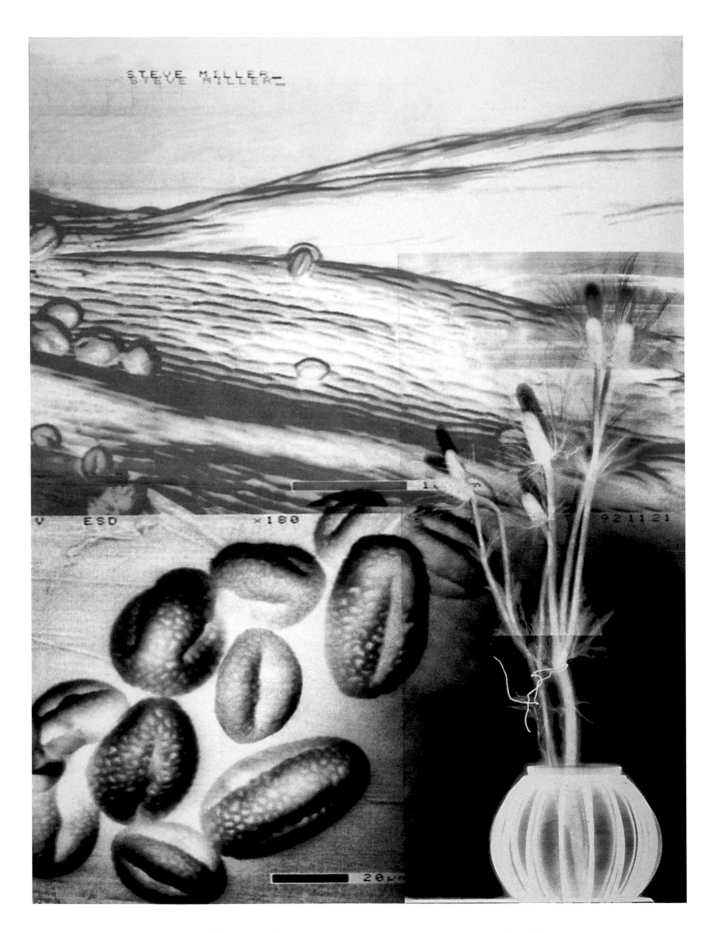

Vanitas #022, 1998 | Spray enamel and silkscreen on cotton rag | 50 x 38 in.

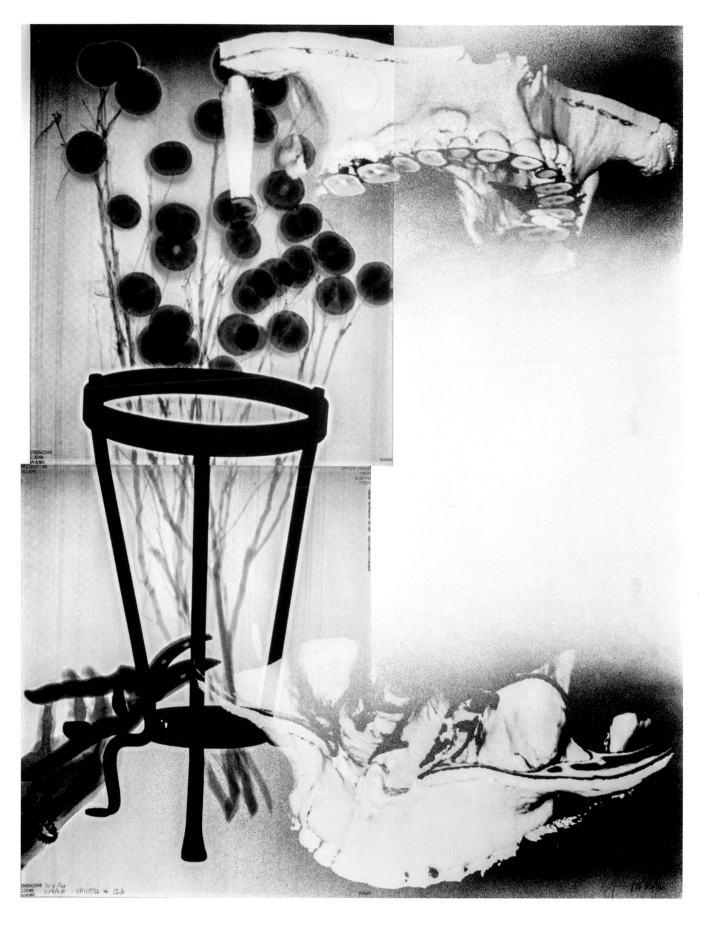

Self-Portrait Vanitas #126, 2000 | Spray enamel and silkscreen on cotton rag | 50 x 38 in.

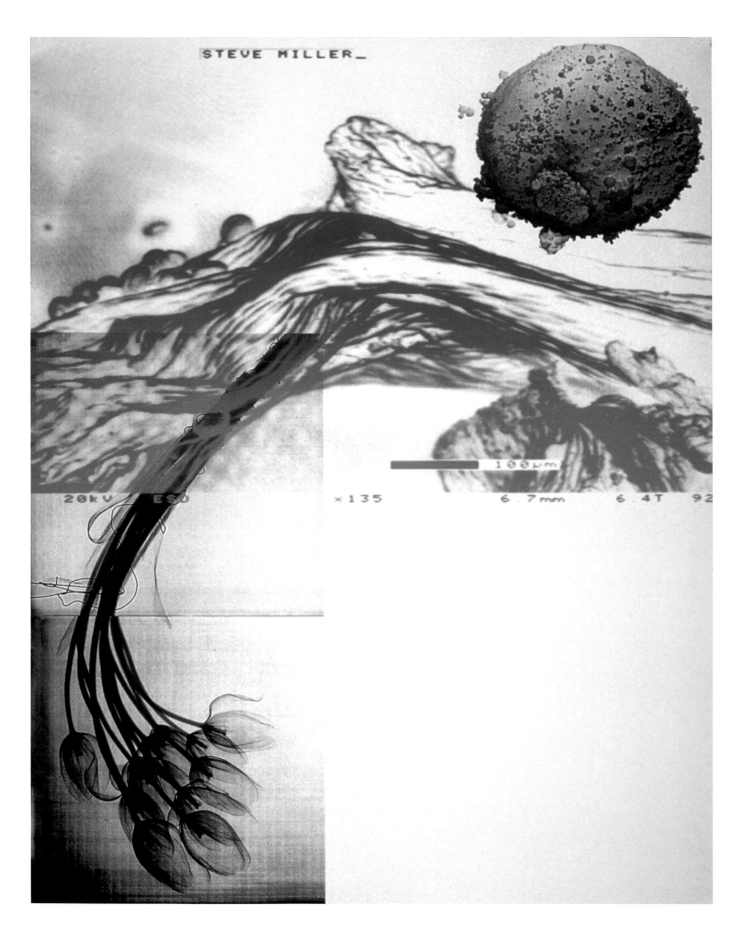

Vanitas #027, 1998 | Silkscreen on cotton rag | 50 x 38 in.

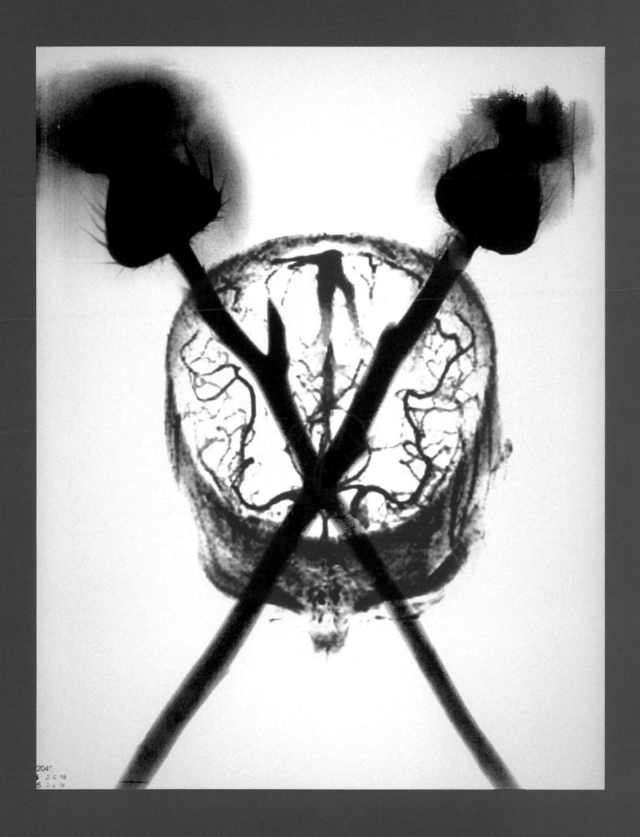

Self-Portrait Vanitas #025, 1998 | Silkscreen on cotton rag | 50 x 38 in.

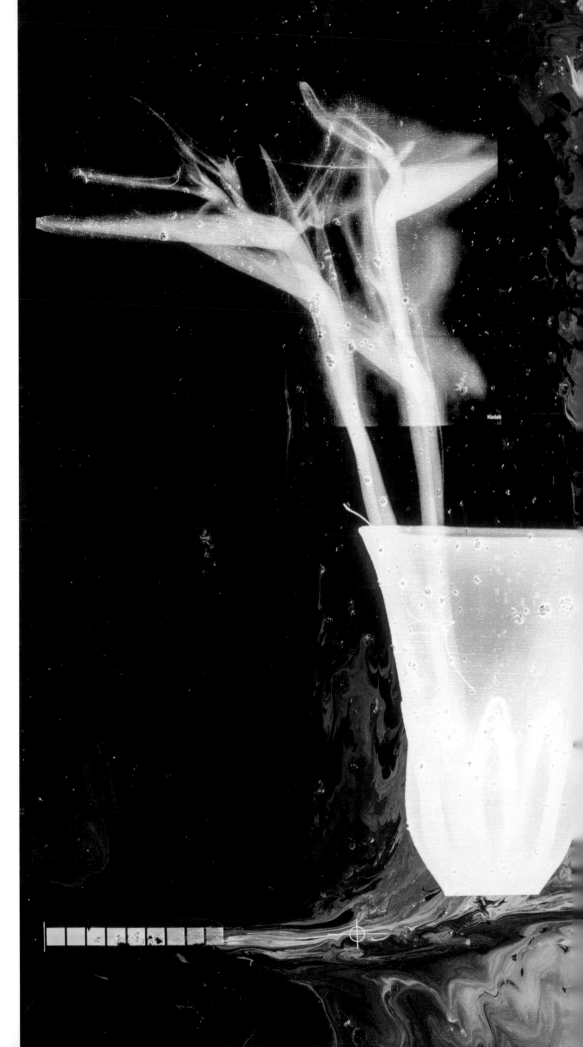

Poetic Champions Compose, 2000
Pigment dispersion and silkscreen on
canvas | 48 x 62 in.

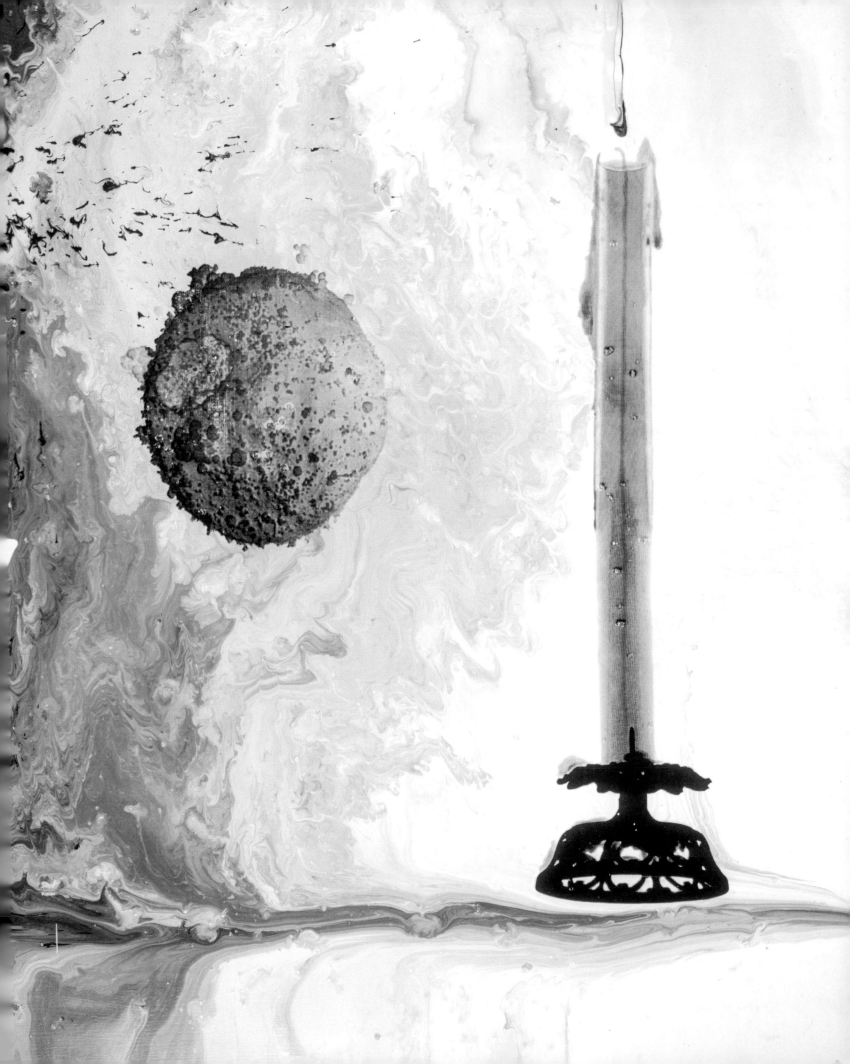

Self-Portrait Vanitas #069, 1999 | Spray enamel and silkscreen on cotton rag | 40 x 30 in.

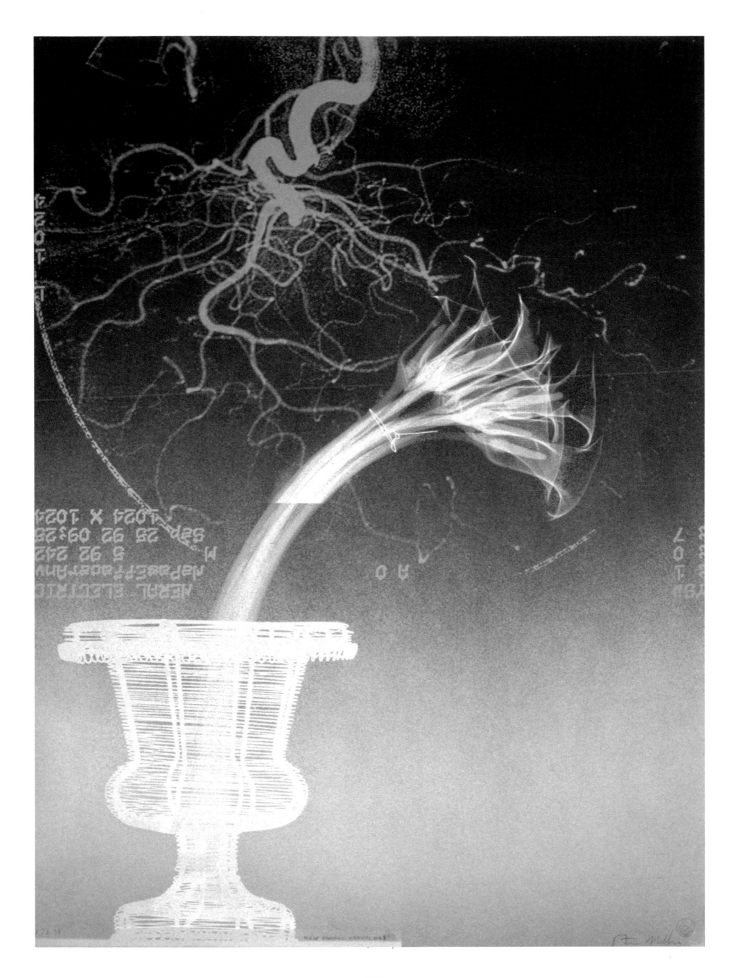

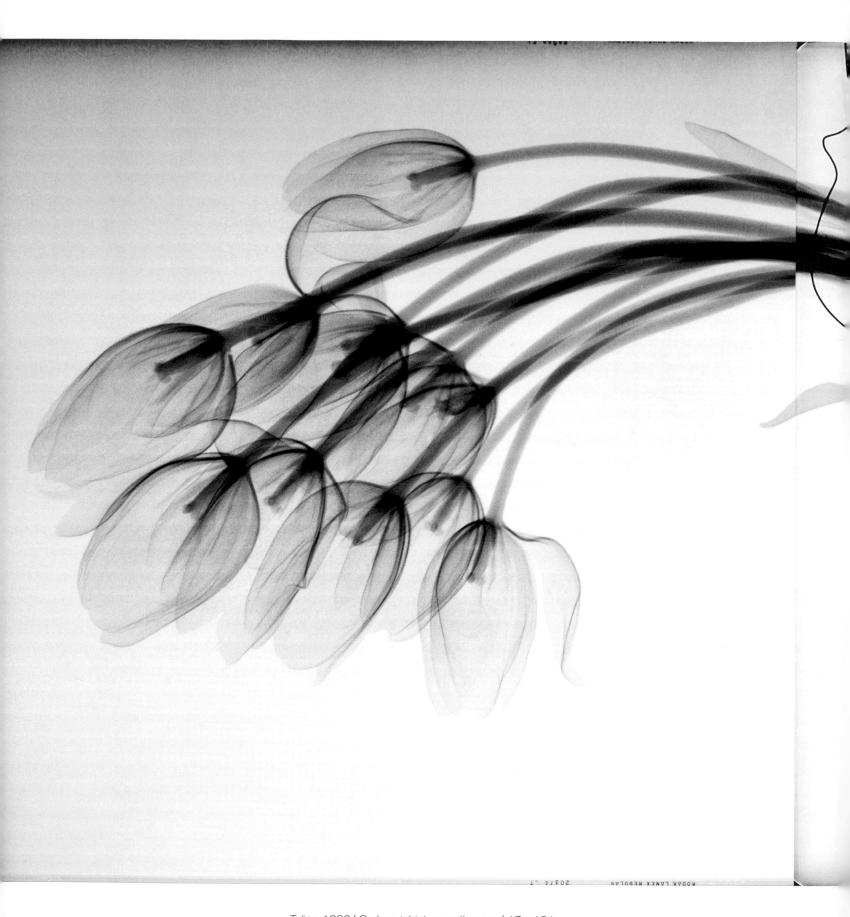

Tulips, 1996 | Carbon inkjet on cotton rag | 17 x 13 in.

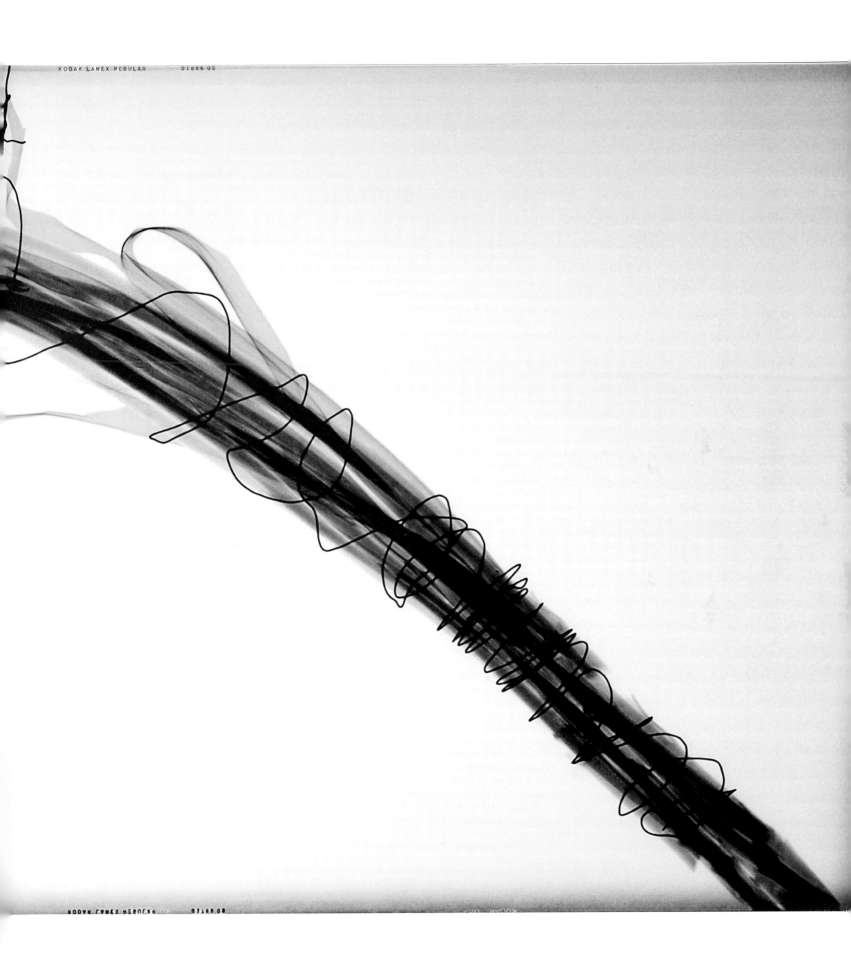

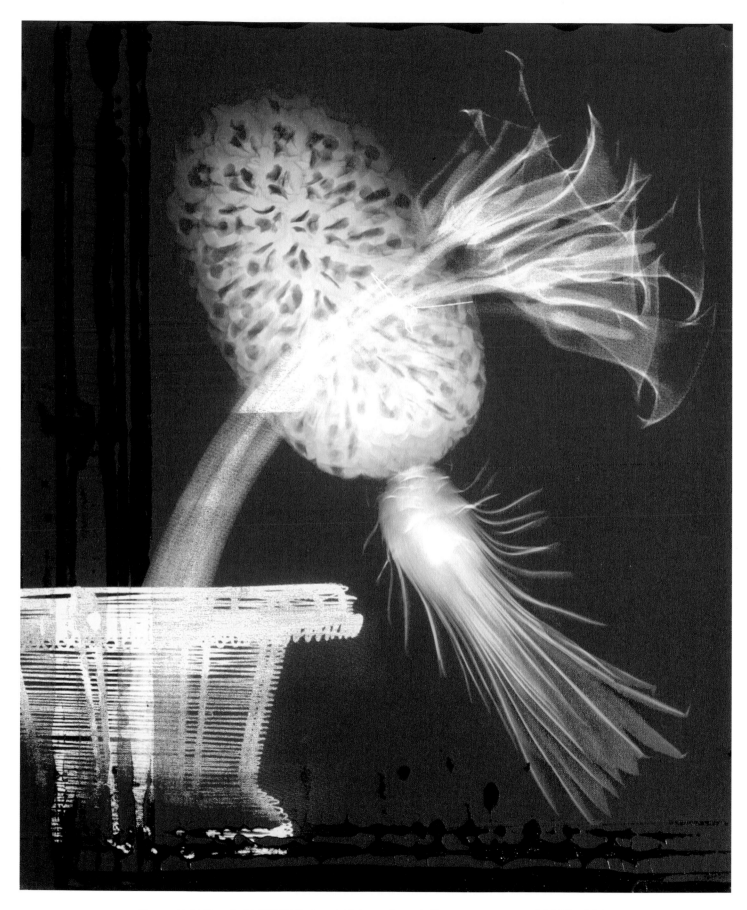

Above: *Light Threshold*, 2009 | Carbon inkjet, acrylic and silkscreen on canvas | 26.25 x 22 in.

Opposite: *Health of the Planet #473*, 2008 | Inkjet, enamel and silkscreen on cotton rag | 31.125 x 24 in.

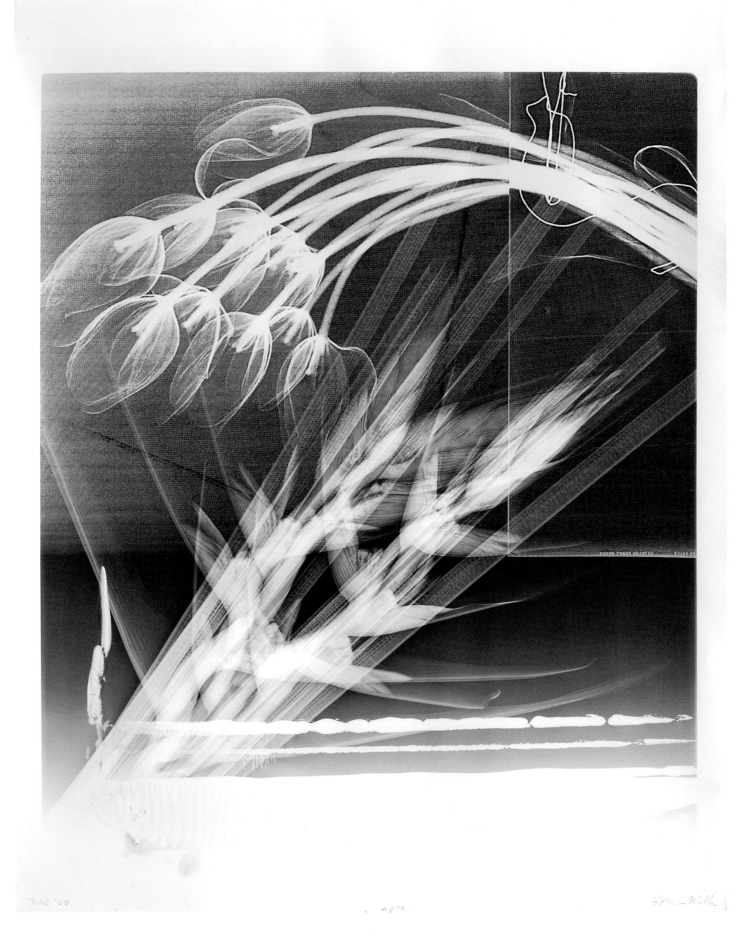

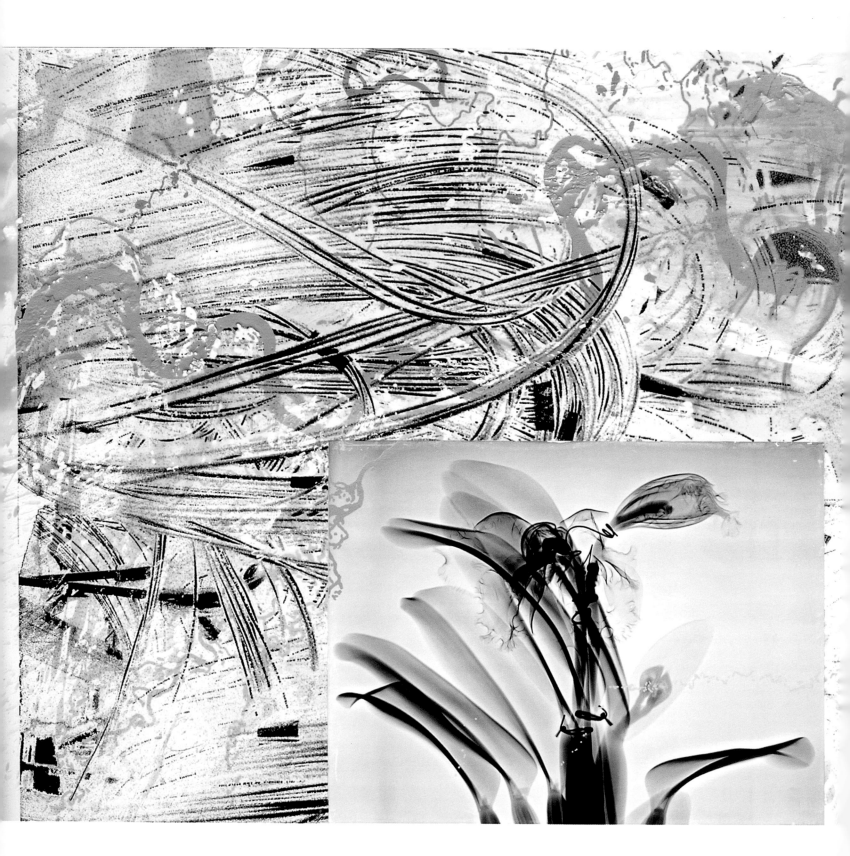

One Way or the Other, 2011 | Inkjet, pigment dispersion and silkscreen | 40 x 82 in.

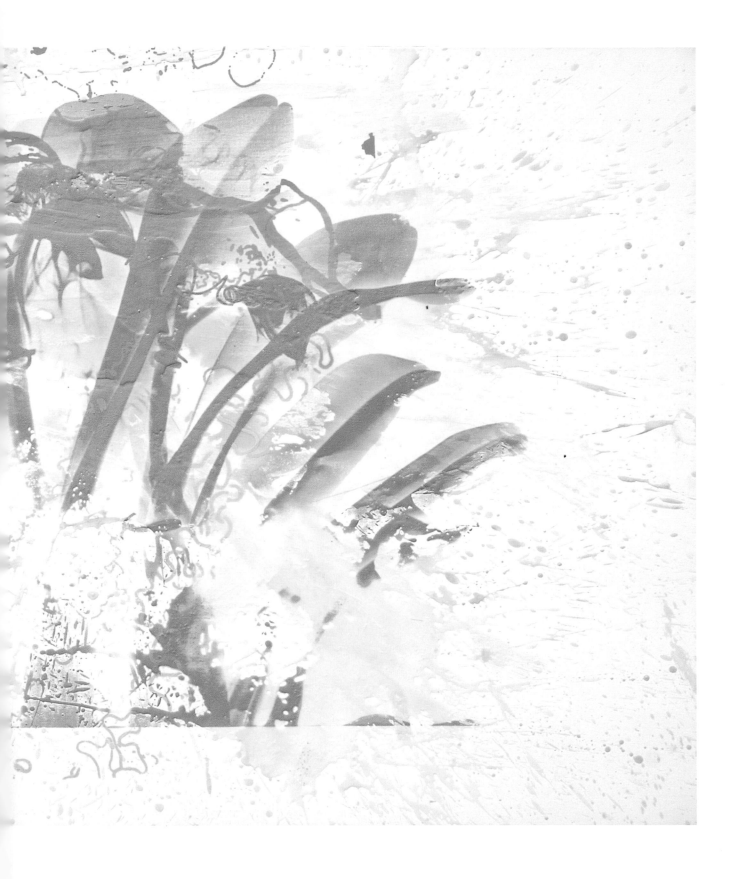

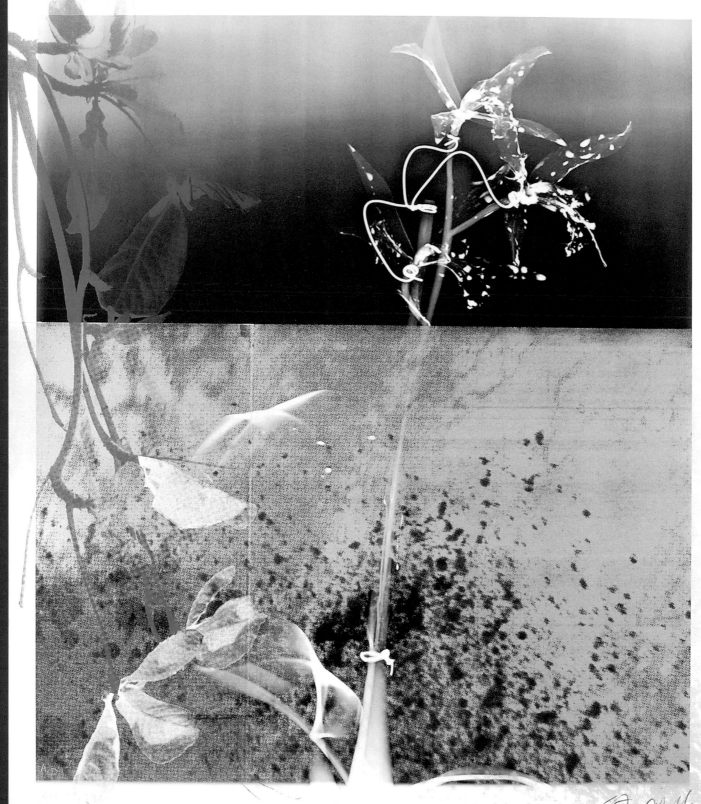

#627

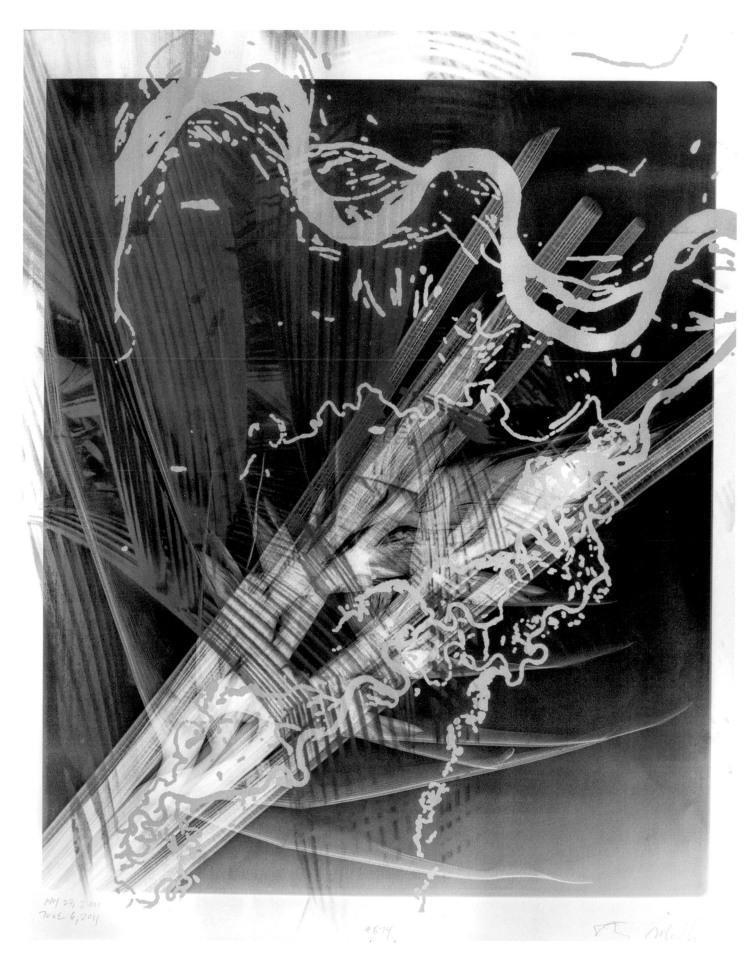

MAY 27, 2011
JUNE 6, 2011

#514

Health of the Planet #521, 2009 | Carbon inkjet and silkscreen on cotton rag | 28.75 x 24 in.

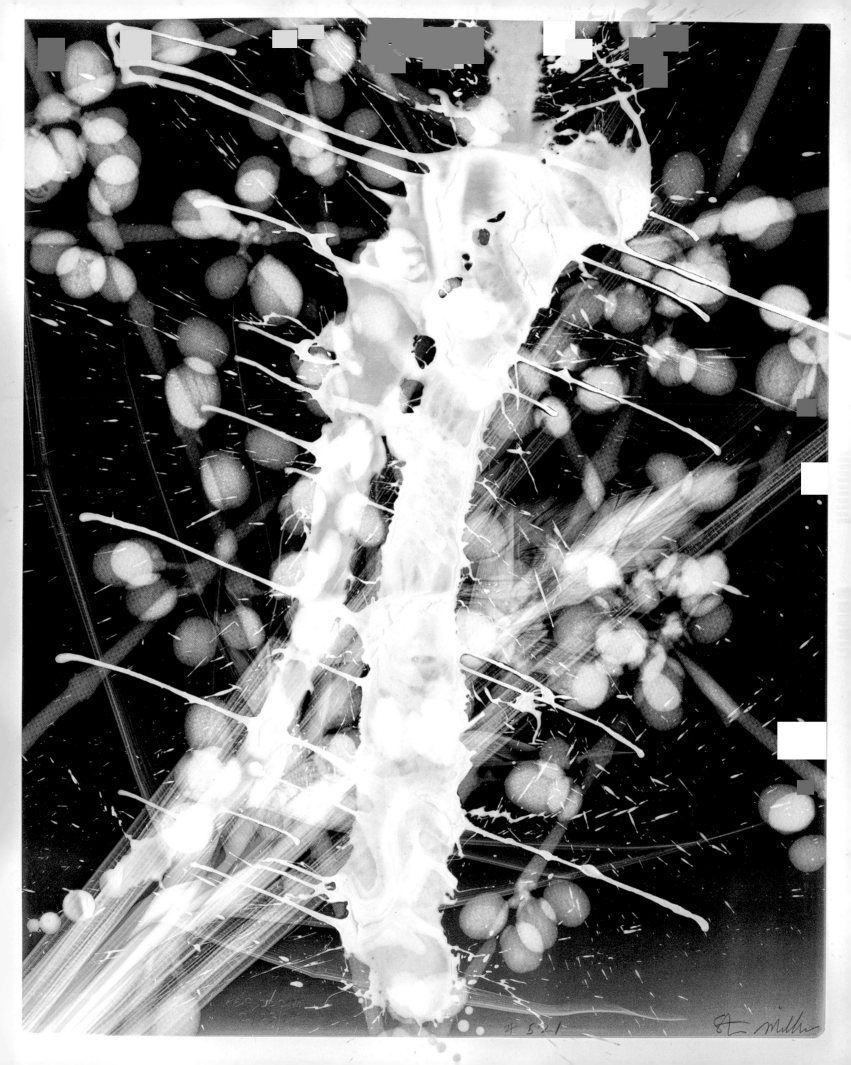

521

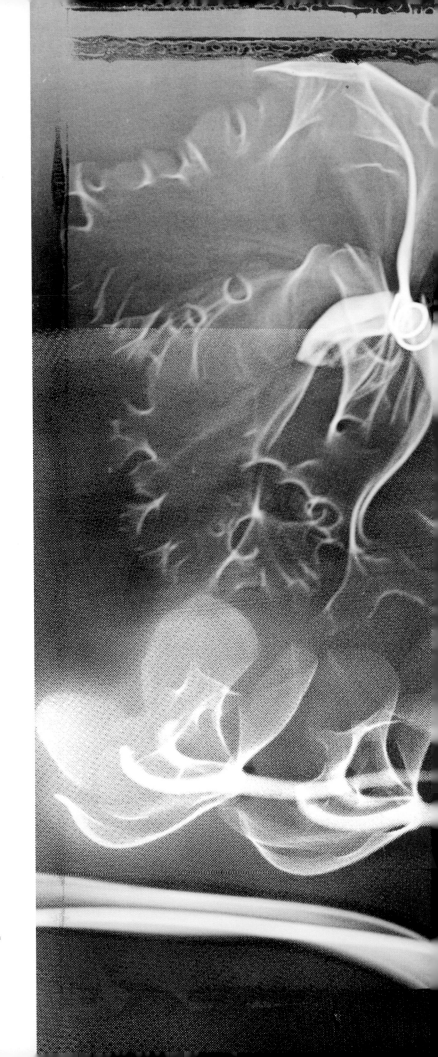

Natural Philosophy, 2009 | Carbon inkjet, enamel and silkscreen
on canvas | 22 x 26.5 in.

Overleaf: *Global Outpost*, 2011 | Inkjet and silkscreen
on canvas | 40 x 60 in.

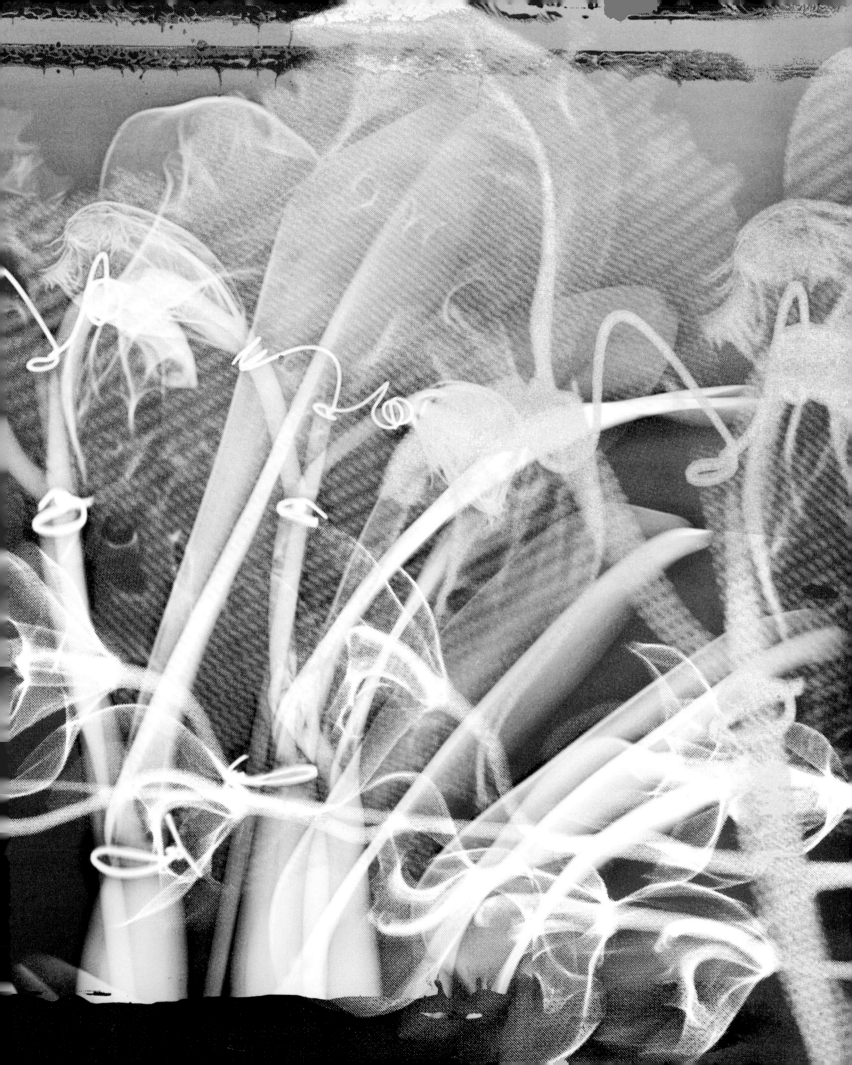

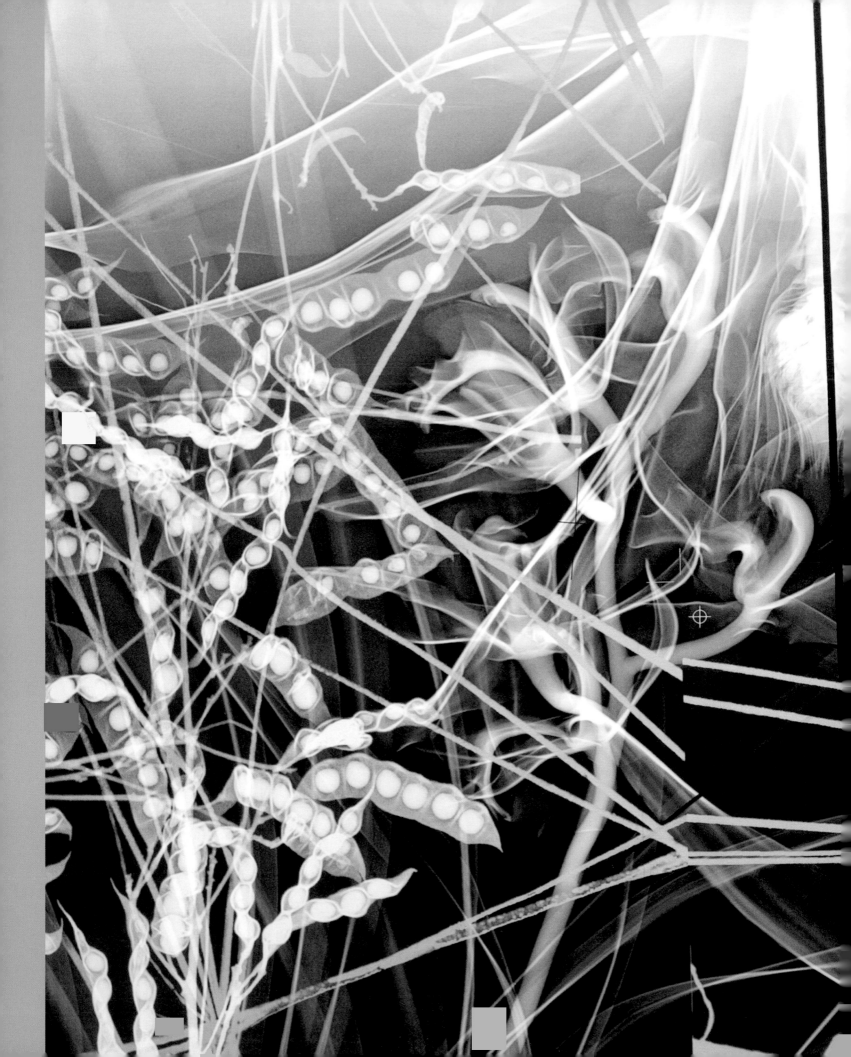

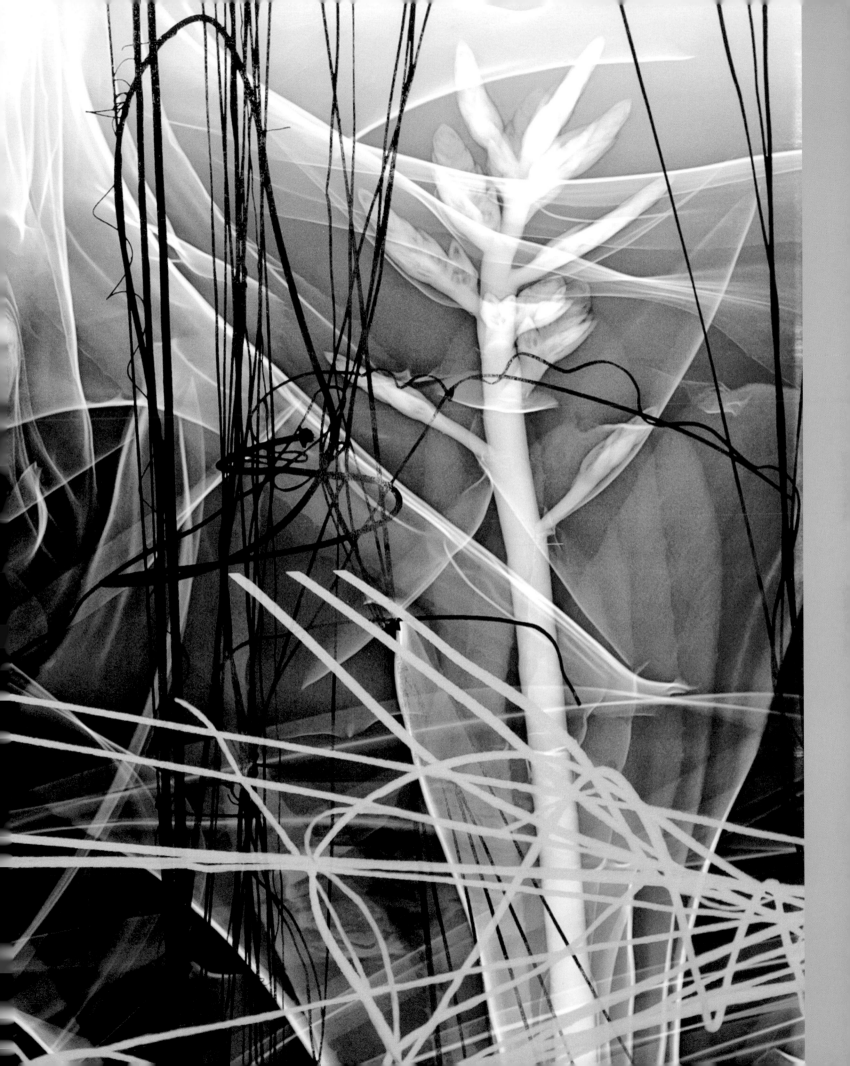

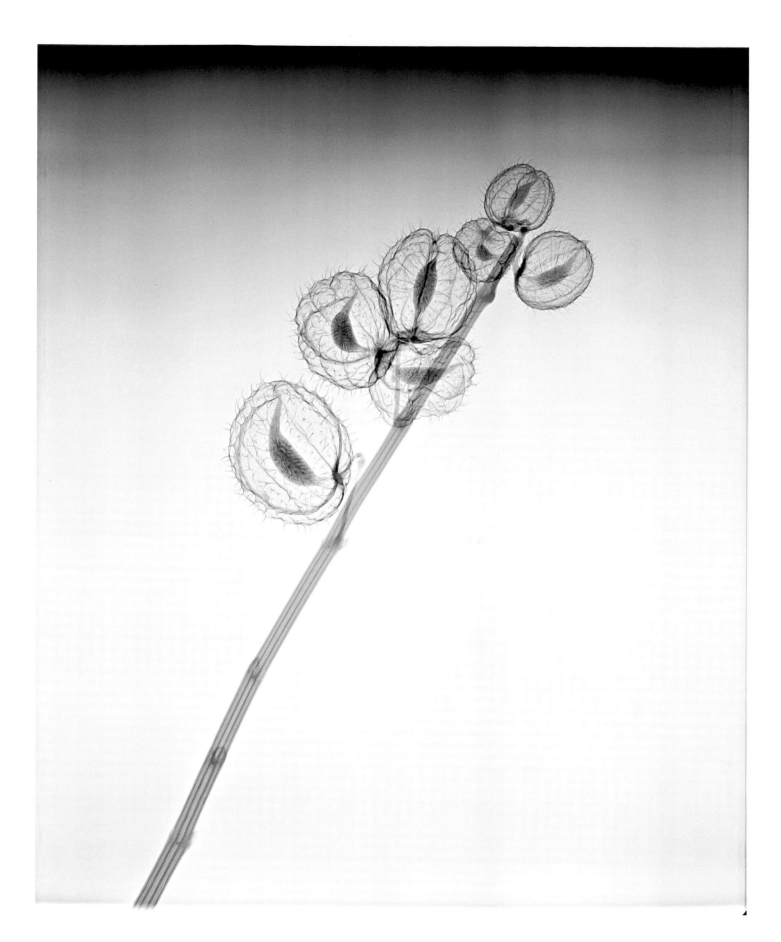

Solo Saco Velho, 2008 | Carbon inkjet on cotton rag | 28.75 x 24 in.

PROJECT, MILLER,
STEVE

O
1

PATTERN AP
5/28/97
18:07
1547
FLOWER

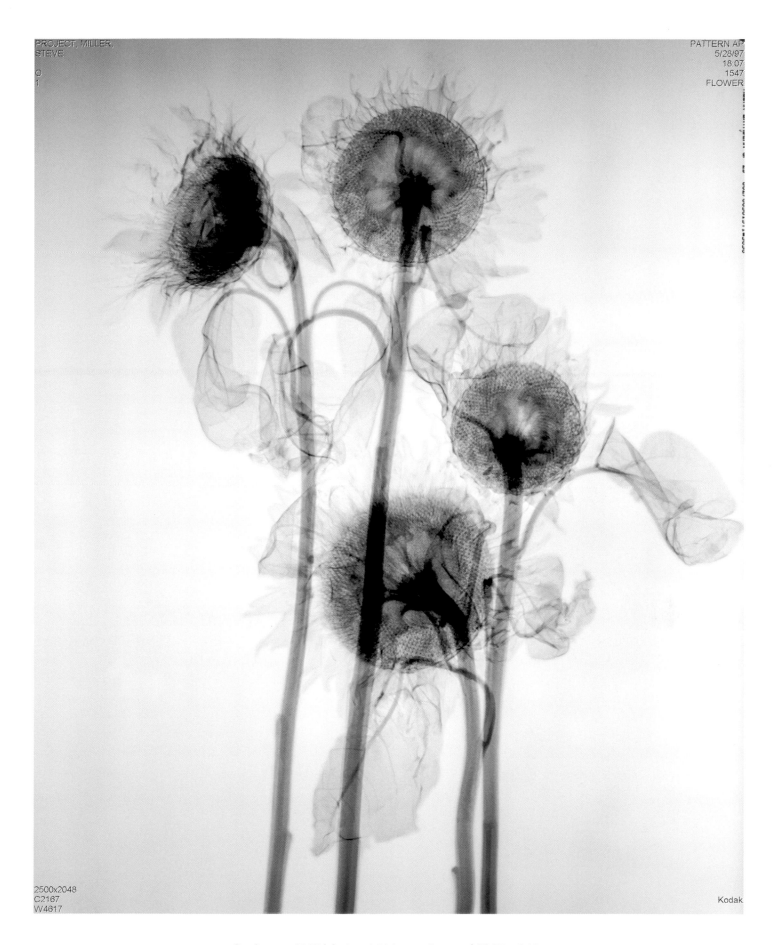

Sunflowers, 2009 | Carbon inkjet on cotton rag | 28.75 x 24 in.

Health of the Planet #592, 2012 | Inkjet and silkscreen on cotton rag | 31.25 x 24 in.

Overleaf: *Emerging Trends*, 2013 | Inkjet and silkscreen on canvas | 40 x 60 in.

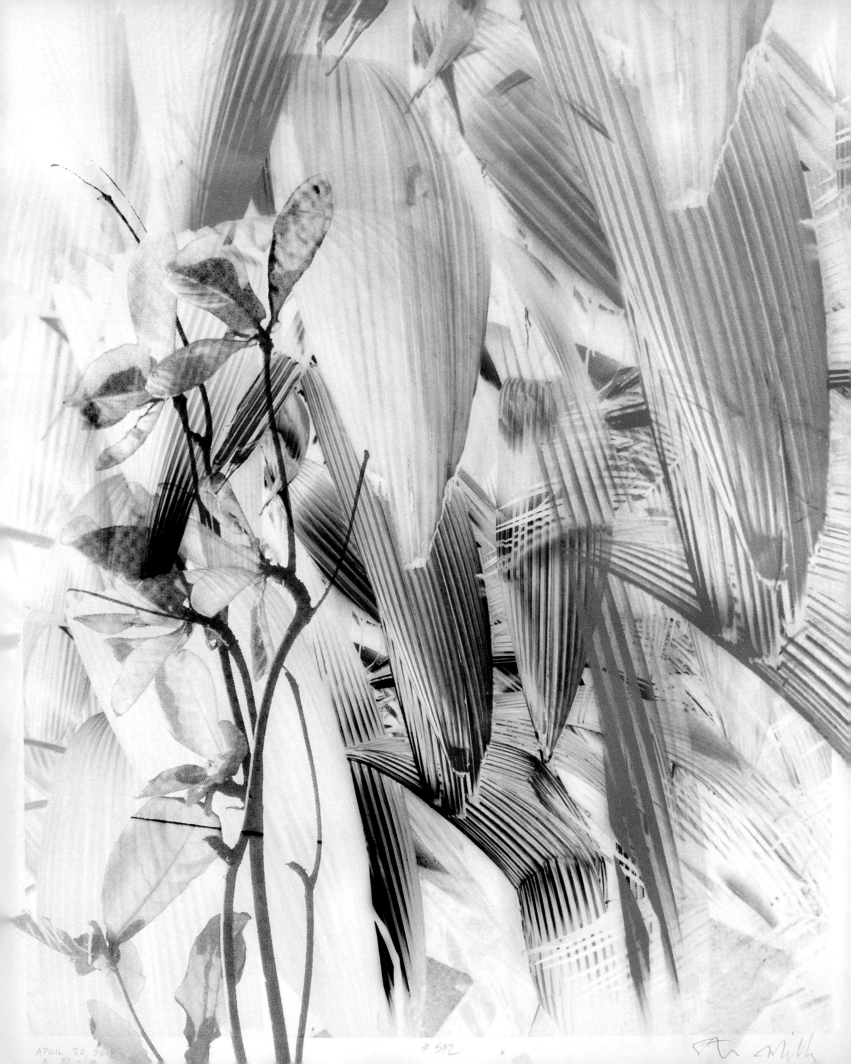

APRIL 30, 2012 # 592

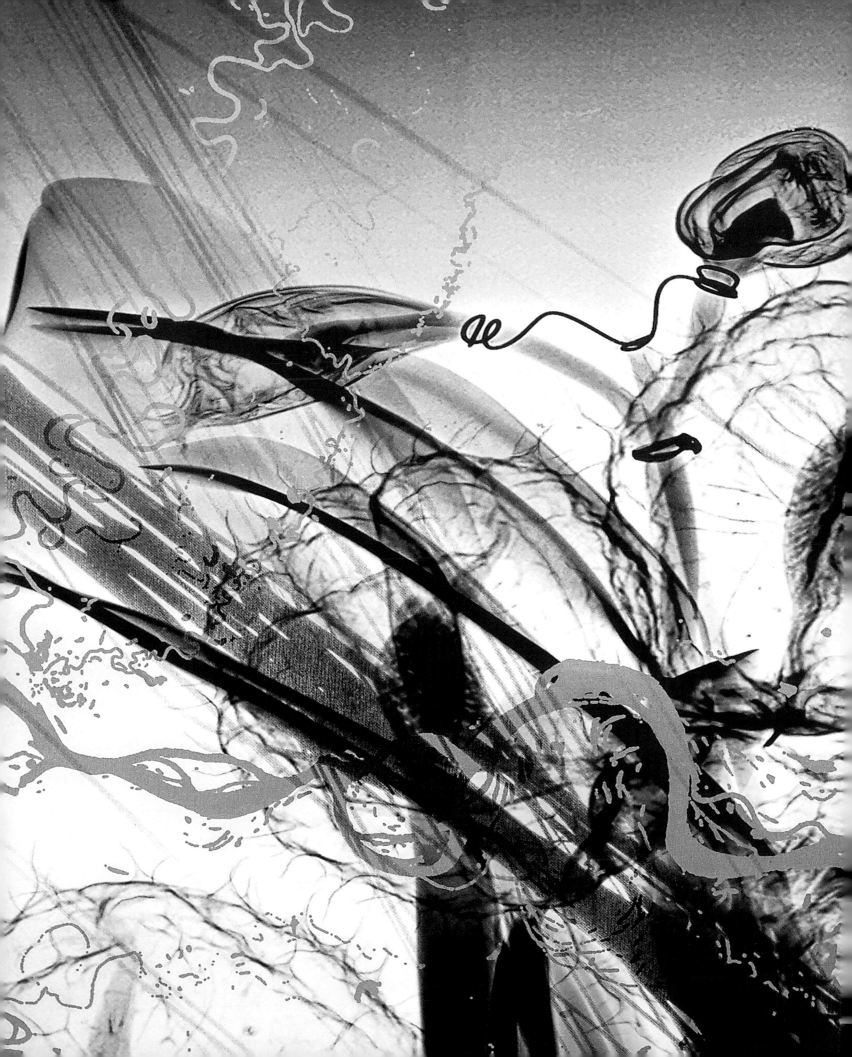

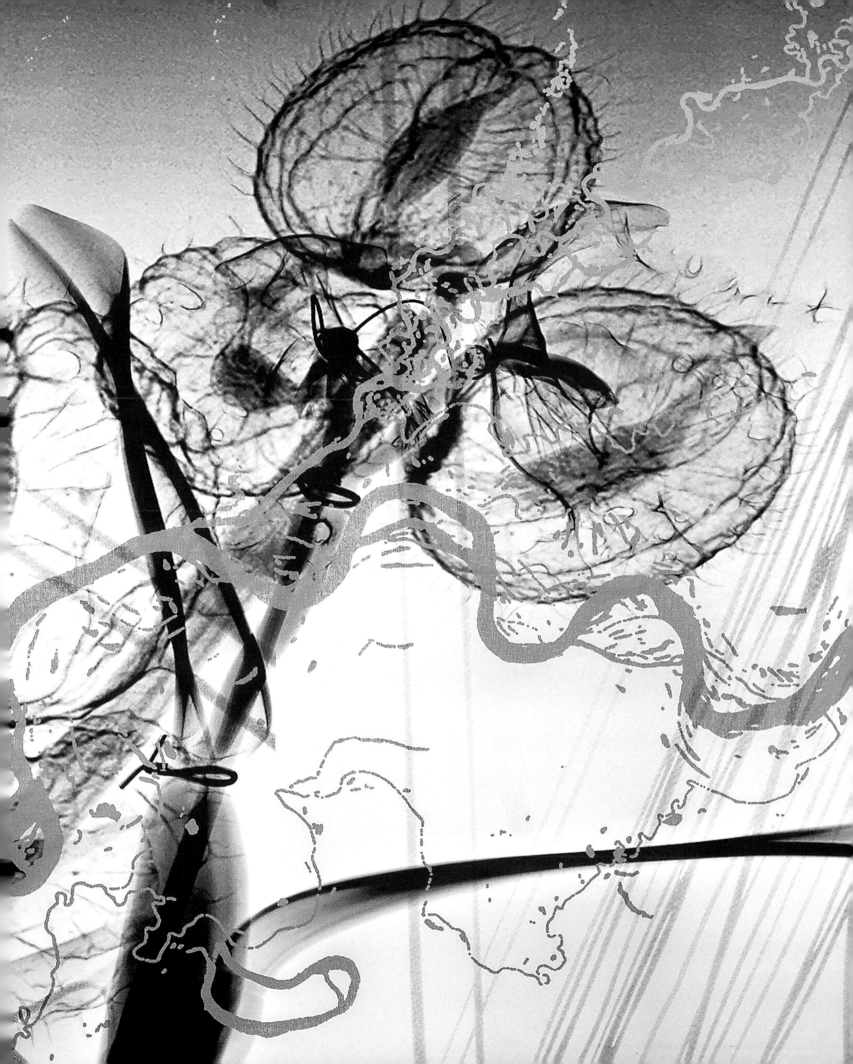

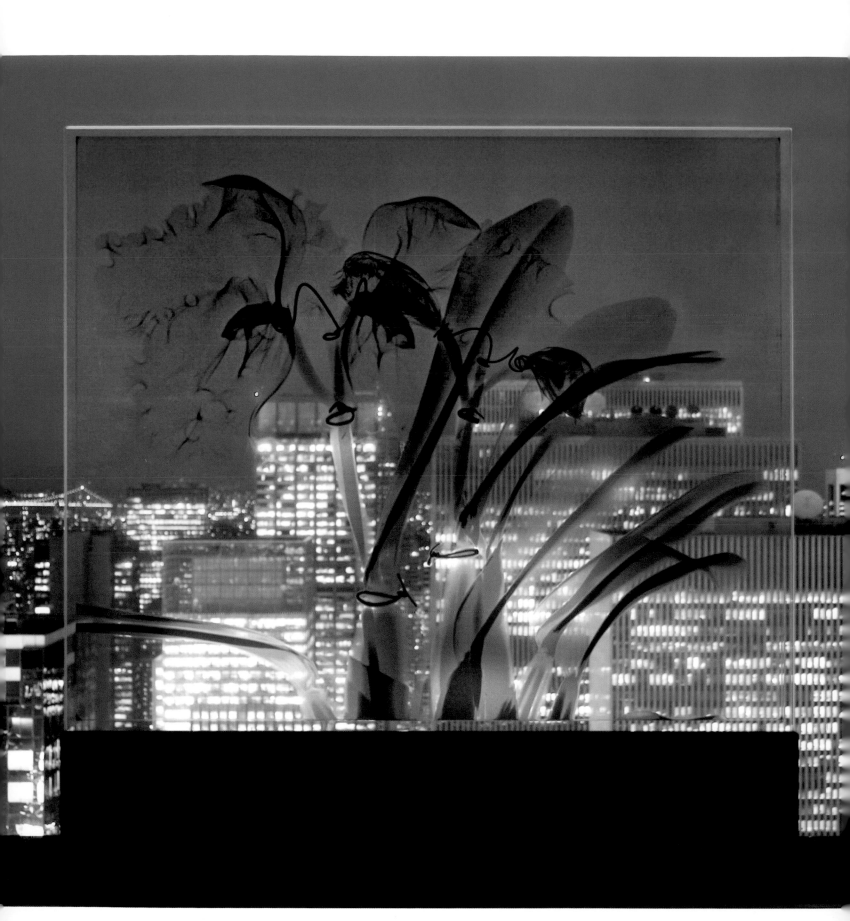

Glass Times Square, 2008 | Inkjet, laminated glass, steel | 31.5 x 32 x 1 in.

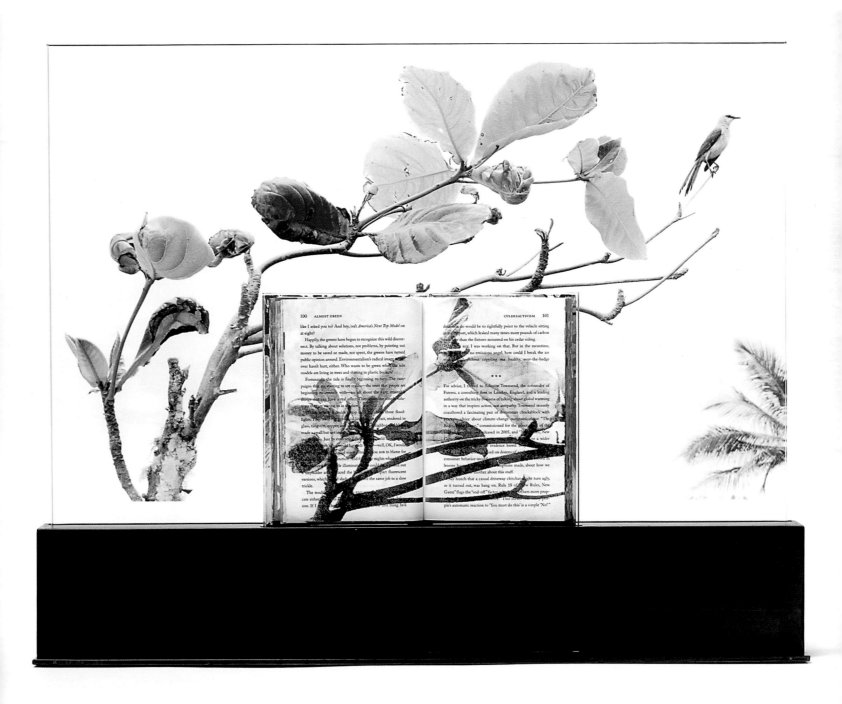

Library Branch, 2011 | Silk-screened book, inkjet, laminated glass, steel | 24.75 x 30.75 x 5 in.

Law of the Jungle, 2010 | Inkjet on glass, steel | 45.5 x 32.5 x 6 in.

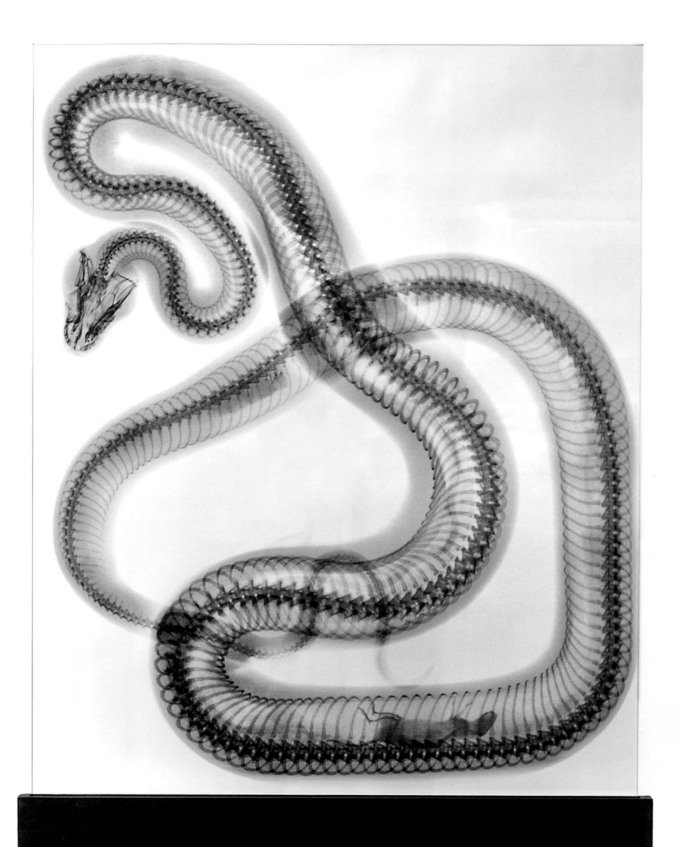

Kickback with Skateboard, 2015 | Pigment dispersion and silkscreen on canvas | 79 x 67.5 in.

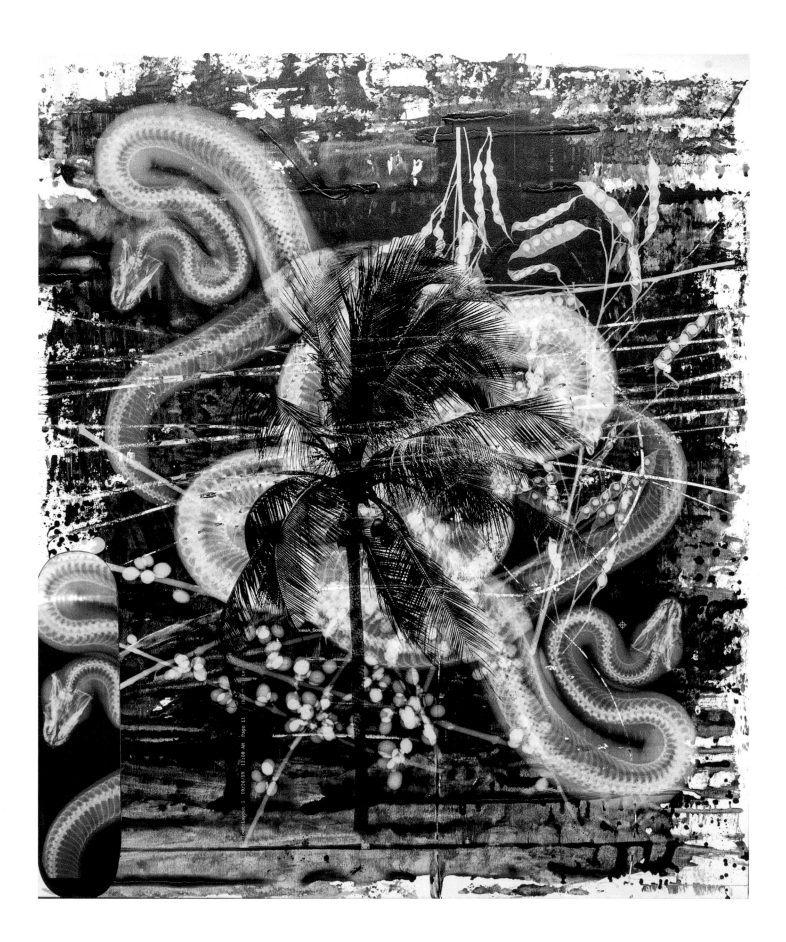

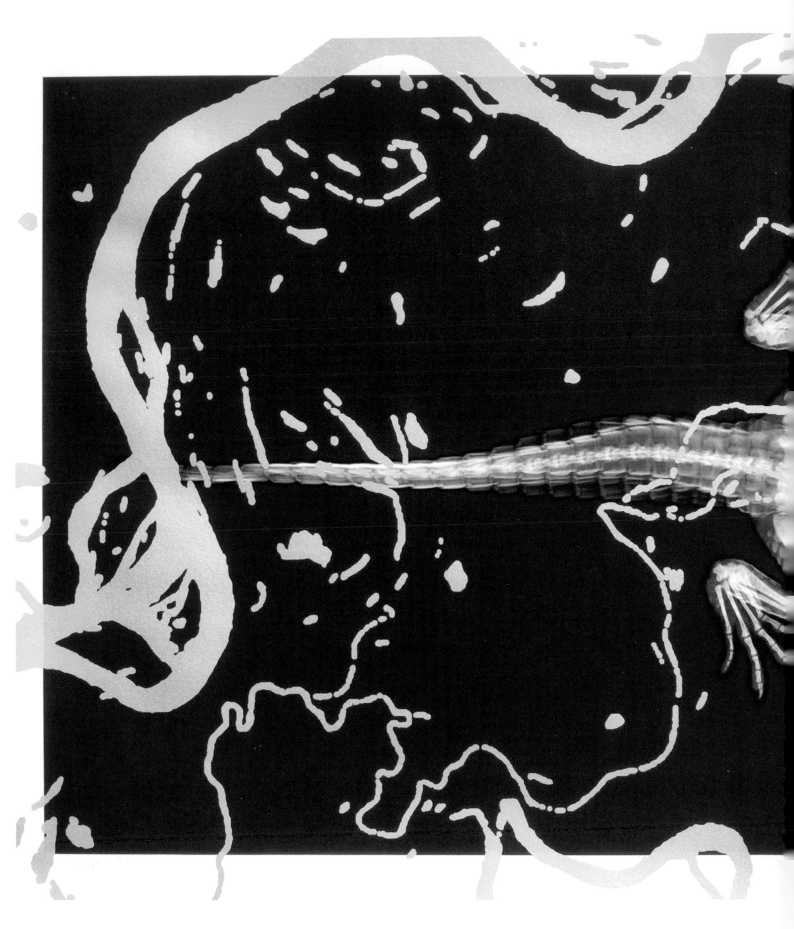

Health of the Planet #612, 2012 | Inkjet and silkscreen on cotton rag | 17 x 31.25 in.

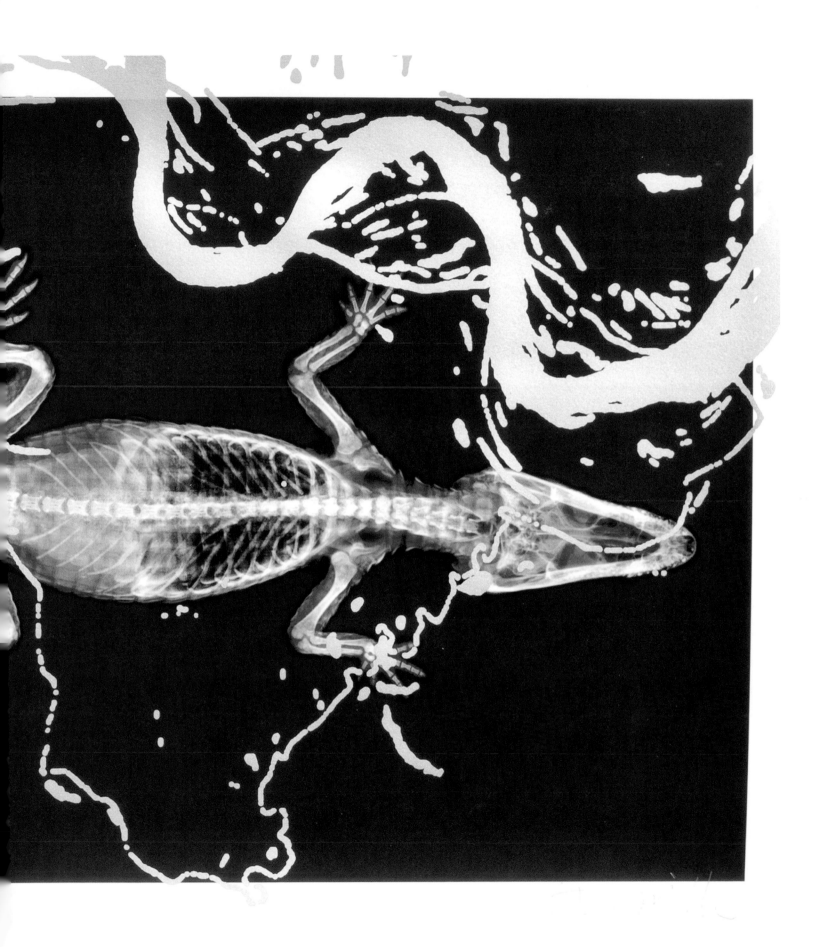

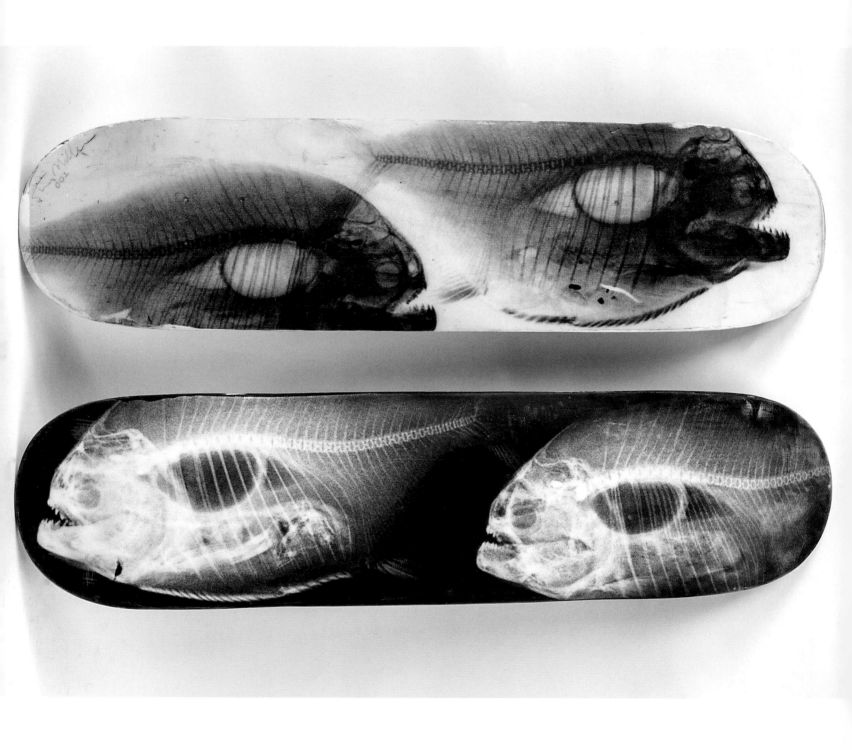

Piranha Diptych, Skateboards, 2015/2016, *#001* and *#008* | Silkscreen on wood, fiberglass | 31.5 x 8 in.

Opposite: *Yin and Yang*, Skateboard Edition, 2016 | Silkscreen on wood, fiberglass | 31.5 x 8 in.

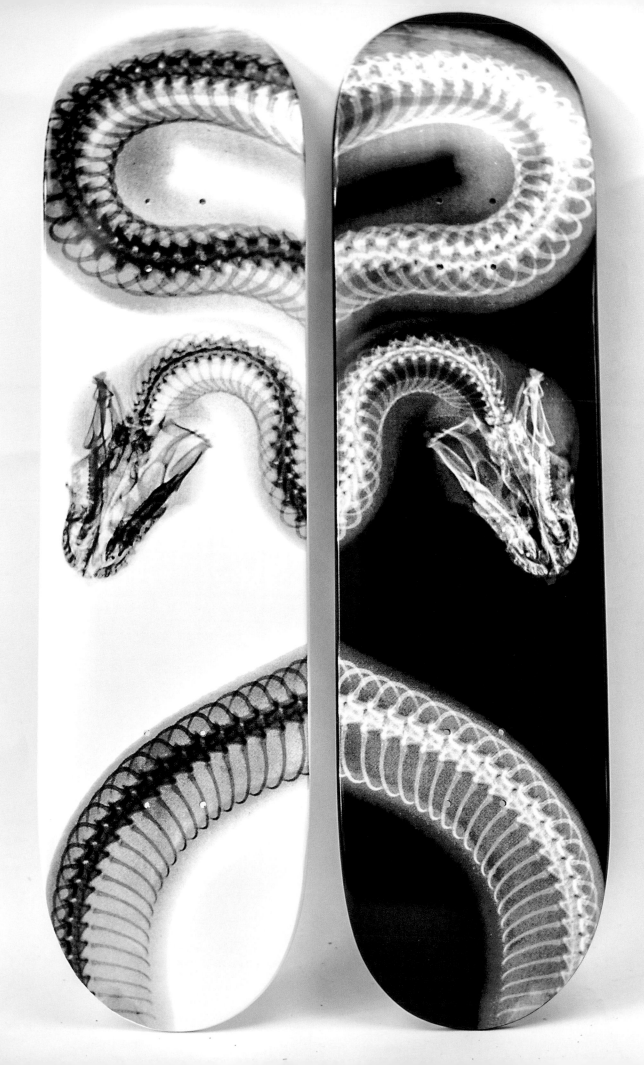

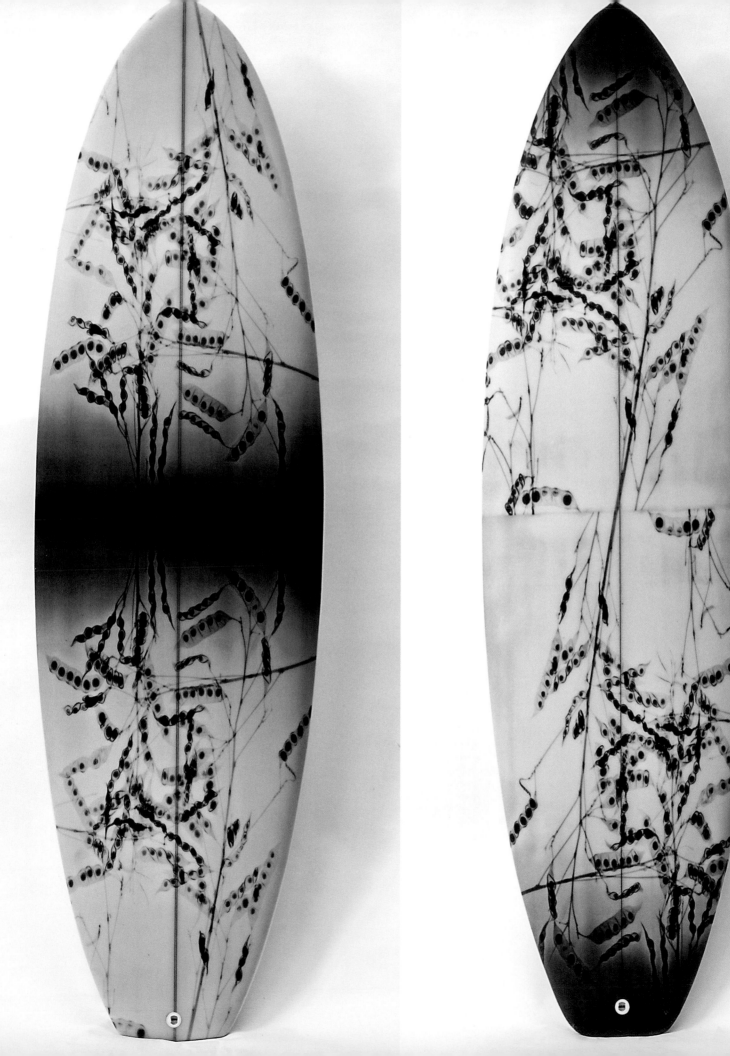

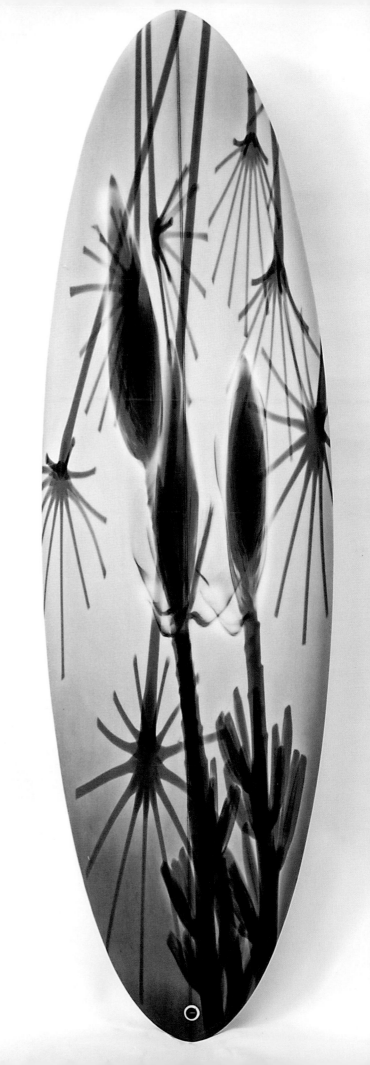

Opposite left: *#030, Pods on Pale Purple Board*, 2015
Squashtail, Three-Fin Thruster | 71.5 x 20.5 in.

Opposite right: *#032, Dark Green Pods on Pale Blue Board*,
2015 | Squashtail, Three-Fin Thruster | 71.5 x 21 in.

Right: *#031, Fireworks on Salmon Board*, 2015
Roundtail, Three-Fin Thruster | 71.5 x 21 in.

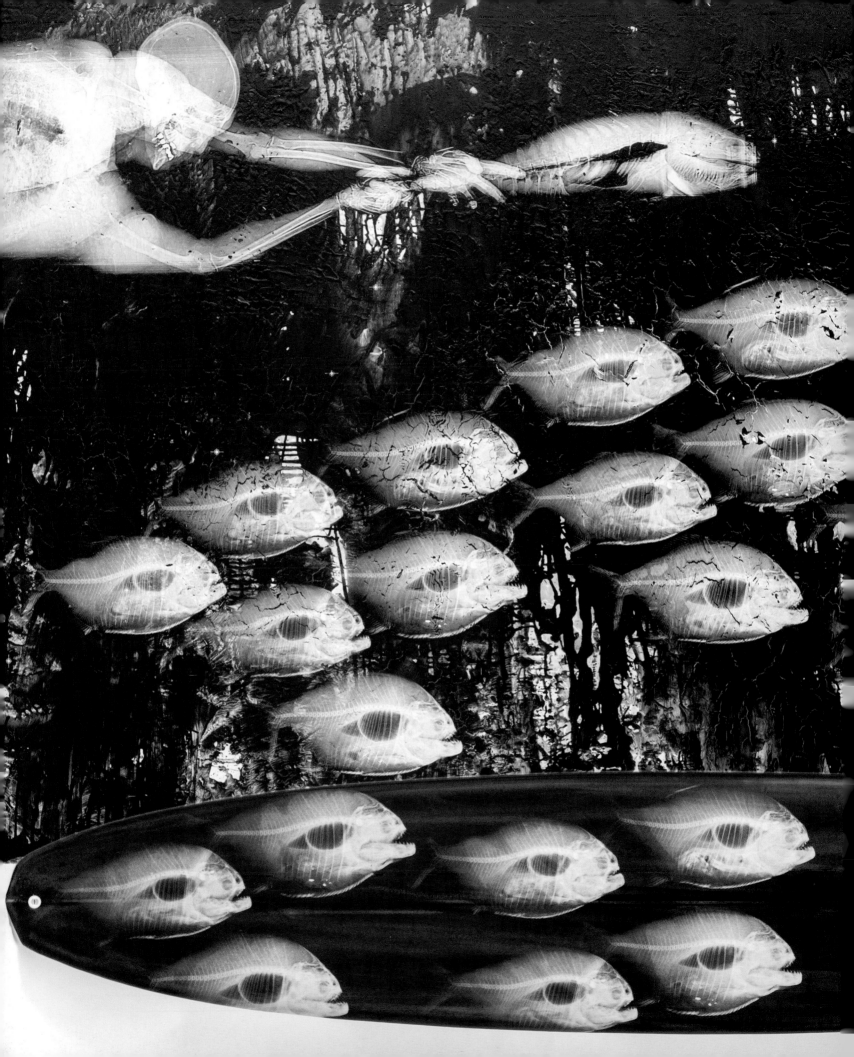

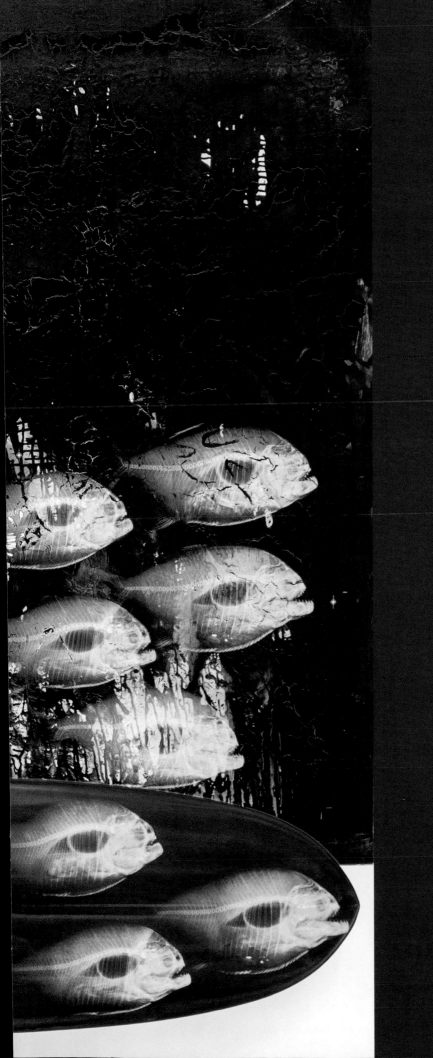

School of the Abyss, 2015 | Pigment dispersion an
canvas with surfboard | 79 x 113 in.

Piranha School, 2014 | Surfboard Triptych

Left to right: *#009* | 87.5 x 22 in. | *#014* | 96 x 22 in. | *#010* | 88 x 21.5 in.

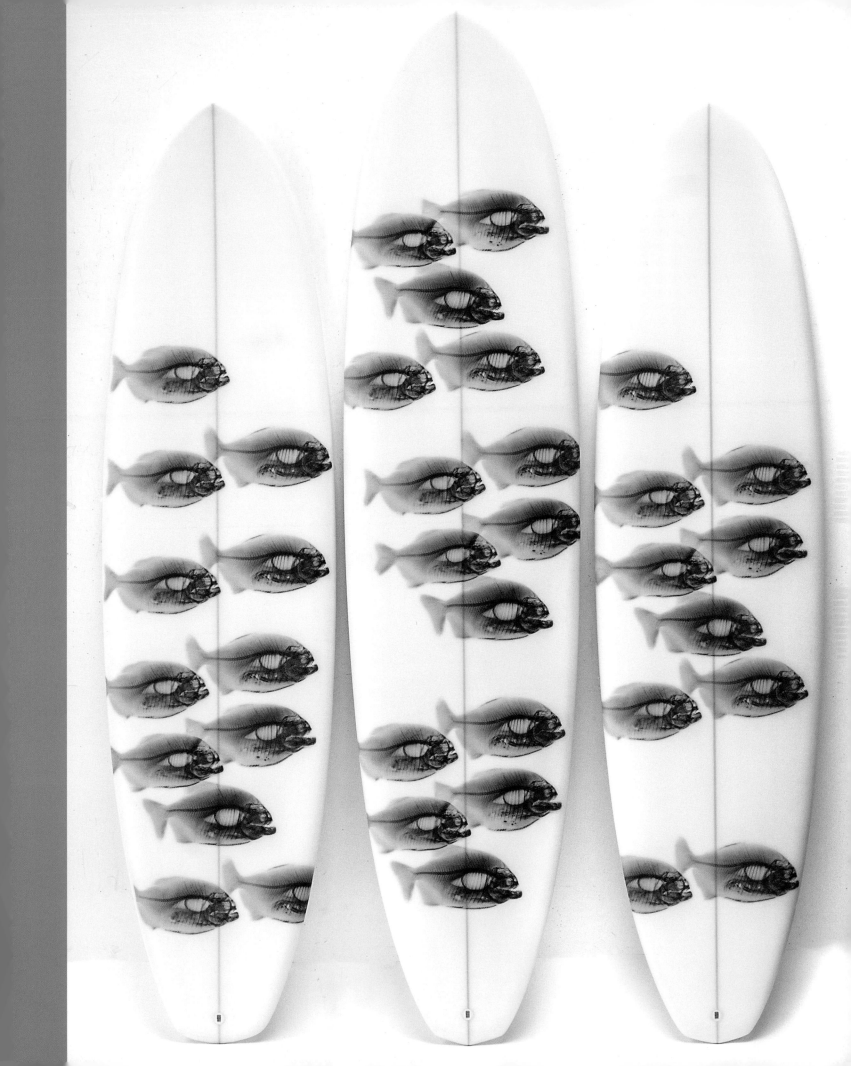

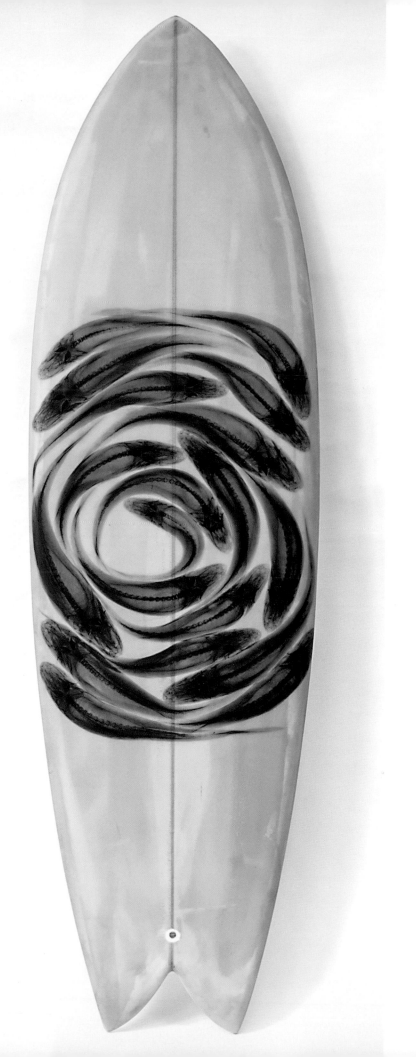

*#025, Fish Circle on
Blue Board*, 2014
Short and Fat Swallow Tail,
Twin Fin | 80 x 23 in.

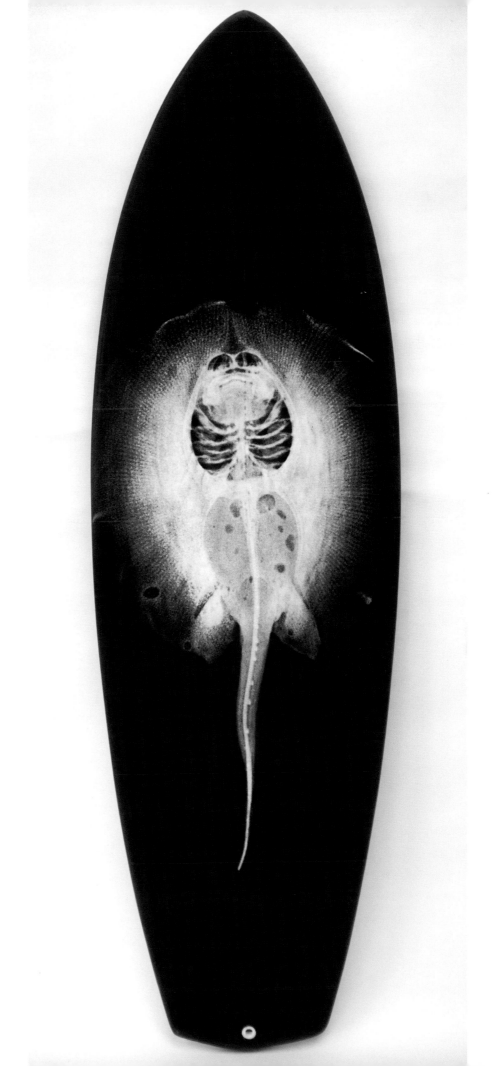

*#005, White Ray on
Black*, 2013
Diamond Tail, Three-Fin
Thruster | 71 x 21.5 in.

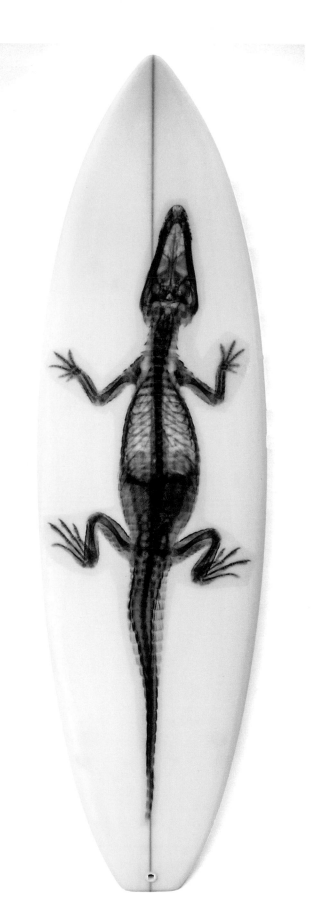

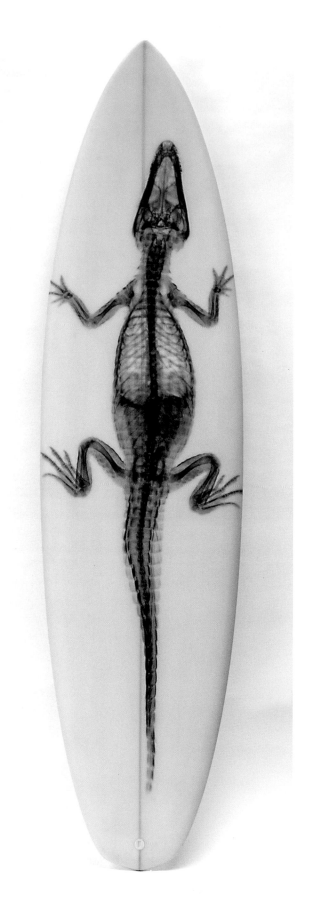

#004, Black Gator on Yellow, 2013
Square Tail Thruster | 70.5 x 20 in.

#013, Green Gator on Pale Blue, 2014
Diamond Tail, Three-Fin Thruster | 87.5 x 22 in.

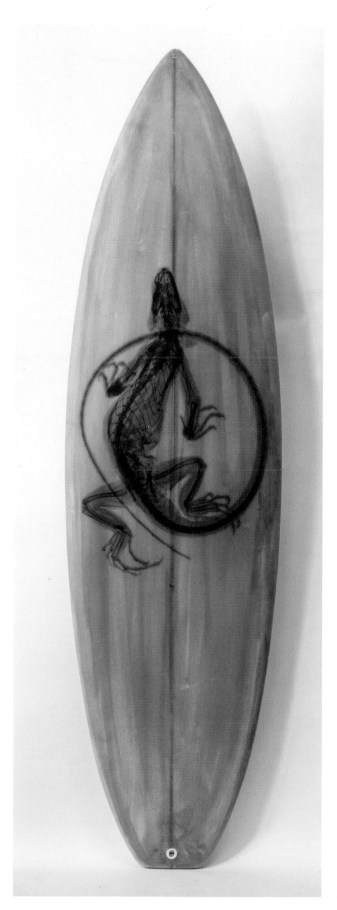

#021, Brown Iguana, Dayglo Pink, 2014
Flat Tail, Three-Fin Thruster | 76 x 20.5 in.

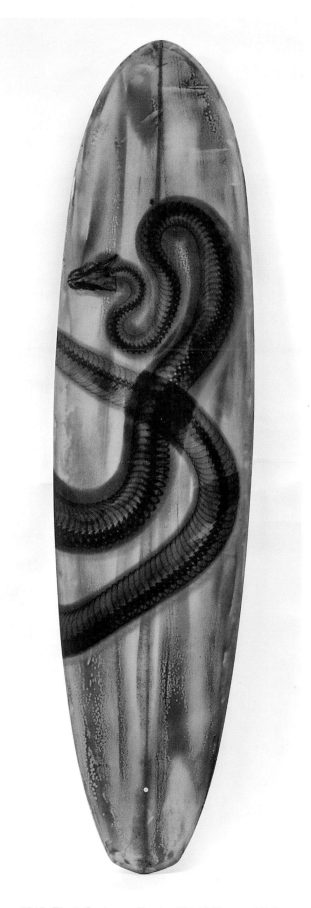

#019, Black Snake on Purple, 2014 | Diamond Tail,
Single Fin | 94.5 x 23.5 in.

Forces at Play, 2015 | Pigment dispersion and silkscreen on canvas | 79 x 78 in.

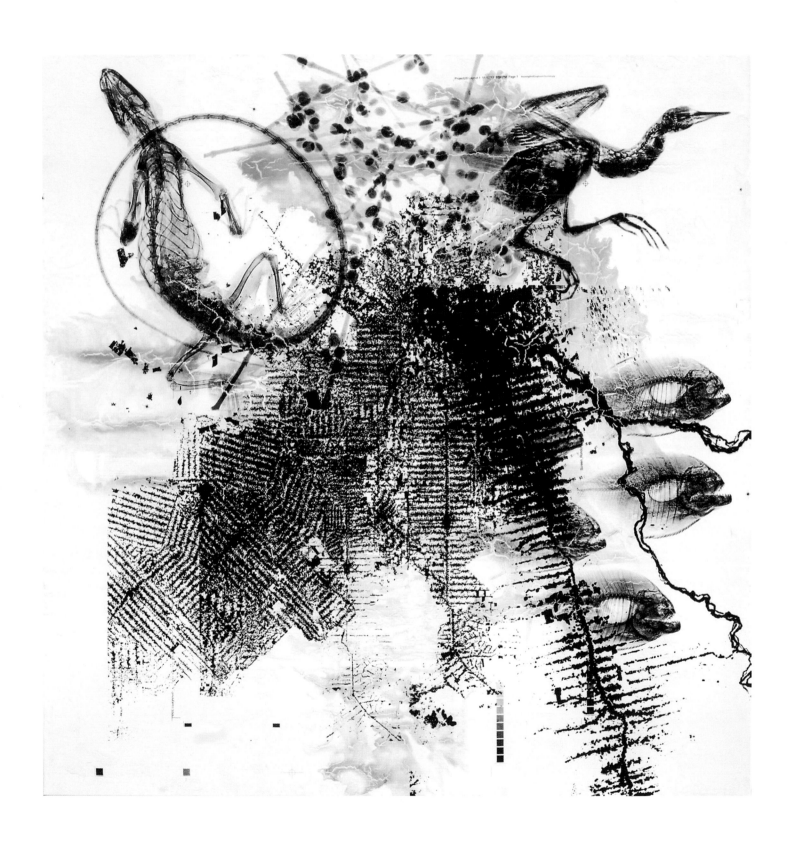

Above: *Beyond Bushwick*, 2015 | Pigment dispersion and silkscreen | 82 x 79 in.

Opposite: *WiFi Favella*, 2015 | Pigment dispersion and silkscreen on canvas | 79 x 69 in.

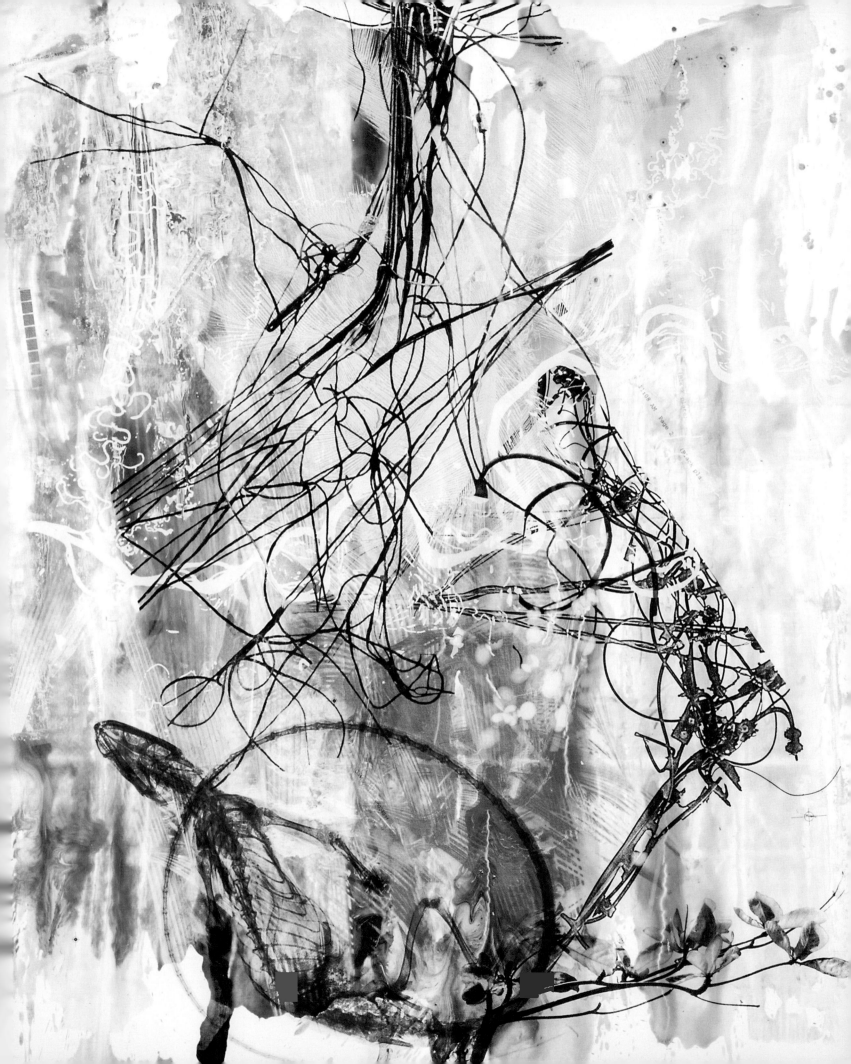

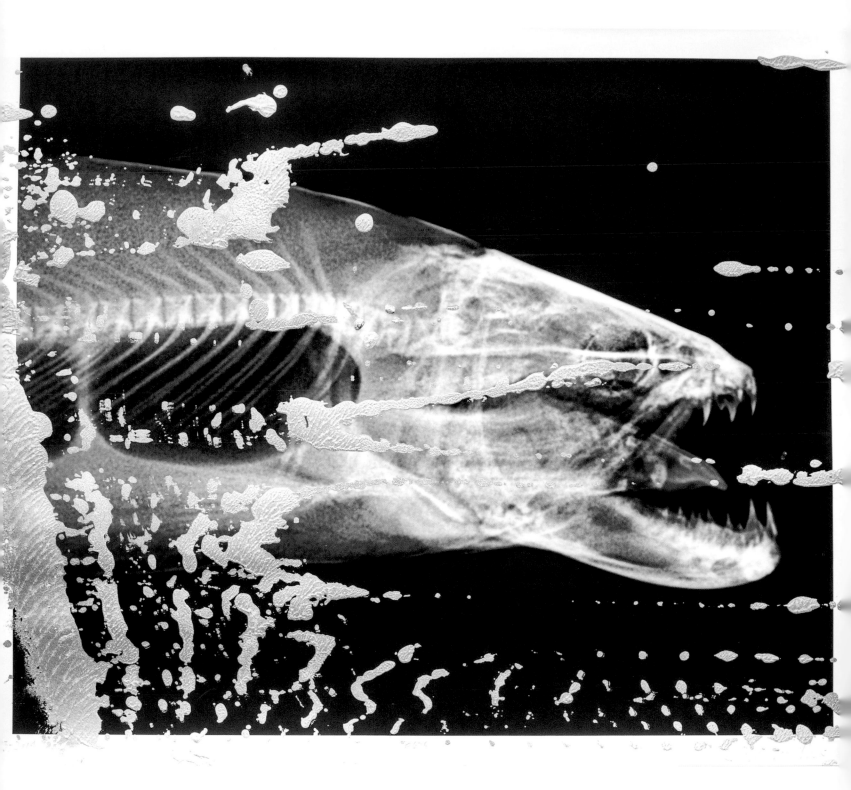

Health of the Planet #675, 2014 | Inkjet and enamel on cotton rag | 24 x 29 in.

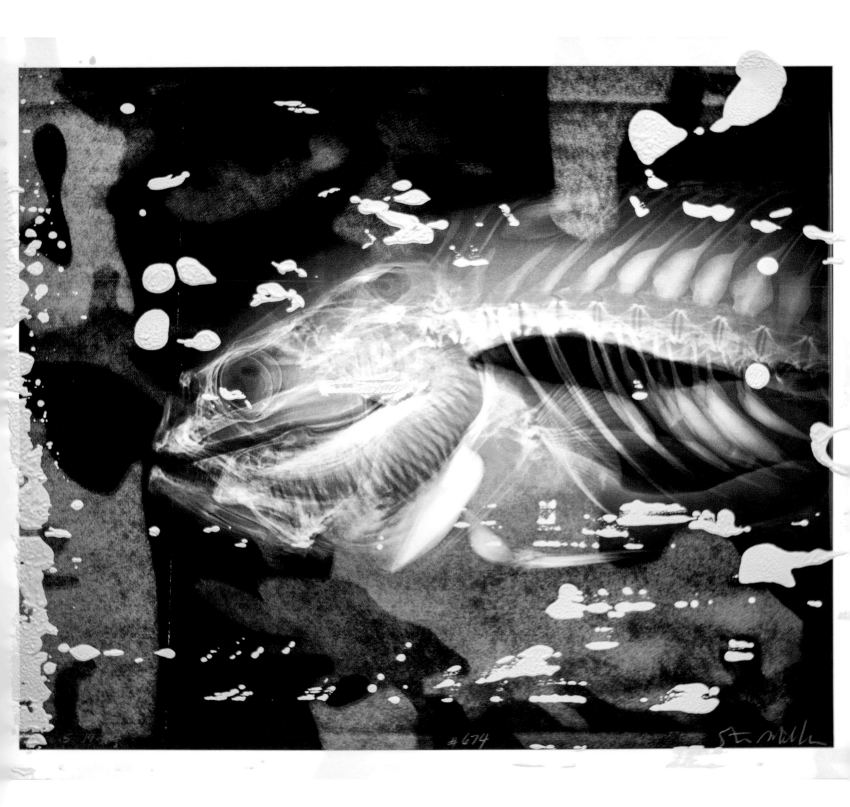

Health of the Planet #674, 2014 | Inkjet and enamel on cotton rag | 24 x 29 in.

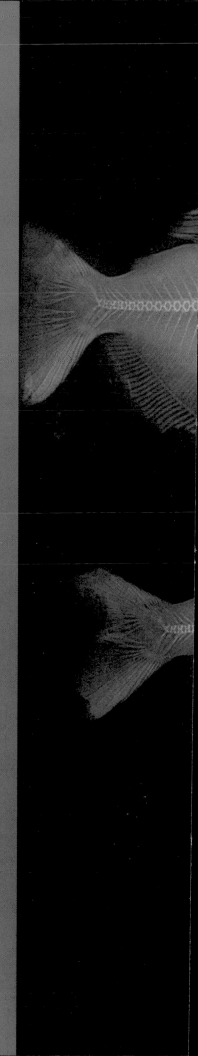

River Raptors, 2011 | Carbon inkjet on cotton rag | 24.21 x 24 in.

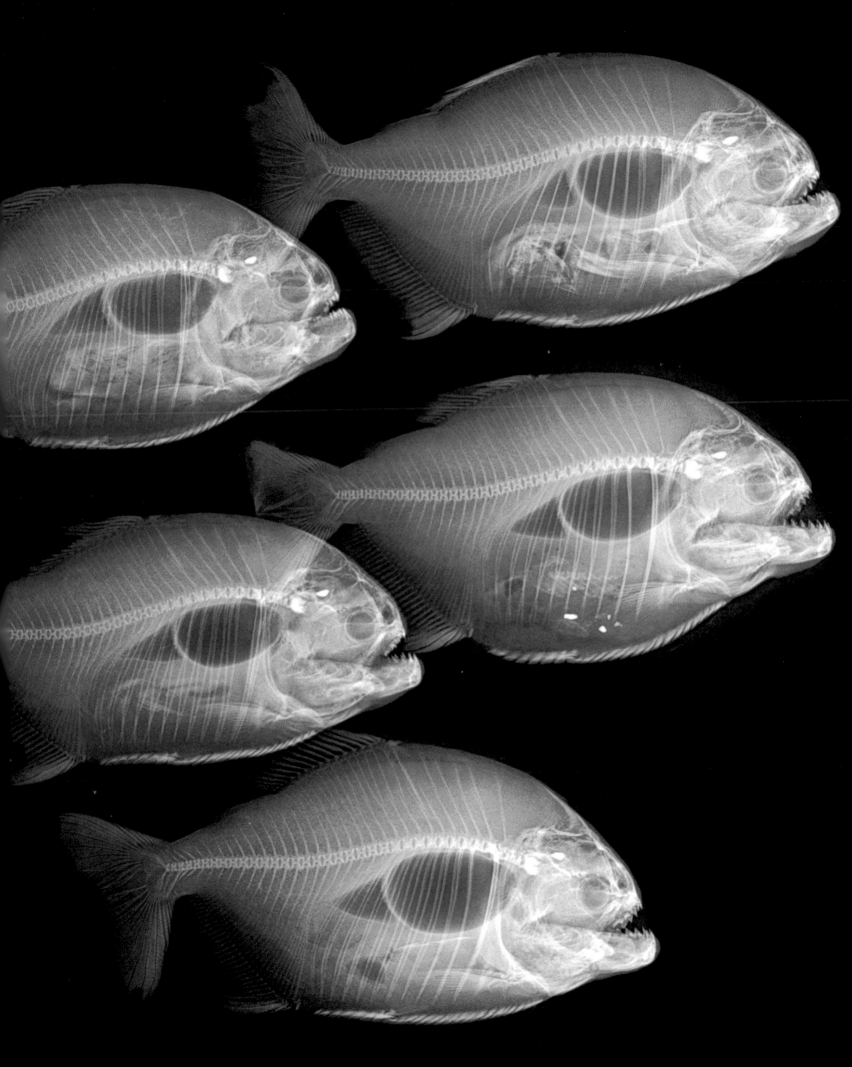

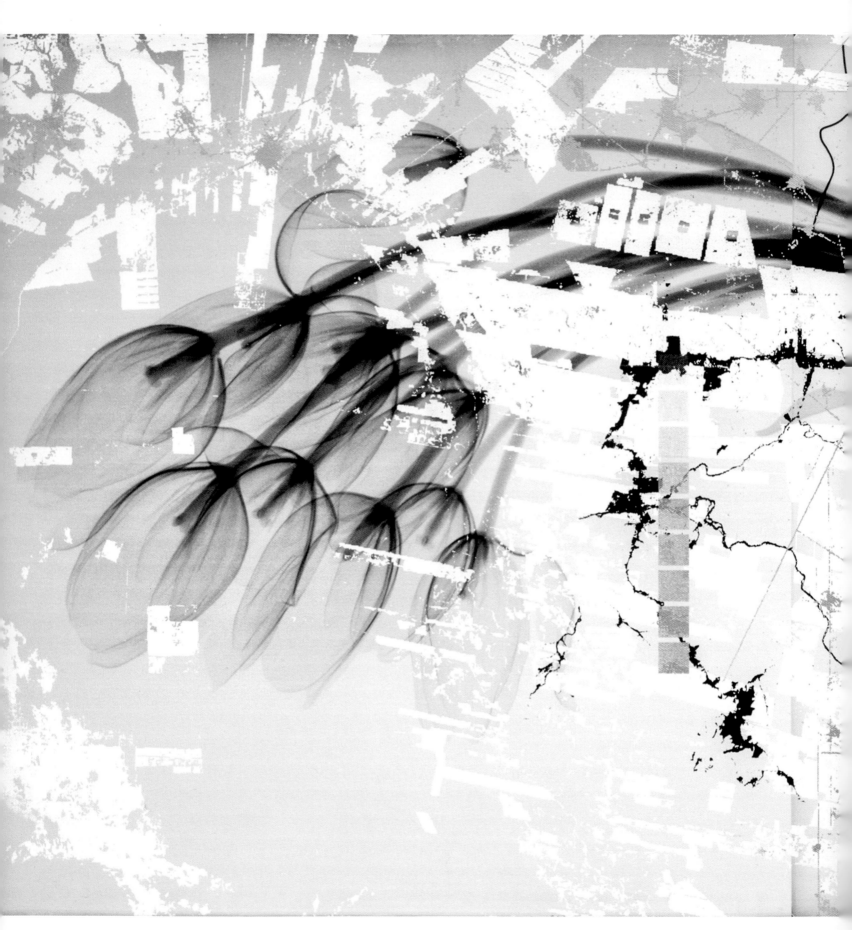

Tulips, 2016 | Inkjet and silkscreen on canvas | 22 x 45 in.

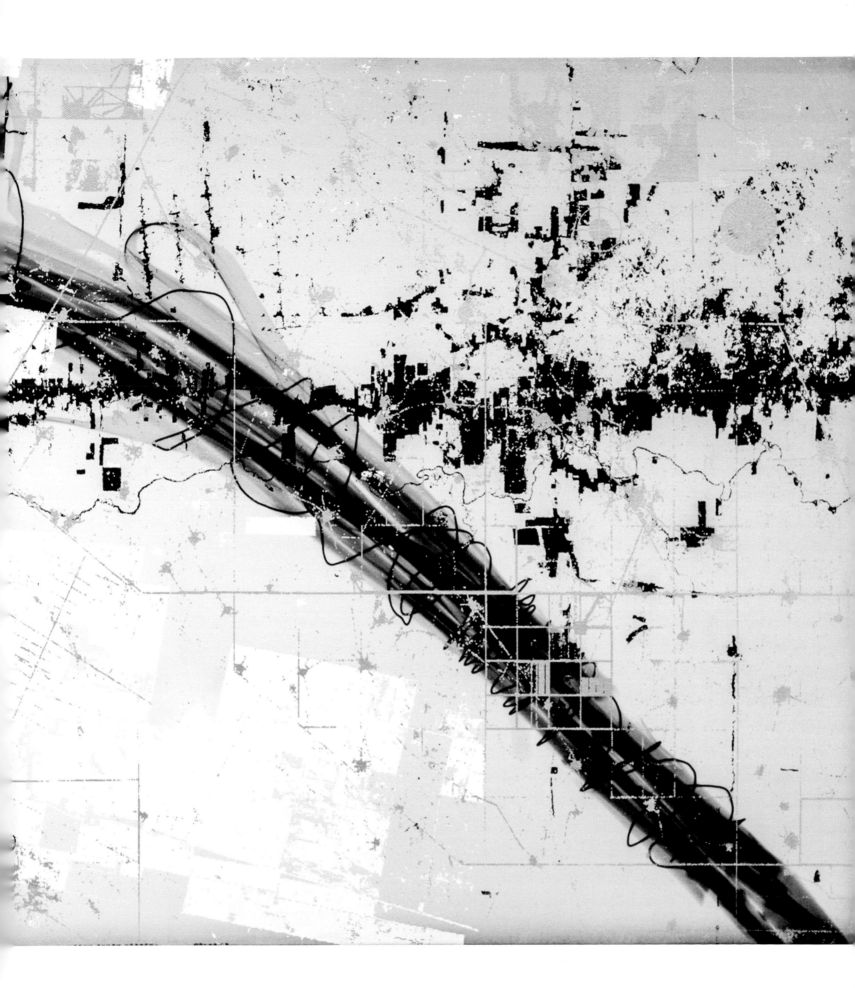

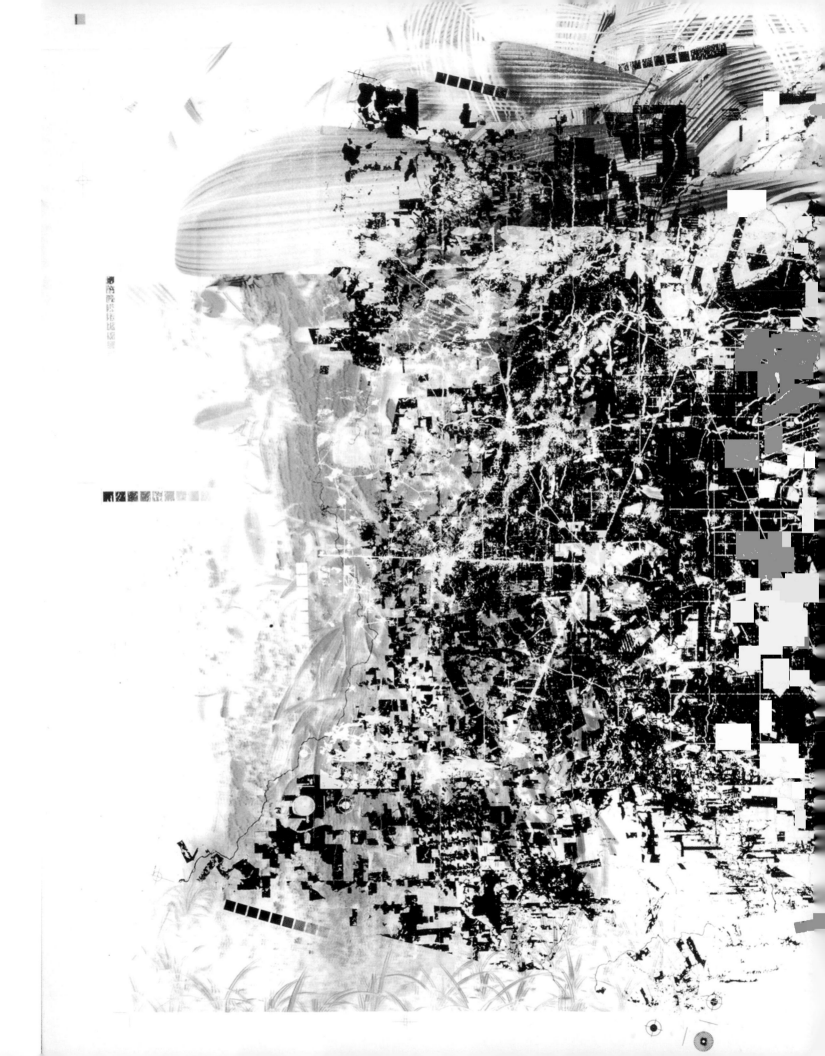

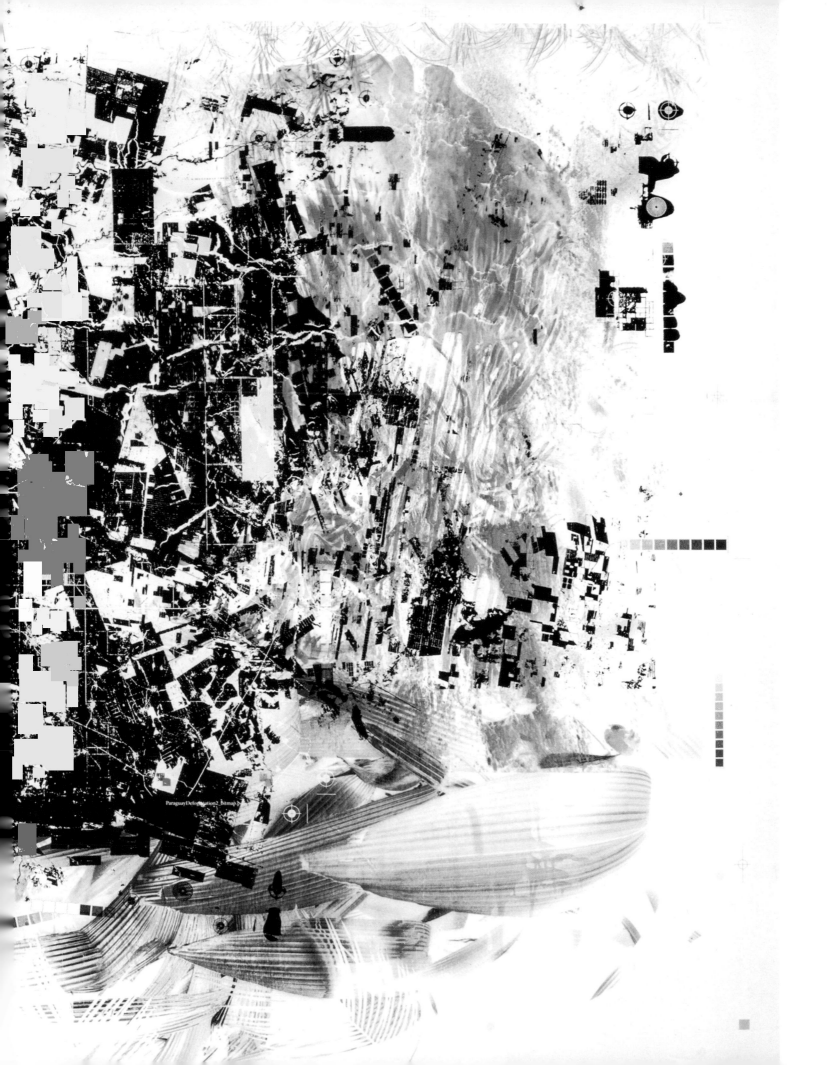

ParaguayDeforestation2_bitmap

Previous page: *Earth Centric*, 2016 | Pigment dispersion and silkscreen on canvas | 70 x 116 in.

Opposite: *Agreement That Emerged*, 2011 | Pigment dispersion and silkscreen on canvas | 79 x 78 in.

Overleaf: *Field Notes*, 2016 | Pigment dispersion and silkscreen on canvas | 55 x 80 in.

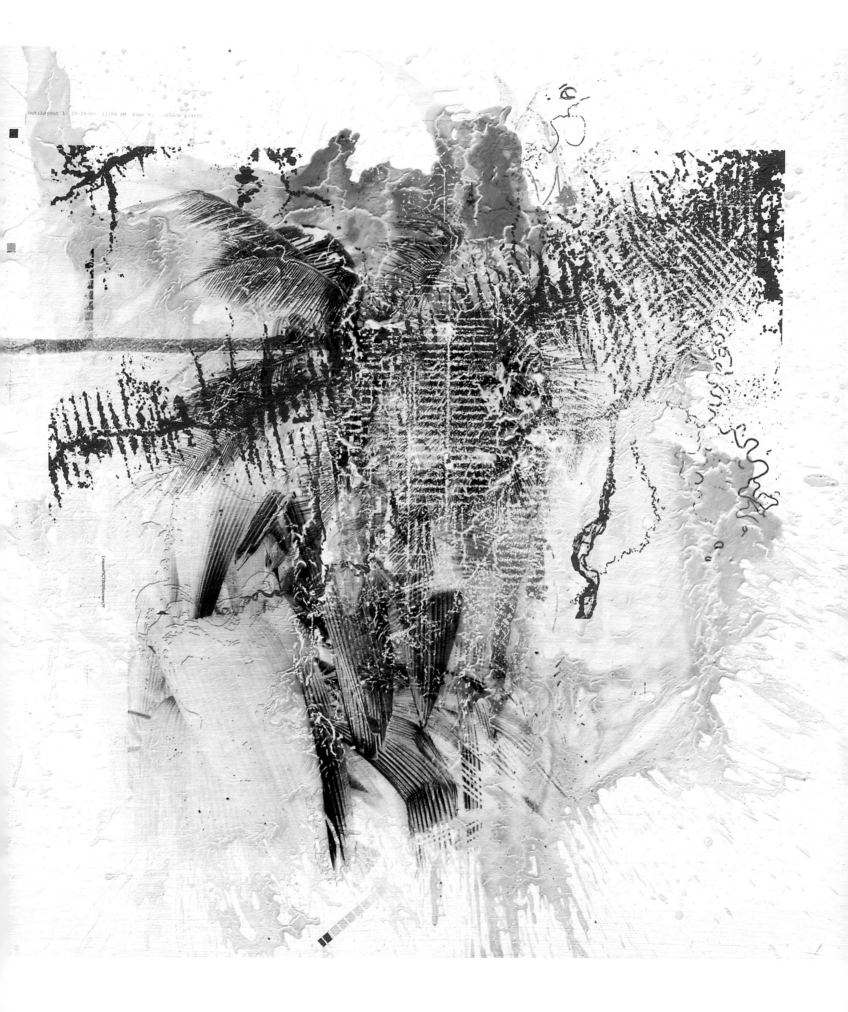

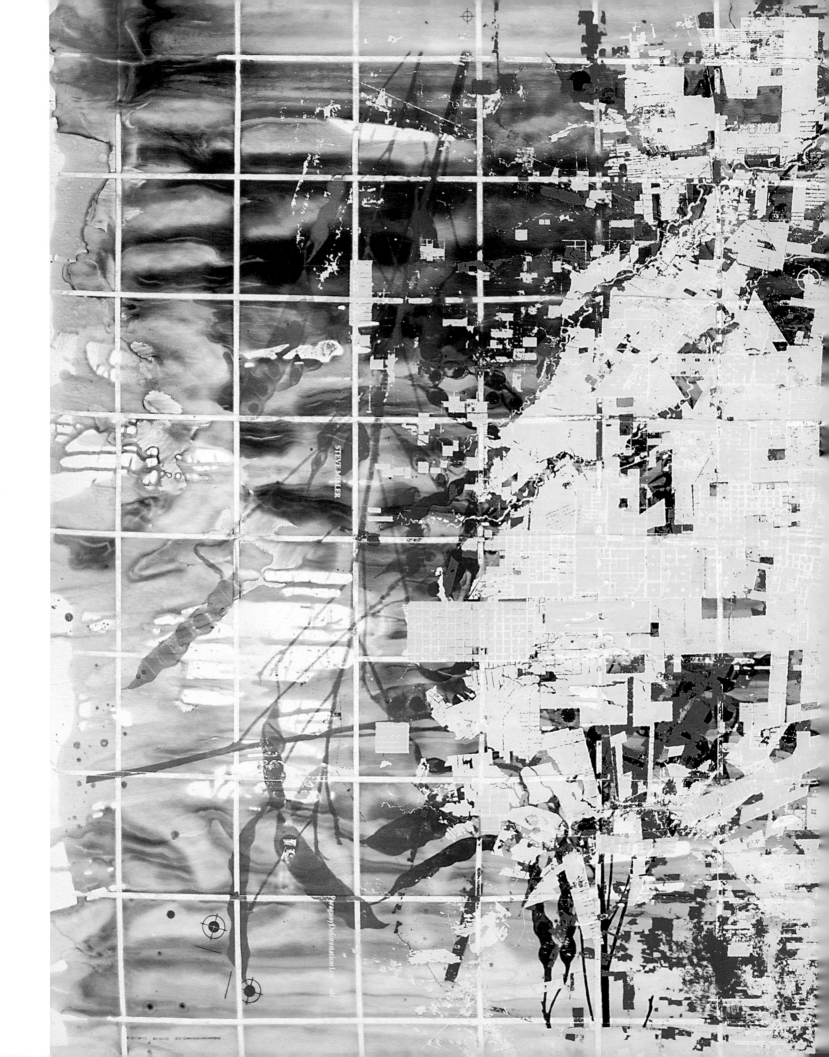

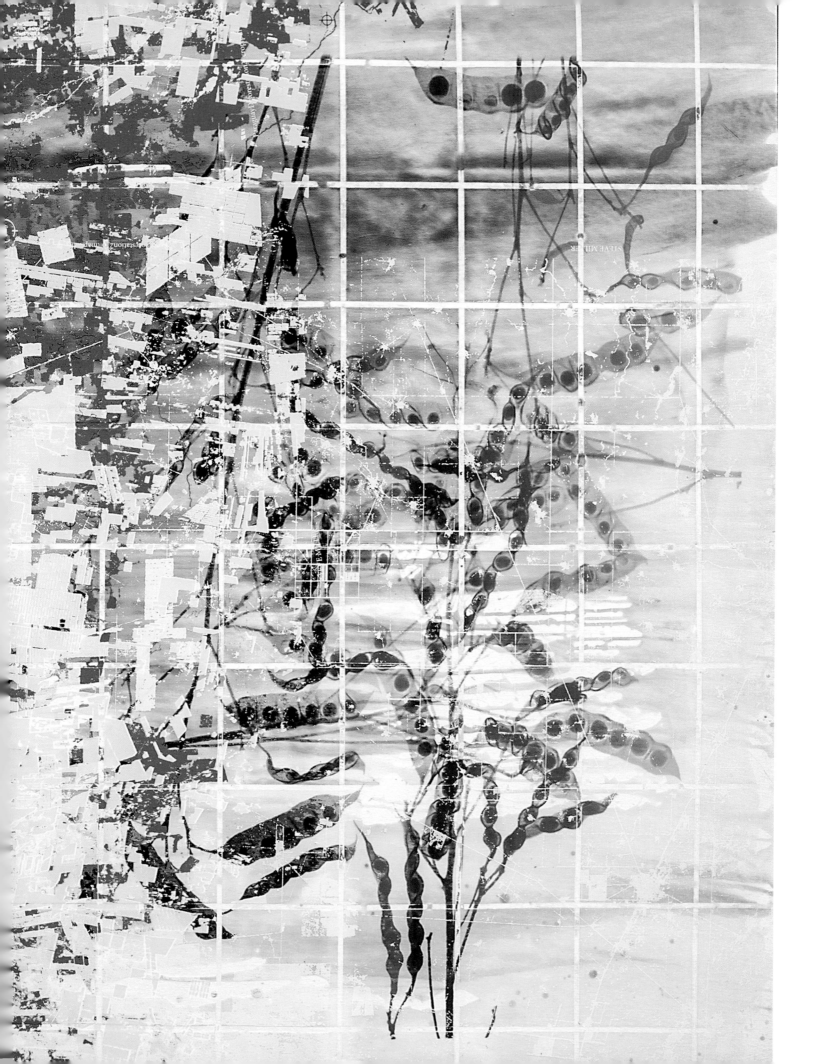

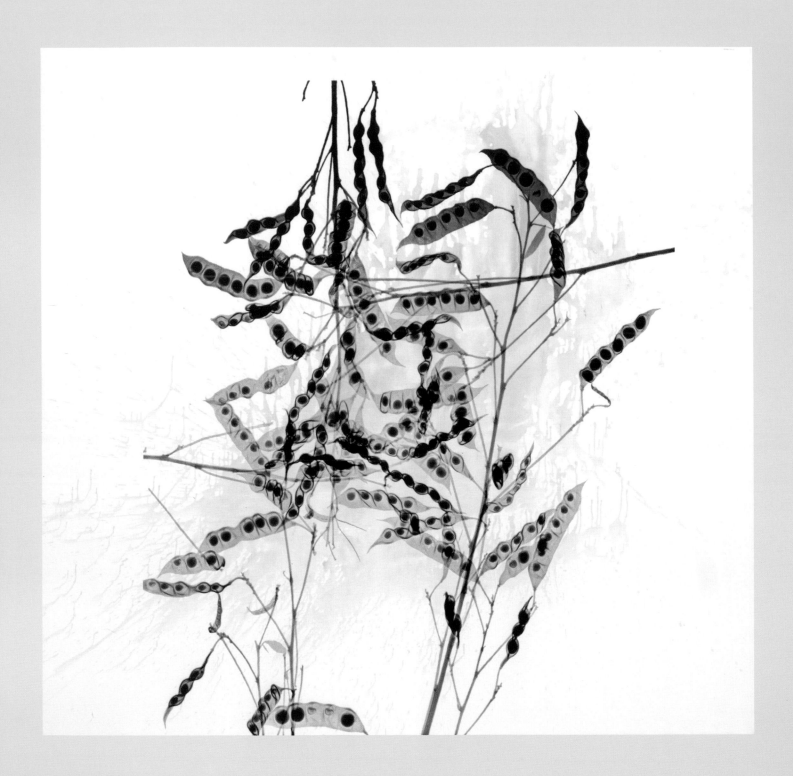

Above: *The Past Several Hundred Thousand Years*, 2012 | Pigment dispersion and silkscreen on canvas | 77 x 80 in.

Opposite: *Perpetual State*, 2009 | Pigment dispersion and silkscreen | 80 x 78 in.

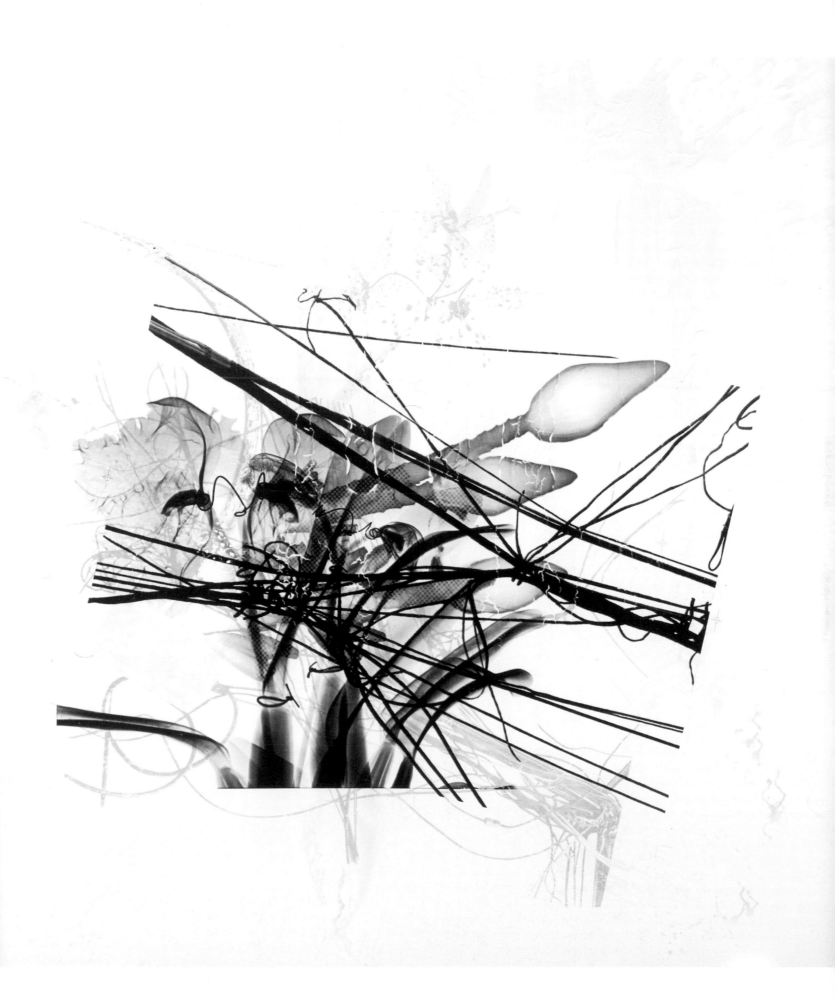

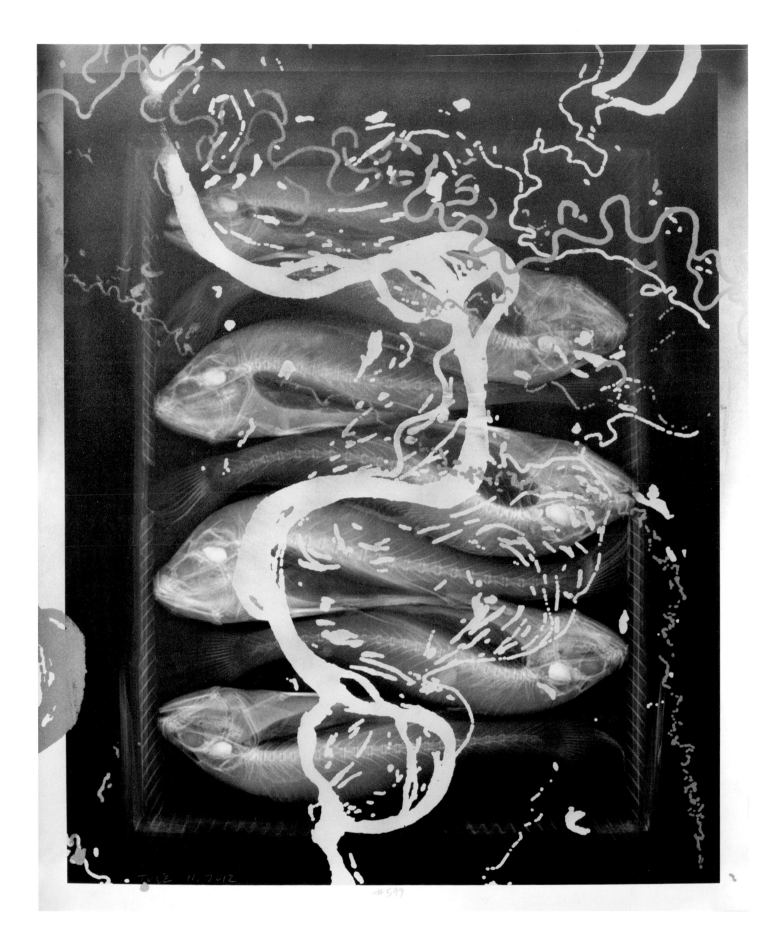

Health of the Planet #599, 2012 | Inkjet, spray enamel and silkscreen on cotton rag | 29.5 x 24 in.

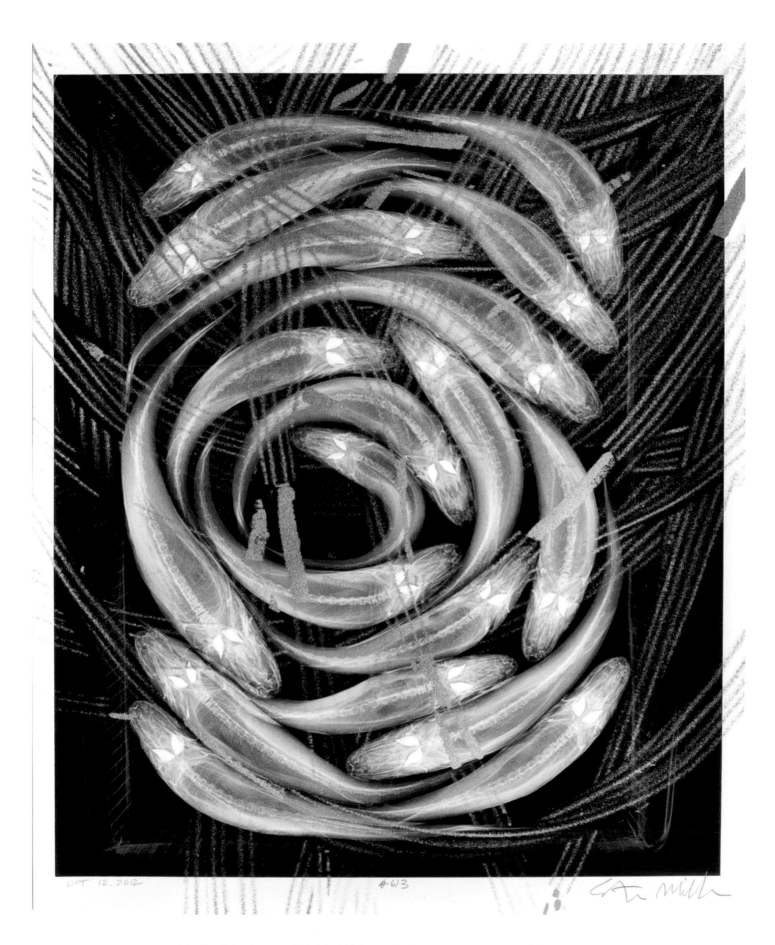

Health of the Planet #613, 2012 | Inkjet and silkscreen on cotton rag | 22.5 x 17 in.

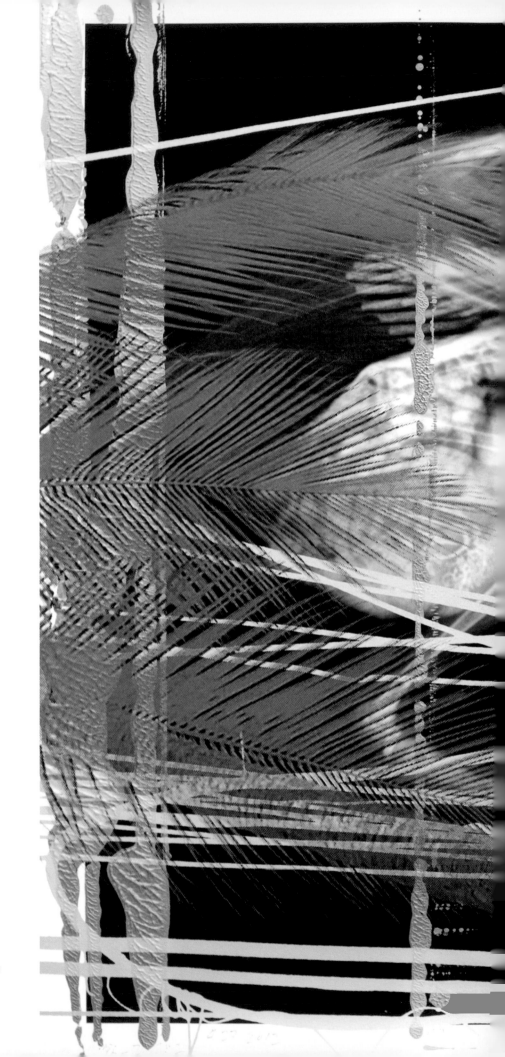

Health of the Planet #591, 2012 | Inkjet, enamel and silkscreen on cotton rag | 24 x 30 in.

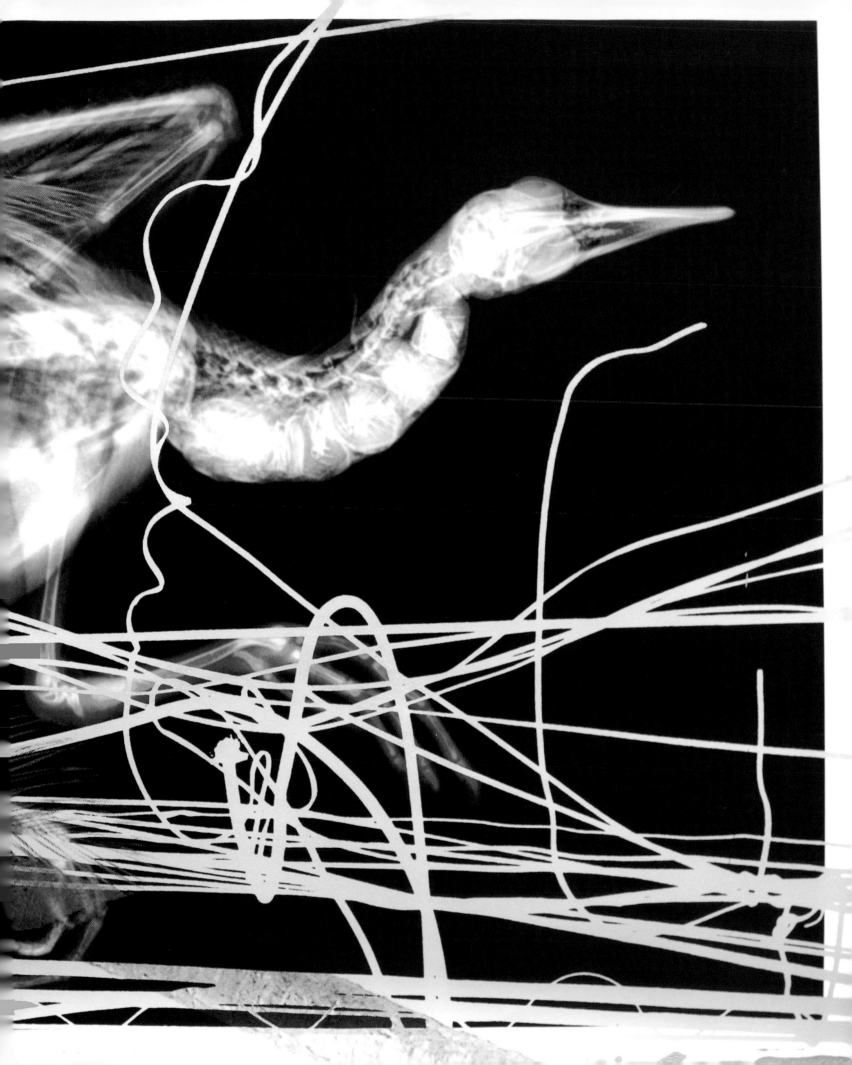

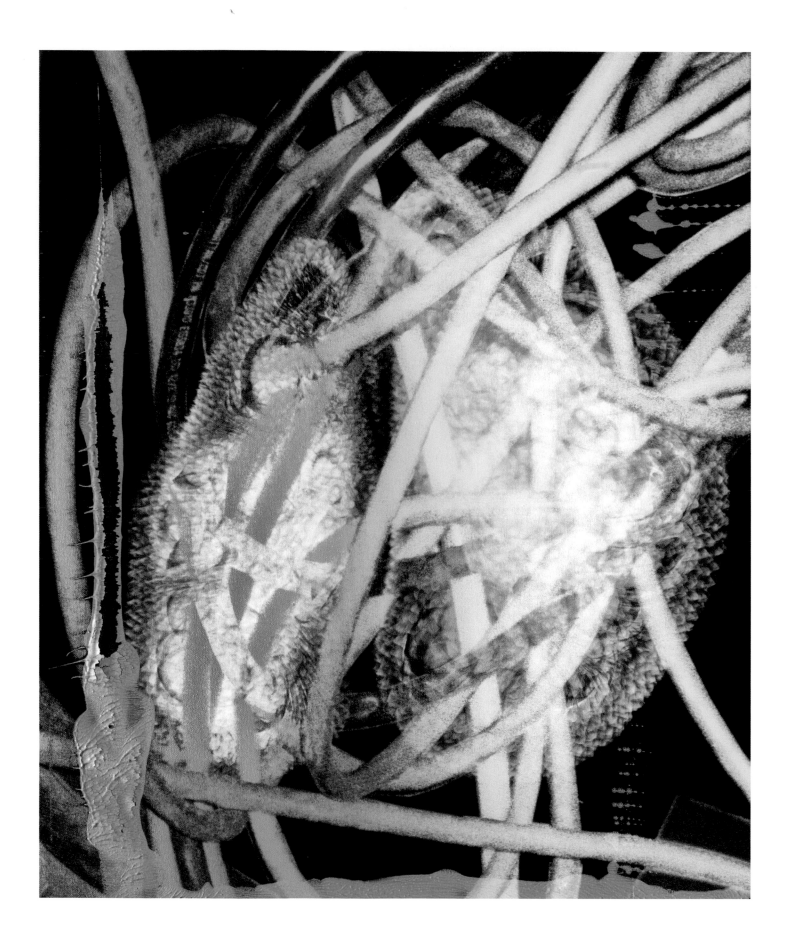

Nutrients for Developing, 2009 | Carbon inkjet, acrylic and silkscreen on canvas | 26.25 x 24 in.

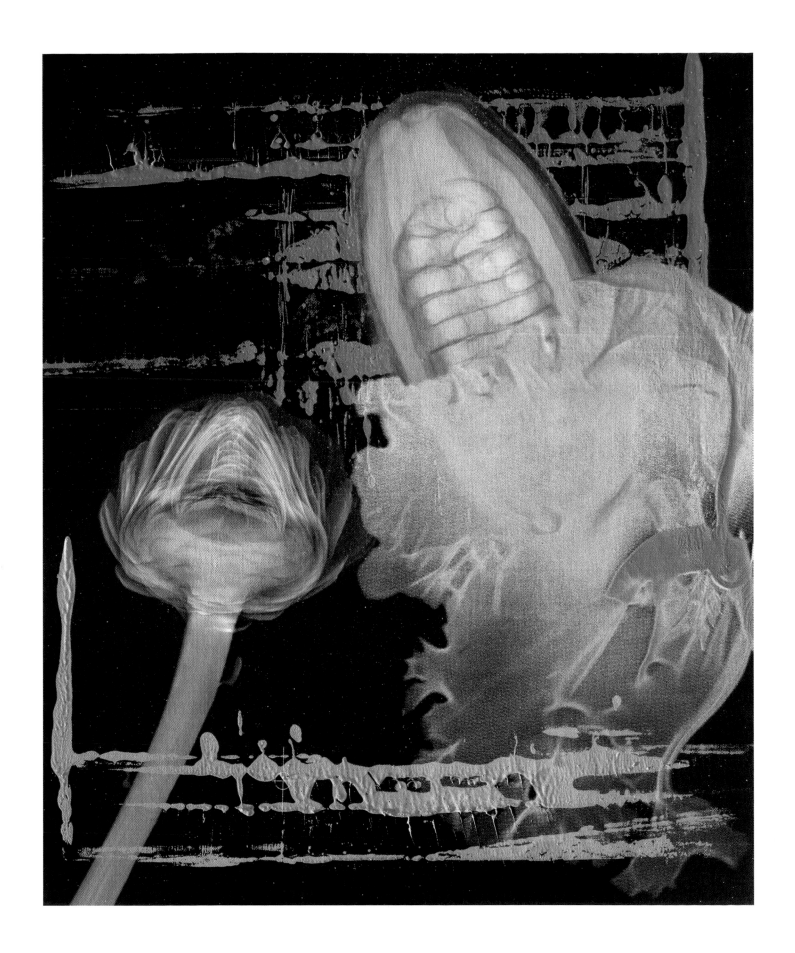

Equilibrium Run, 2011 | Inkjet, enamel and silkscreen on canvas | 25.75 x 22 in.

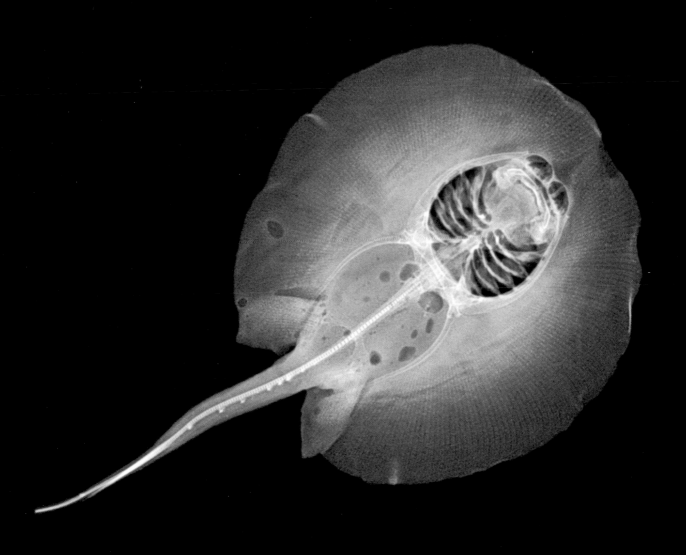

Ray, 2011 | Carbon inkjet on cotton rag | 24 x 30 in.

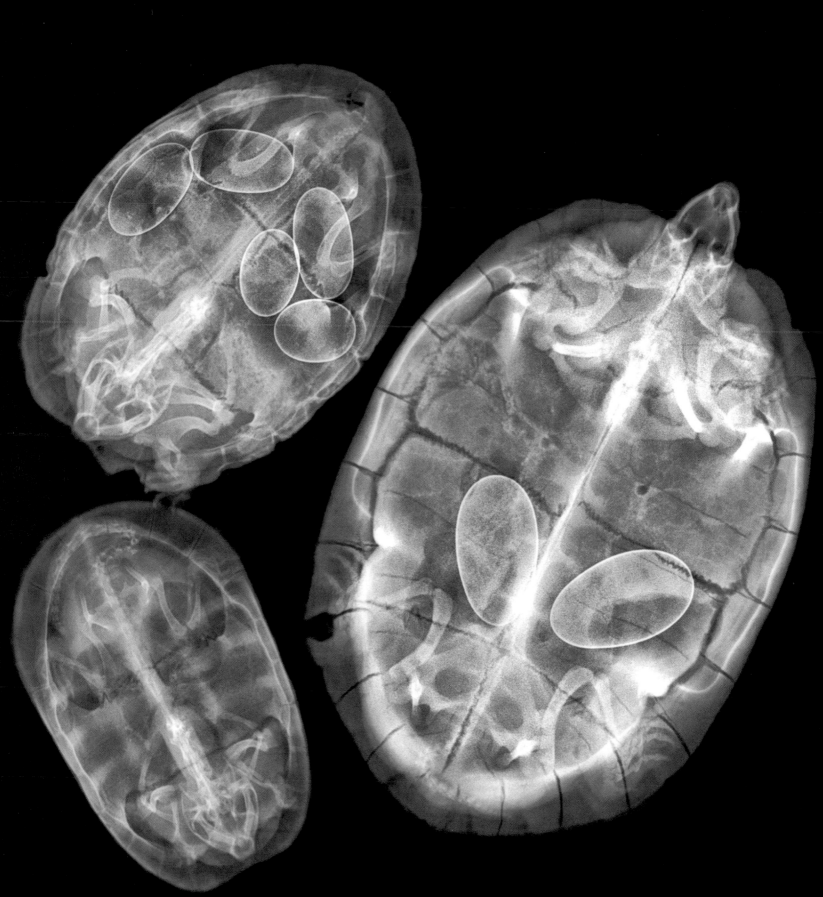

Turtle Eggs, 2011 | Carbon inkjet on cotton rag | 24 x 24 in.

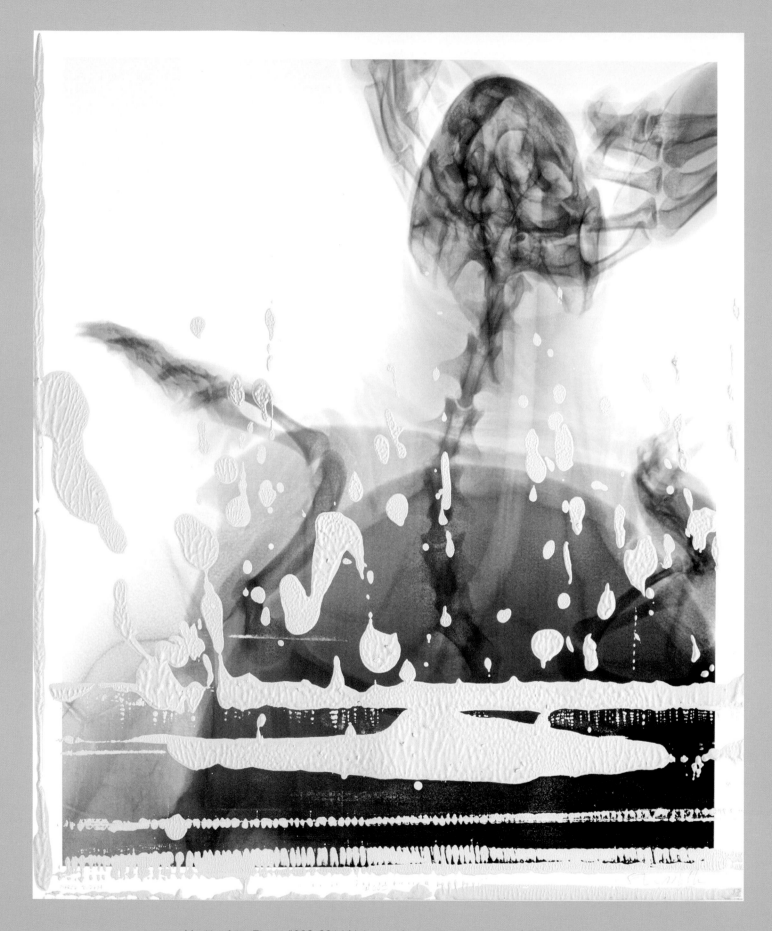

Health of the Planet #662, 2014 | Inkjet and enamel on cotton rag | 24 x 28.3 in.

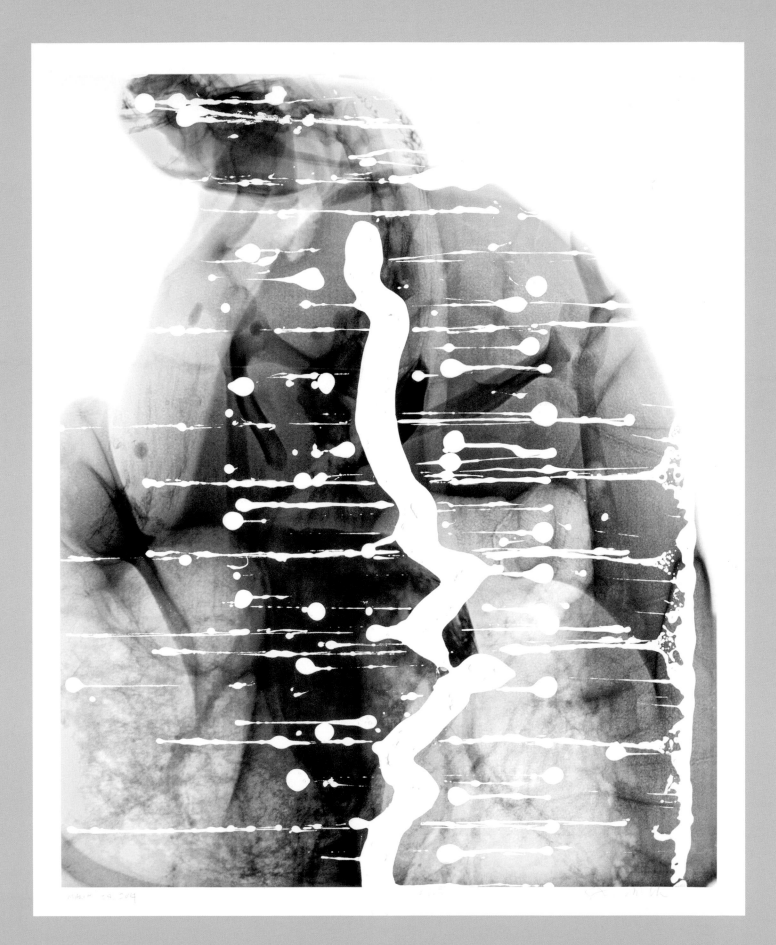

Health of the Planet #663, 2014 | Inkjet and enamel on cotton rag | 24 x 28.8 in.

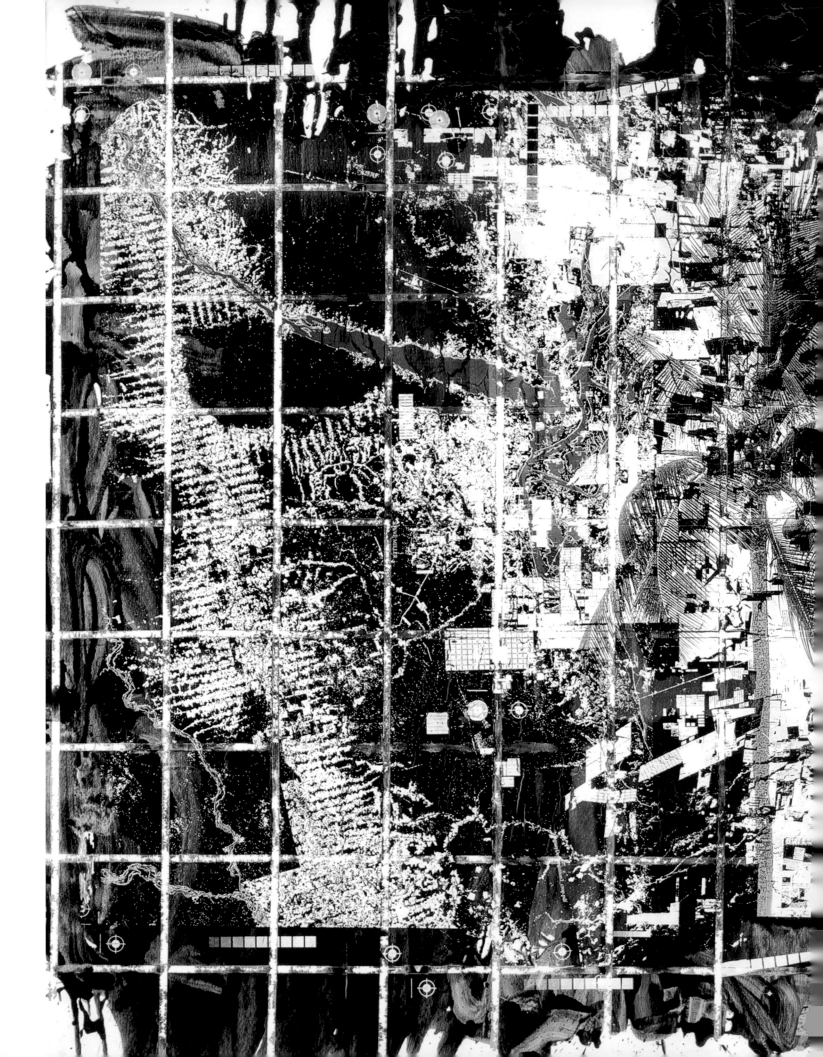

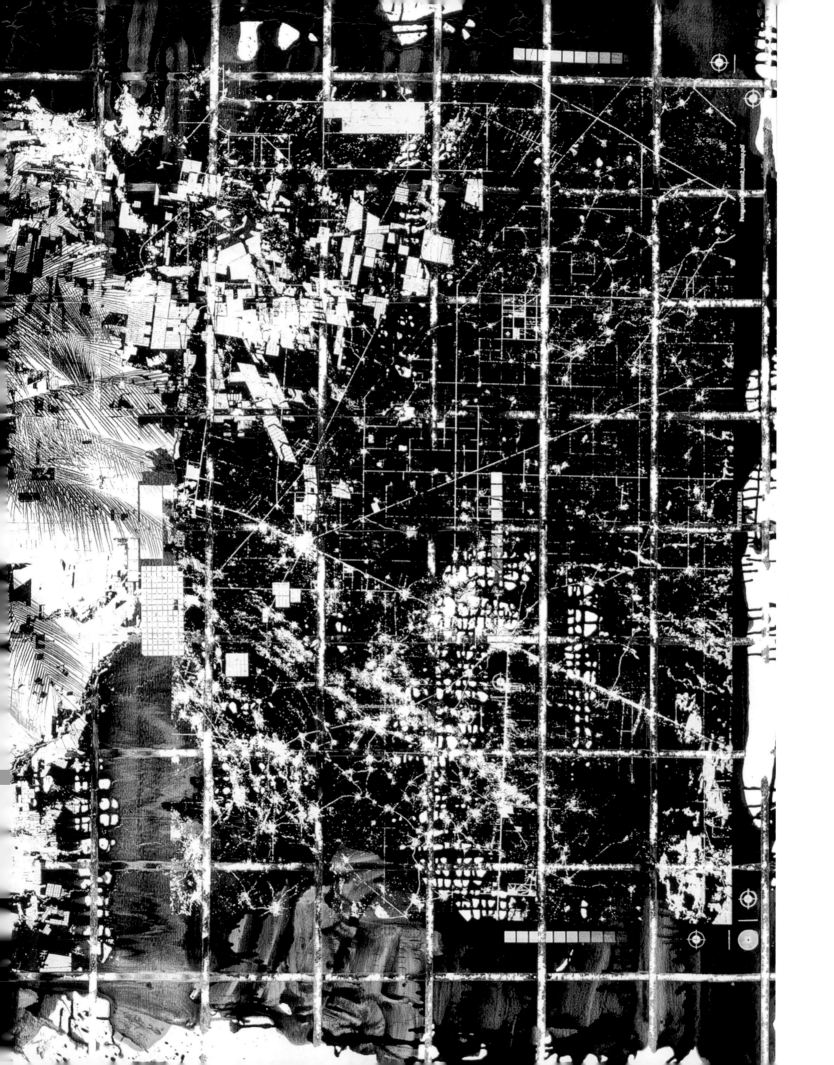

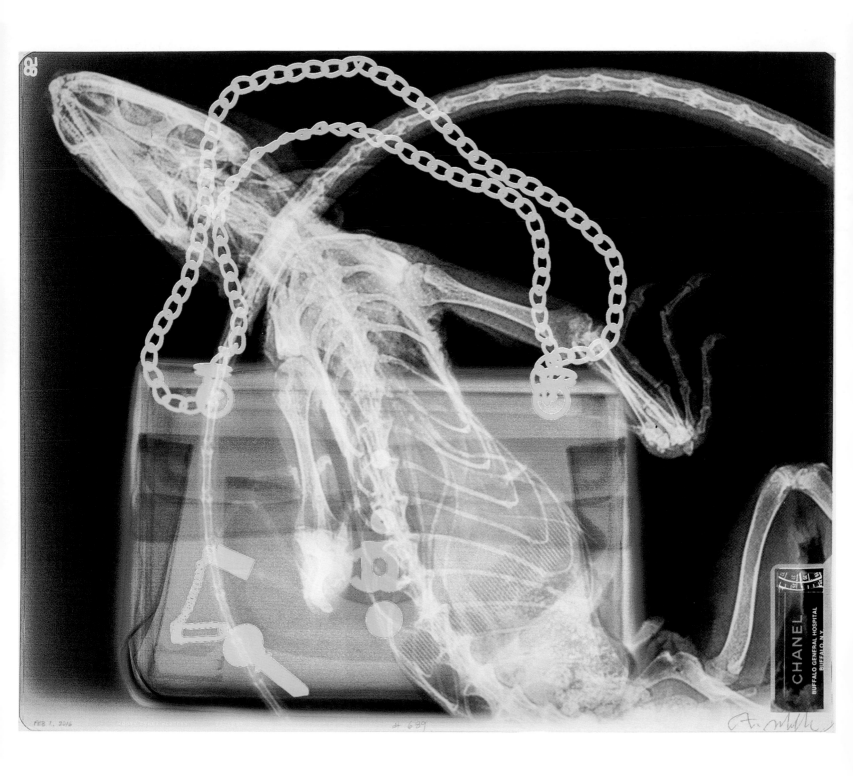

Previous page: *Archeology of Knowledge*, 2016 | Pigment dispersion and silkscreen on canvas | 79 x 115 in.

Above: *Health of the Planet #689*, 2016 | Inkjet and silkscreen on cotton rag | 24 x 28.5 in.

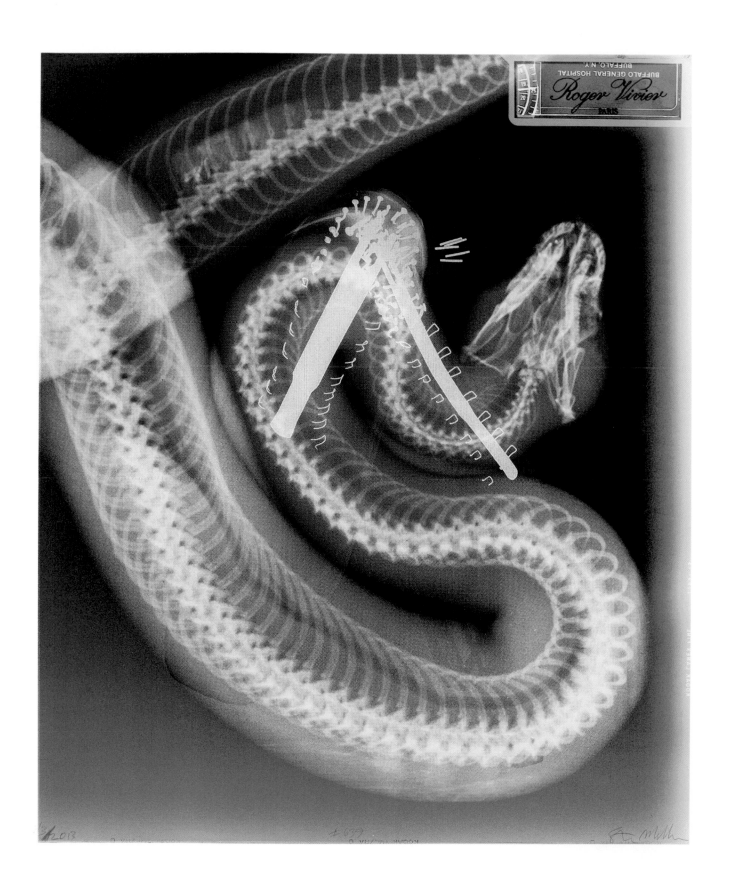

Health of the Planet #637, 2013 | inkjet and silkscreen on cotton rag | 28.5 x 24 in.

Overleaf: *Torch Snake*, 2011 | inkjet on paper | 24 x 36 in.

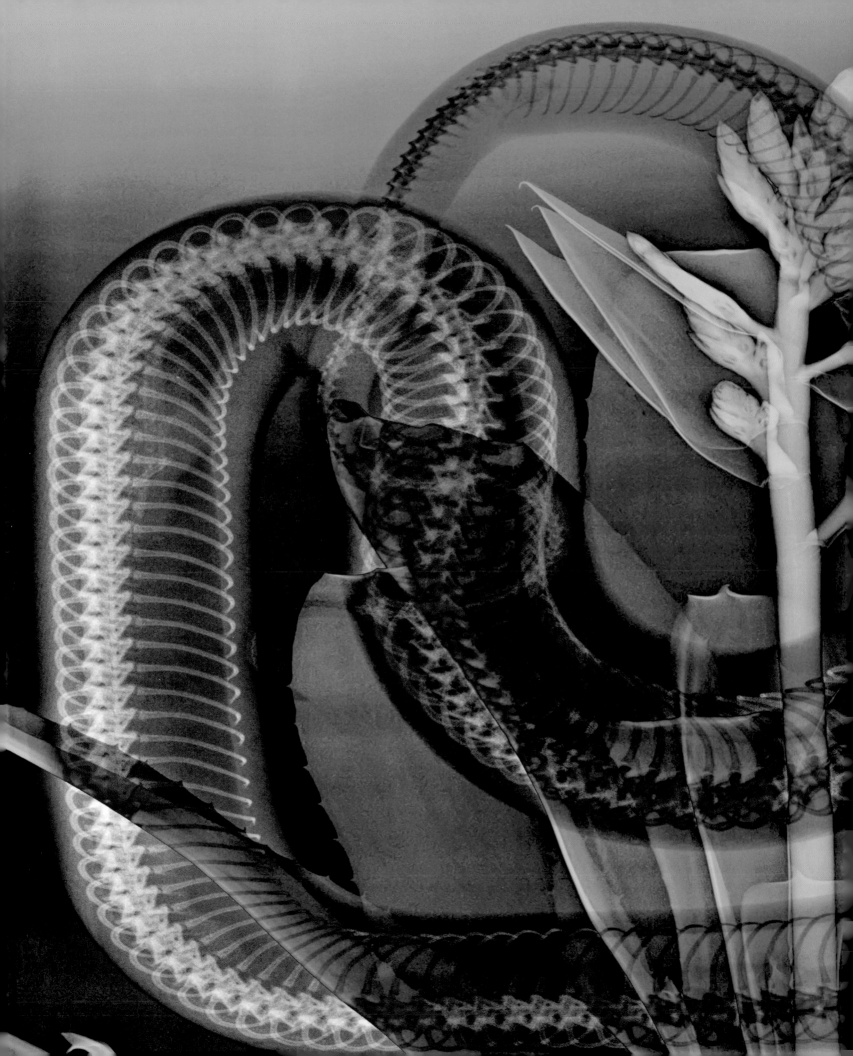

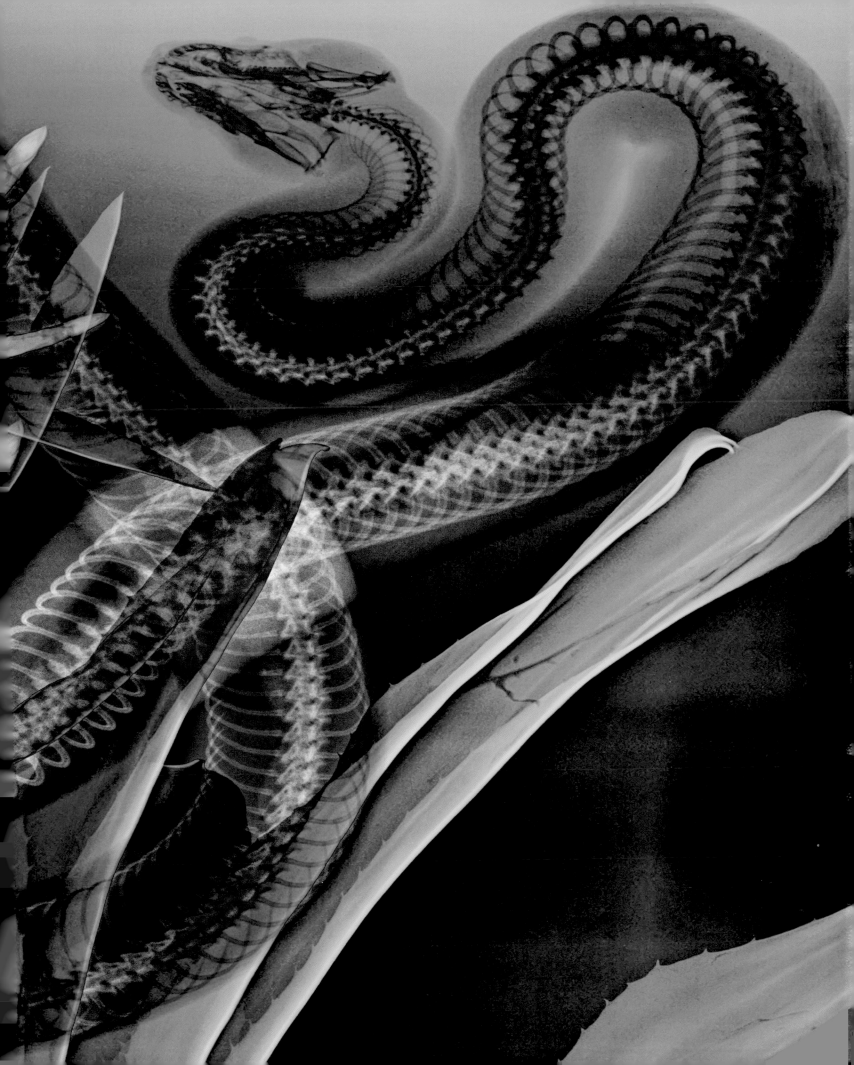

Health of the Planet #646, 2013 | Inkjet and silkscreen on cotton rag | 29 x 24 in.

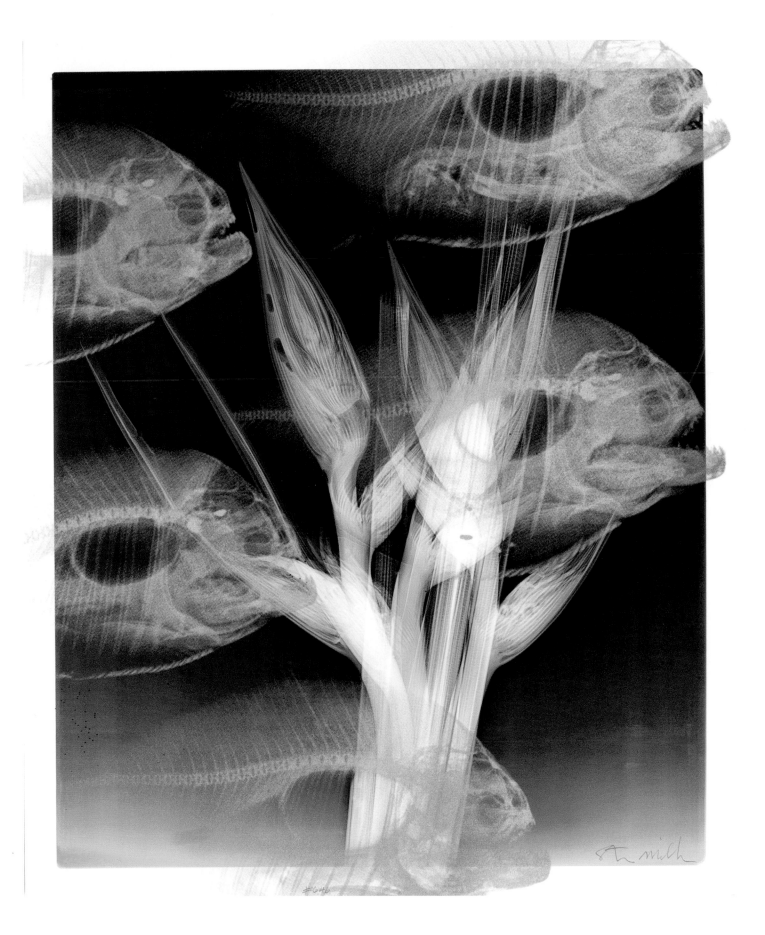

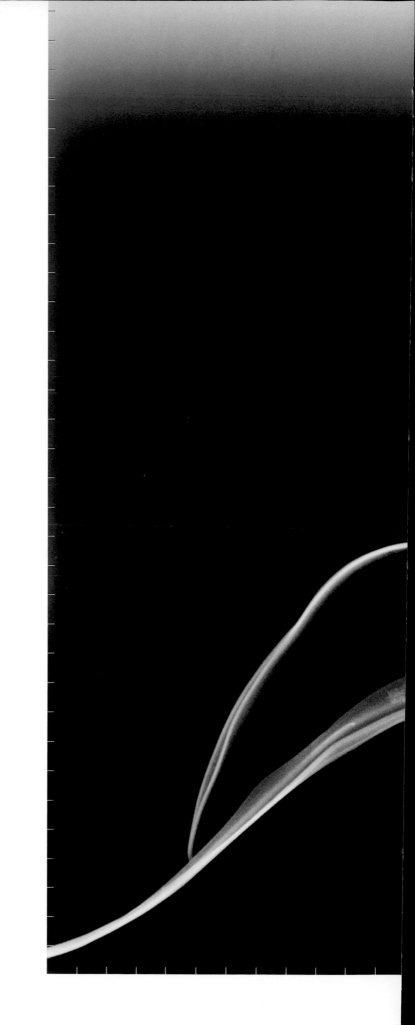

Ladyslipper, 2009 | Carbon inkjet on cotton rag | 17 x 20 in.

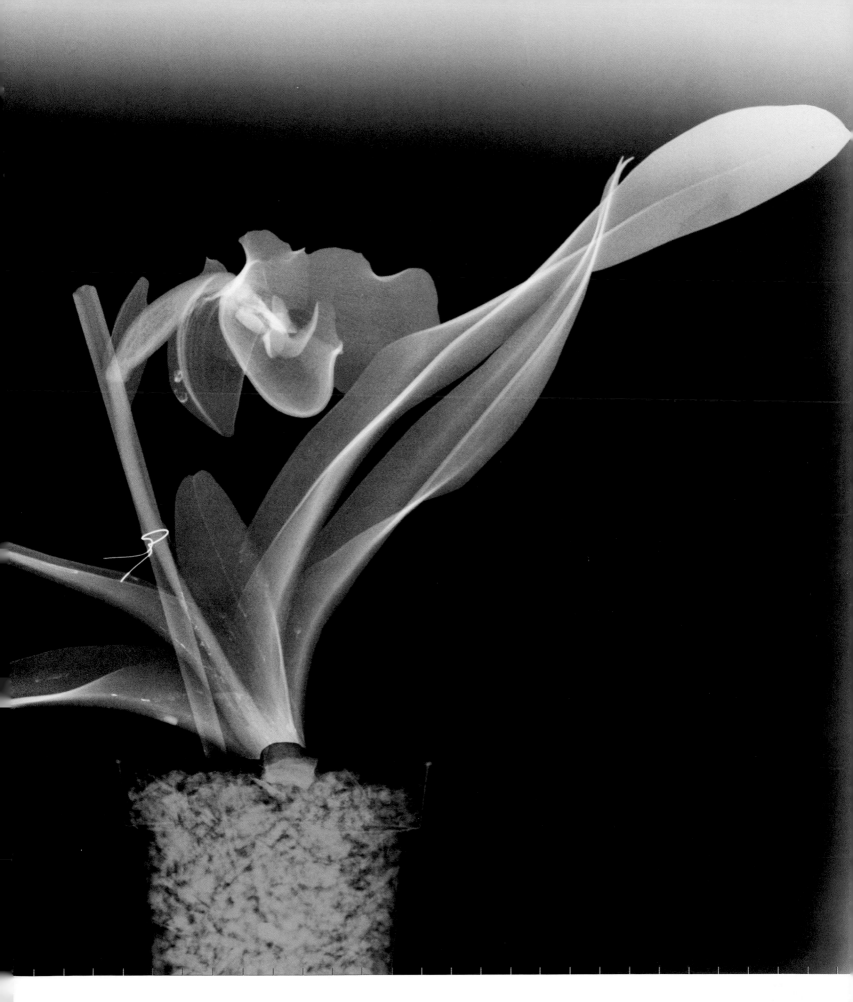

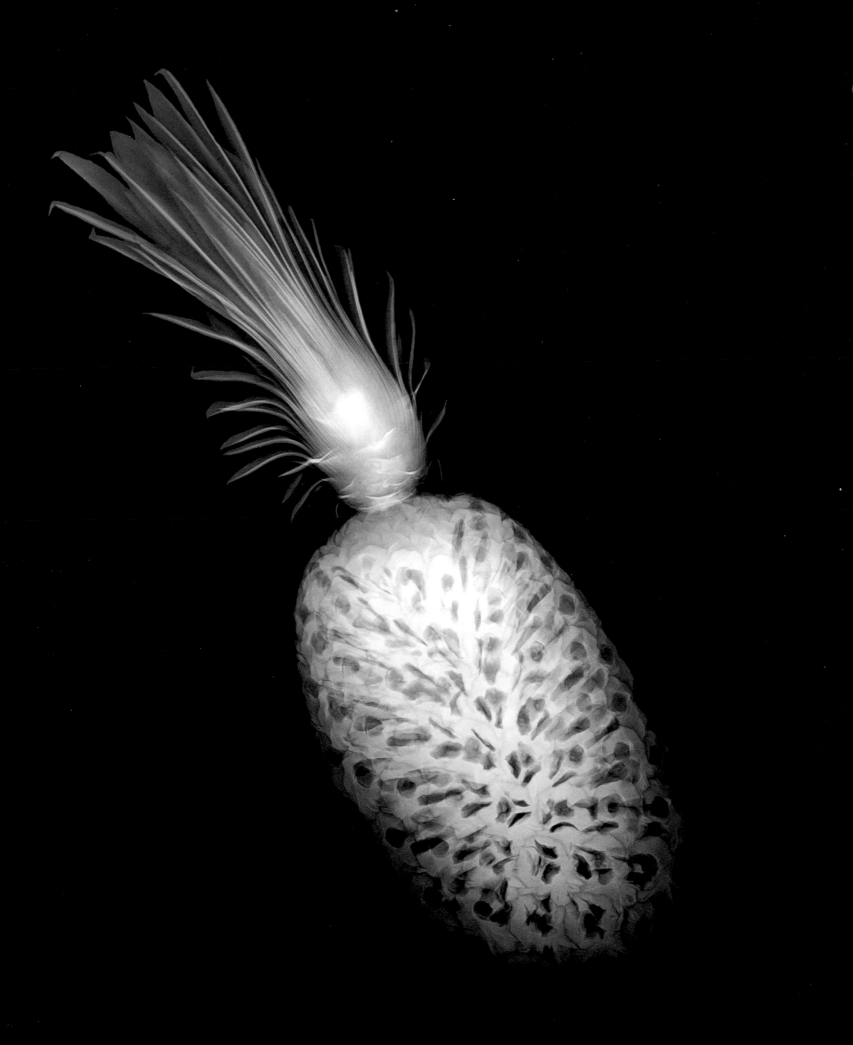

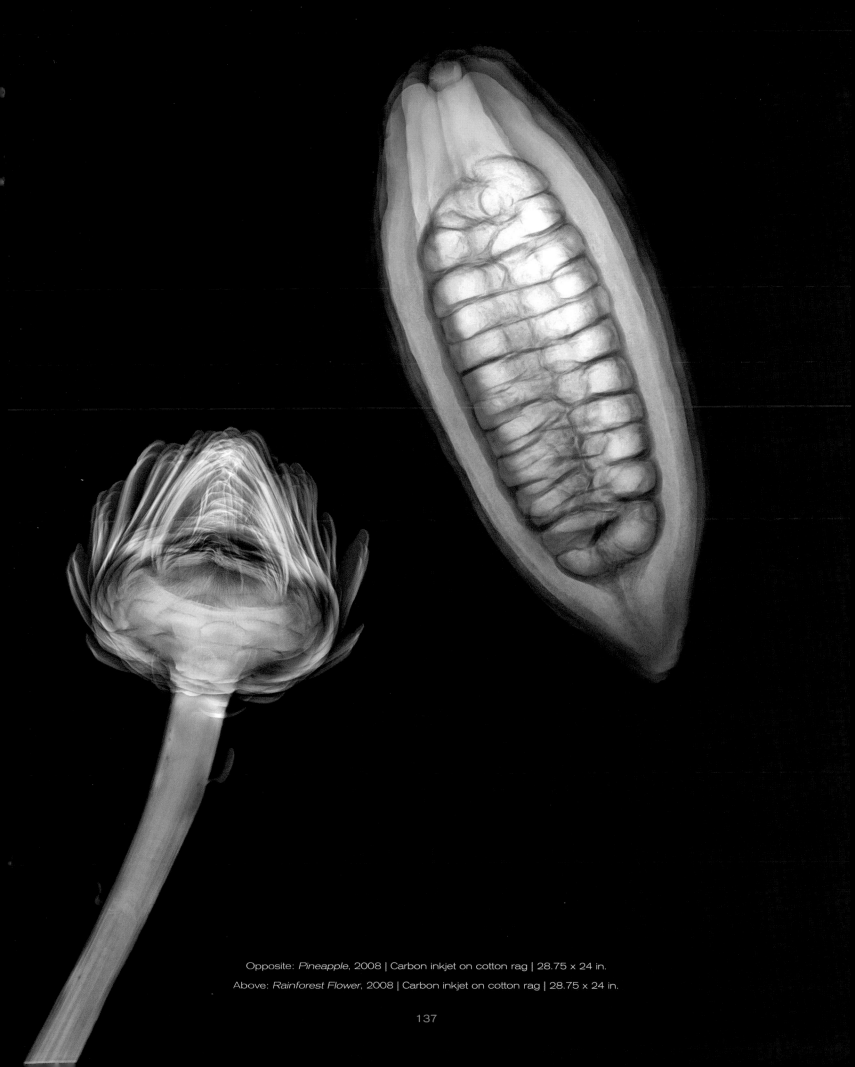

Opposite: *Pineapple*, 2008 | Carbon inkjet on cotton rag | 28.75 x 24 in.

Above: *Rainforest Flower*, 2008 | Carbon inkjet on cotton rag | 28.75 x 24 in.

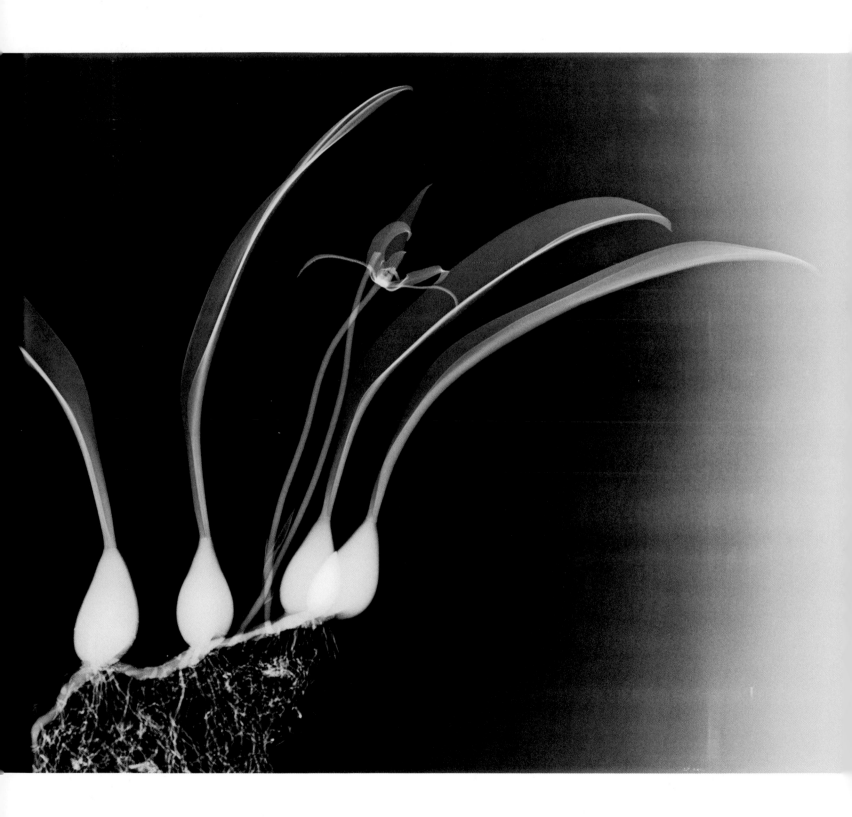

Above: *Roots*, 2008 | Carbon inkjet on cotton rag | 24 x 28.75 in.

Opposite: *Fish Box*, 2011 | Carbon inkjet on cotton rag | 28.75 x 24 in.

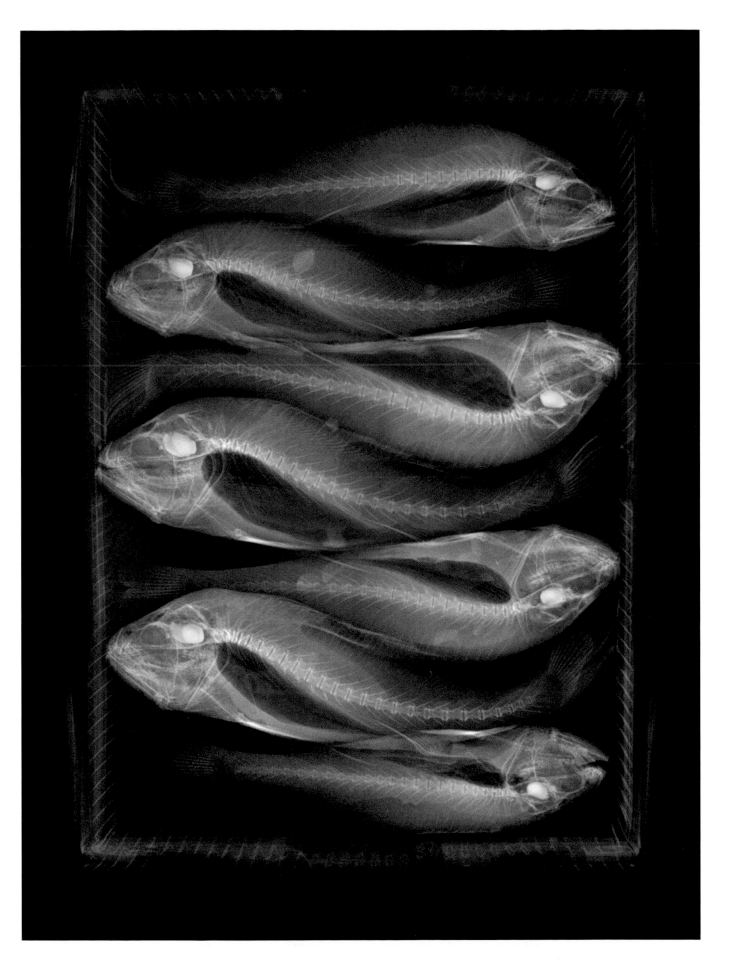

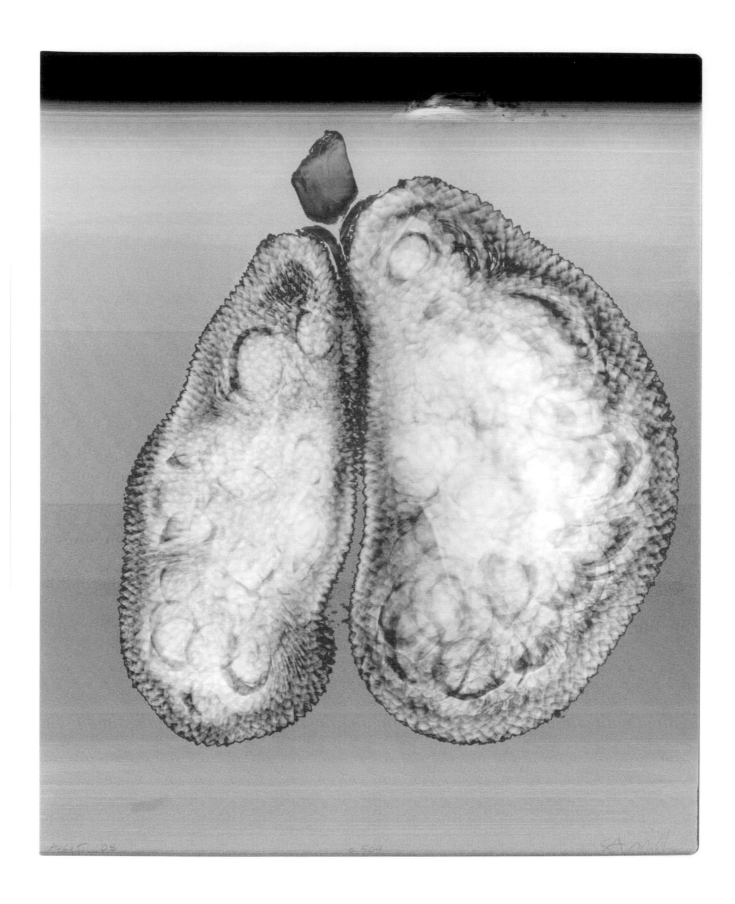

Health of the Planet #504, 2008 | Carbon inkjet on cotton rag | 29 x 24 in.

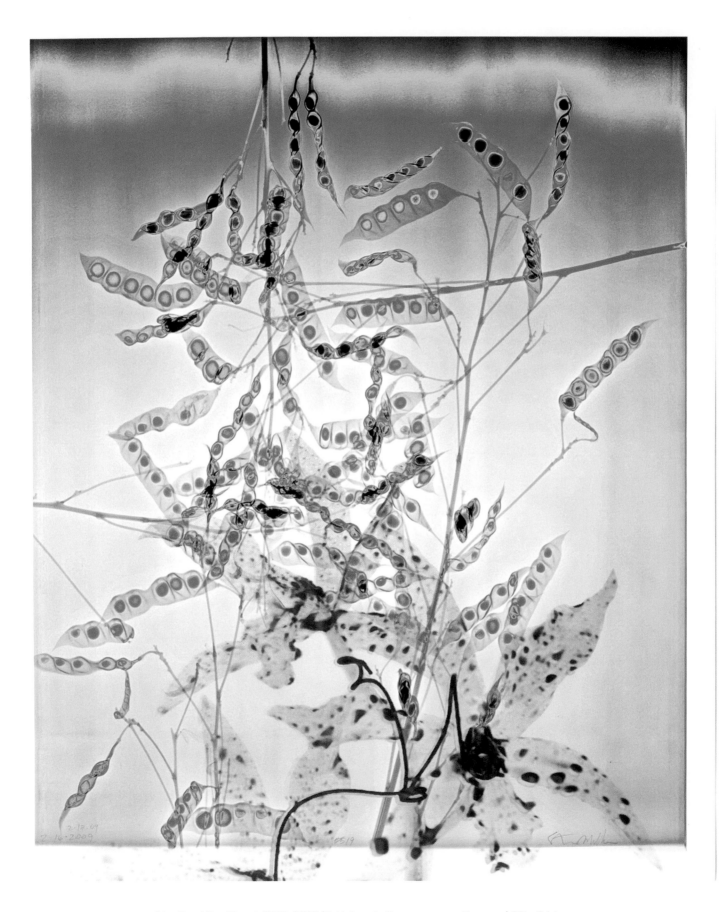

Health of the Planet #519, 2009 | Inkjet and silkscreen on cotton rag | 29 x 24 in.

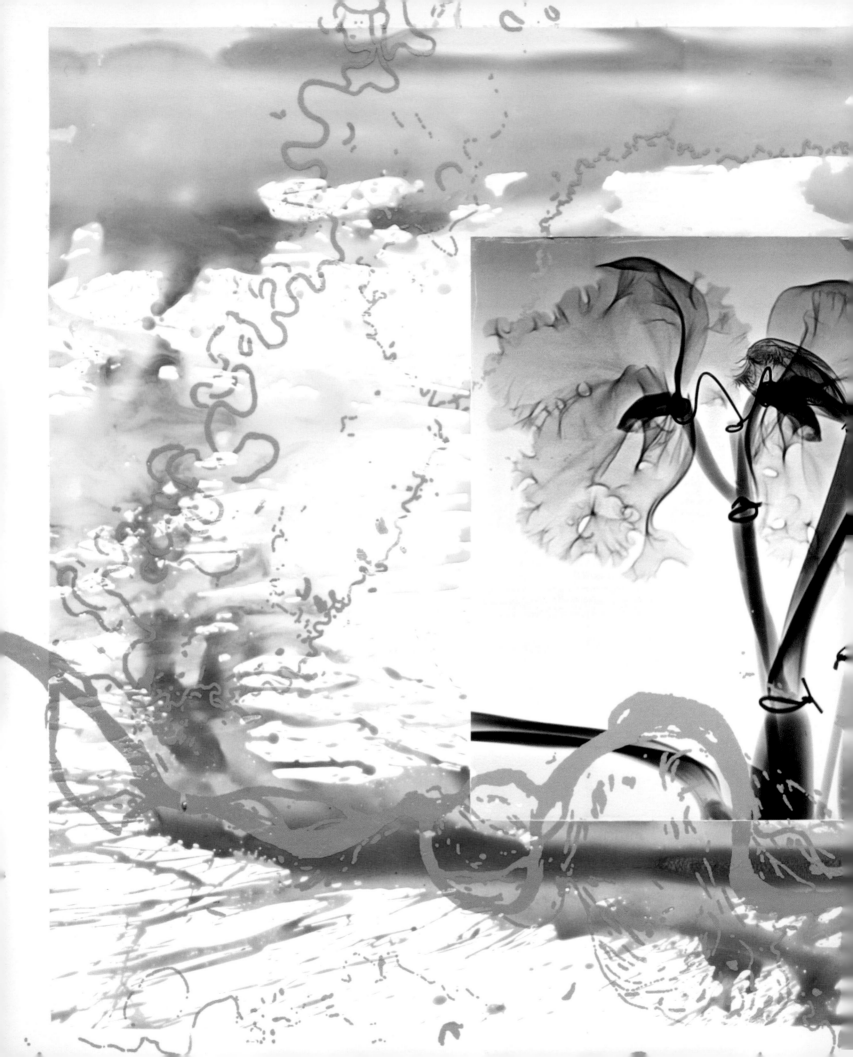

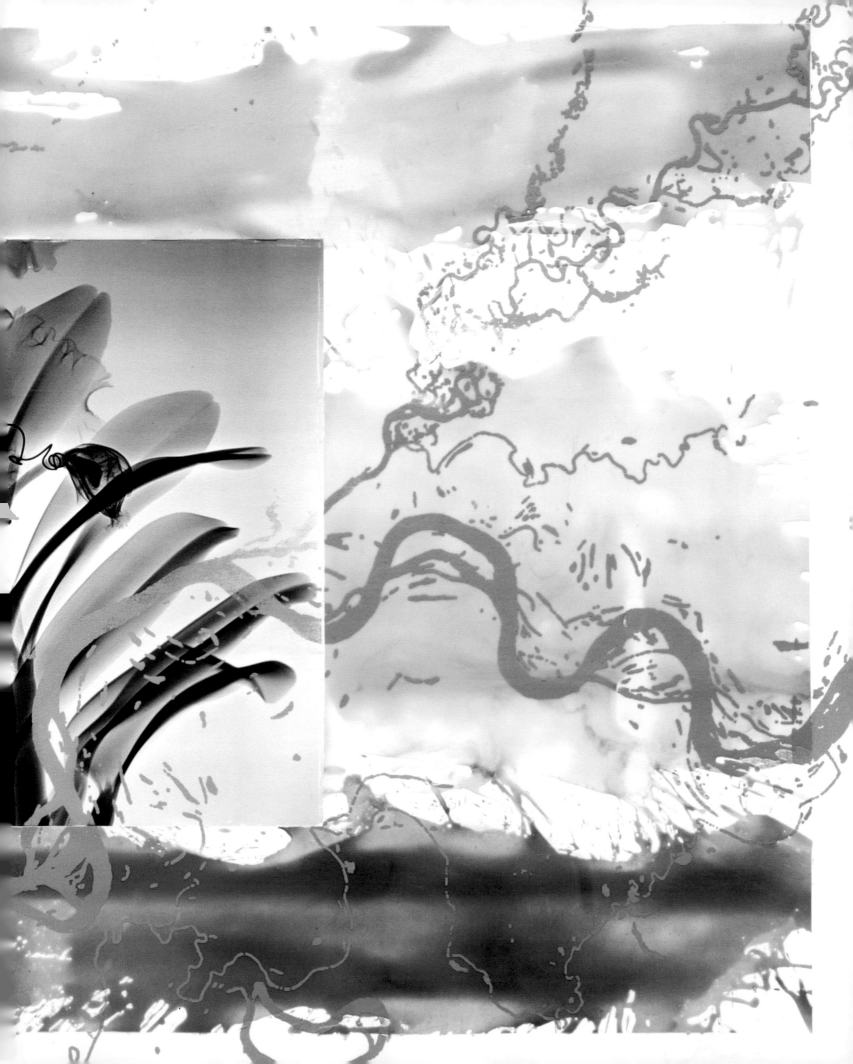

Previous page: *Conditions on the Flow*, 2011 | Inkjet, pigment
dispersion and silkscreen on canvas | 40 x 64 in.

Right: *When Conditions Are Favorable*, 2009 | Inkjet, pigment
dispersion and silkscreen on canvas | 22 x 26.5 in.

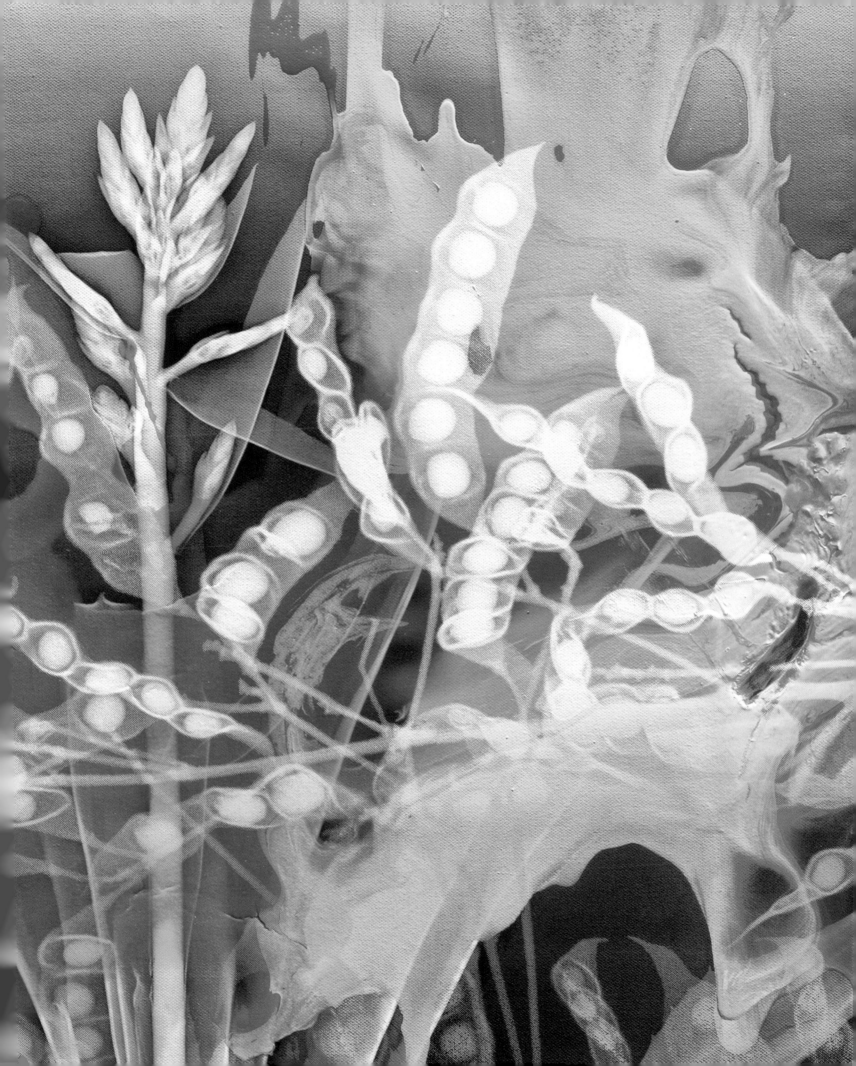

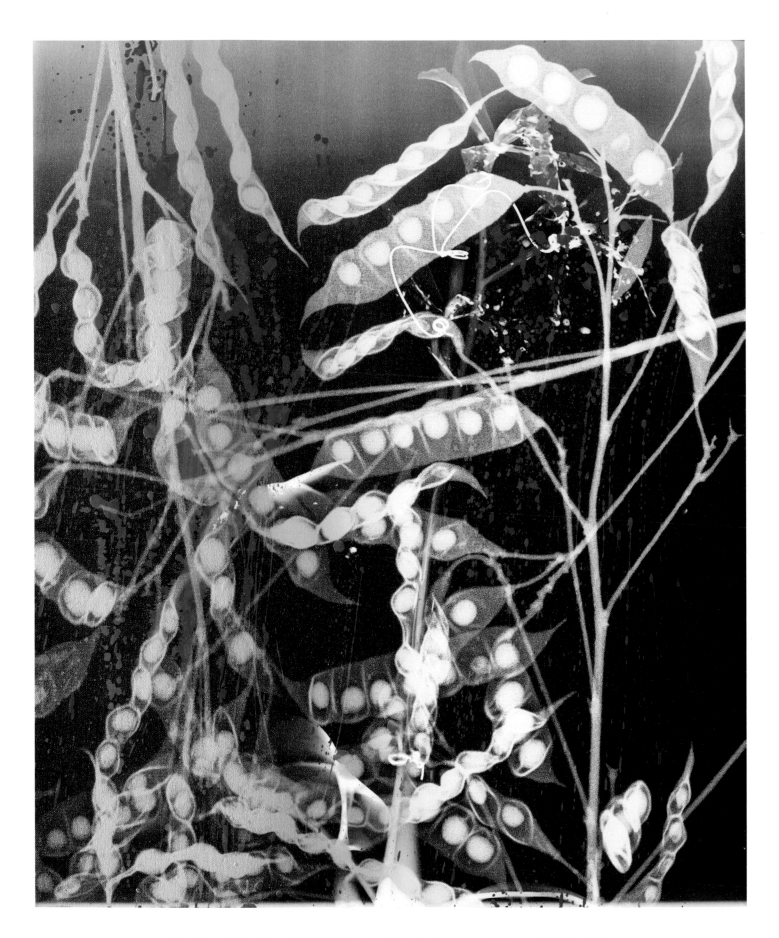

Purely Local Conditions, 2009 | Inkjet, enamel and silkscreen on canvas | 26.25 x 22 in.

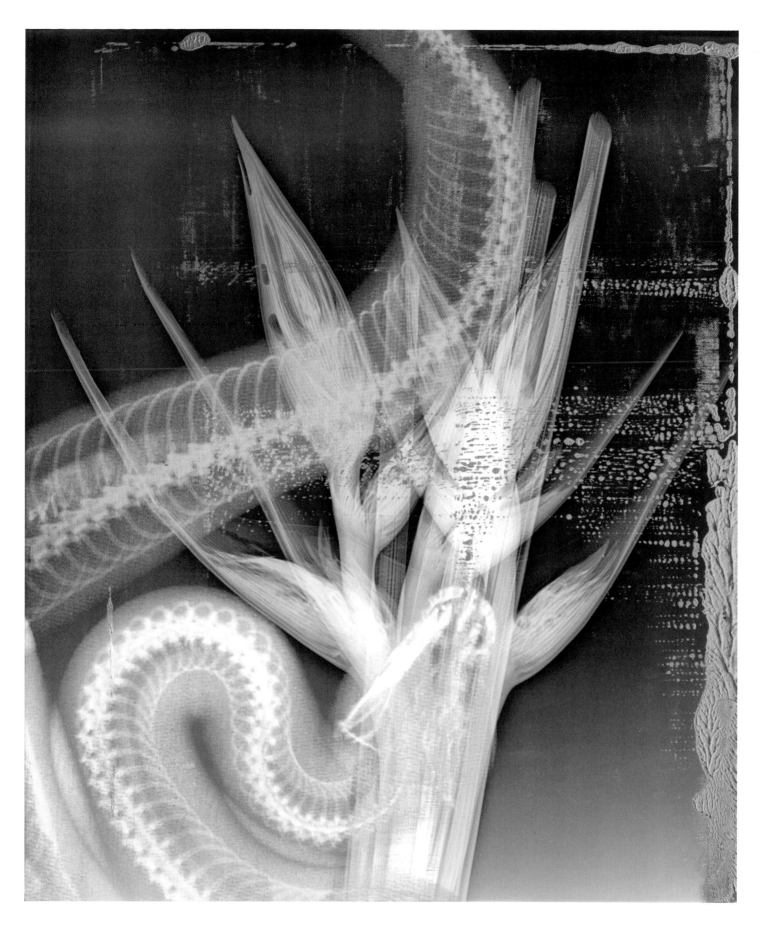

Evolutionary Hierarchy, 2009 | Inkjet, enamel and silkscreen on canvas | 26.25 x 22 in.

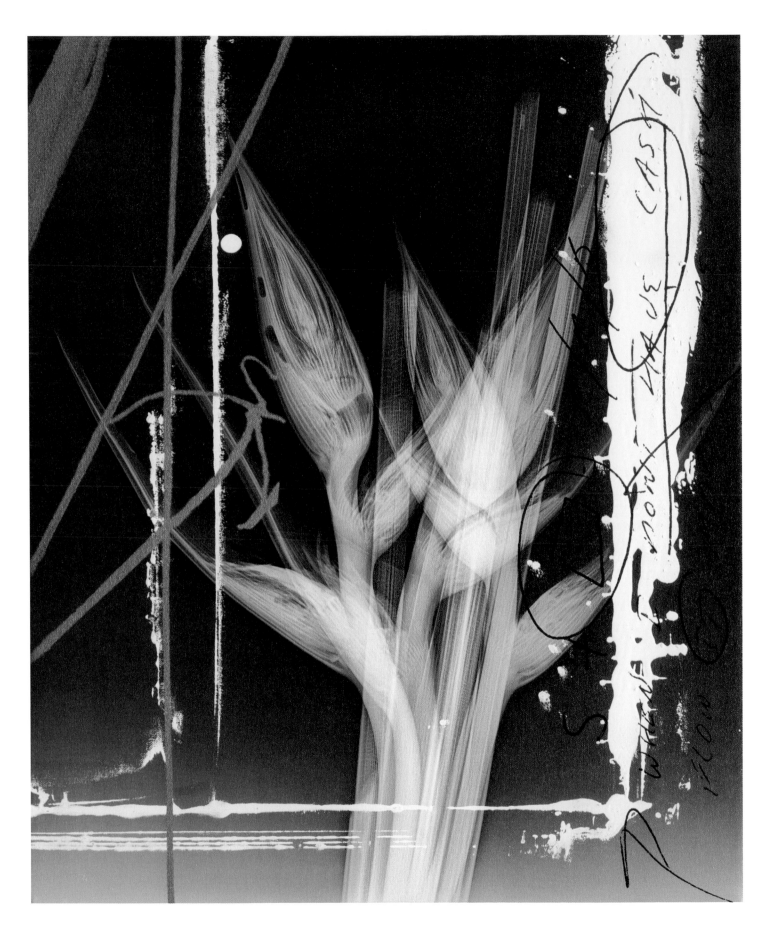

Energy Engine, 2009 | Inkjet, enamel and silkscreen on canvas | 26 x 21.75 in.

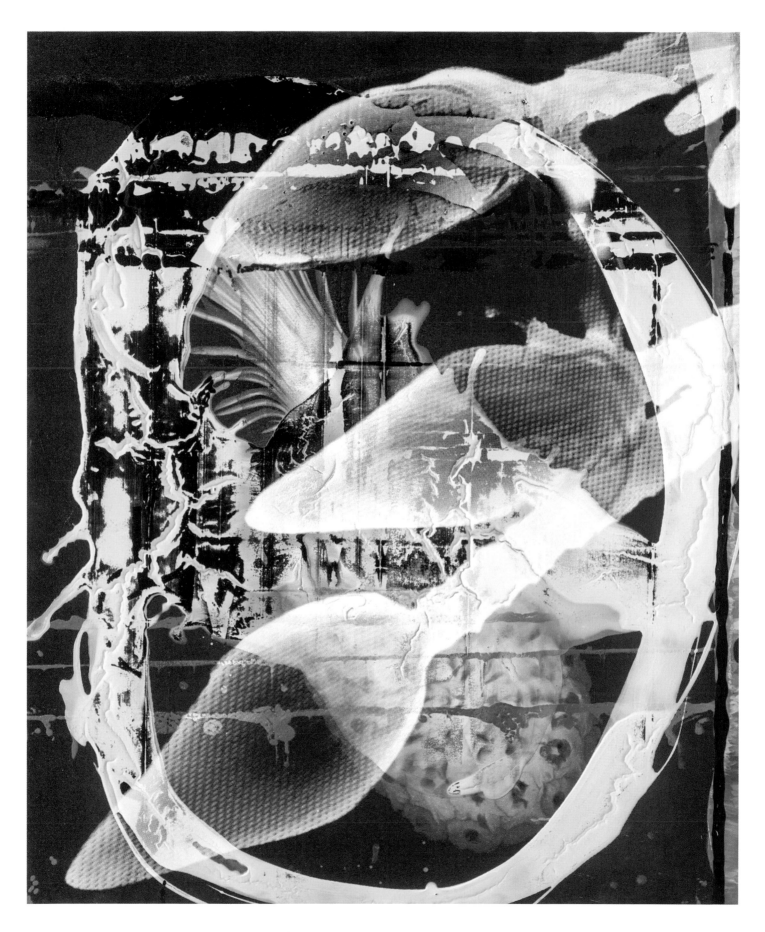

Wild Ones, 2009 | Inkjet, enamel and silkscreen on canvas | 26.5 x 22 in.

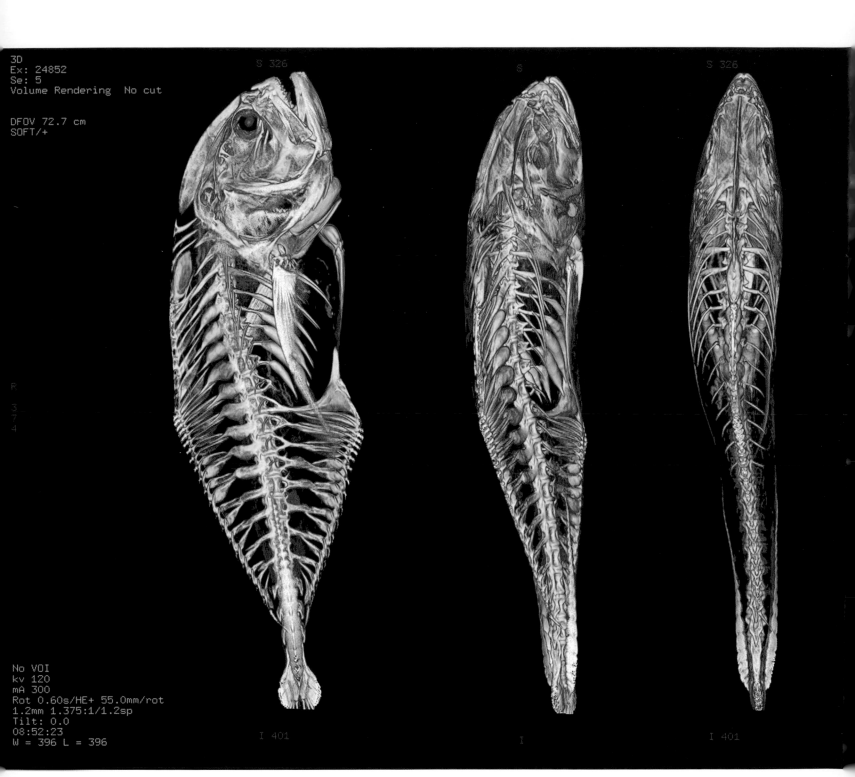

Fish Sextet, 2012 | Inkjet on cotton rag | 22 x 53.5 in.

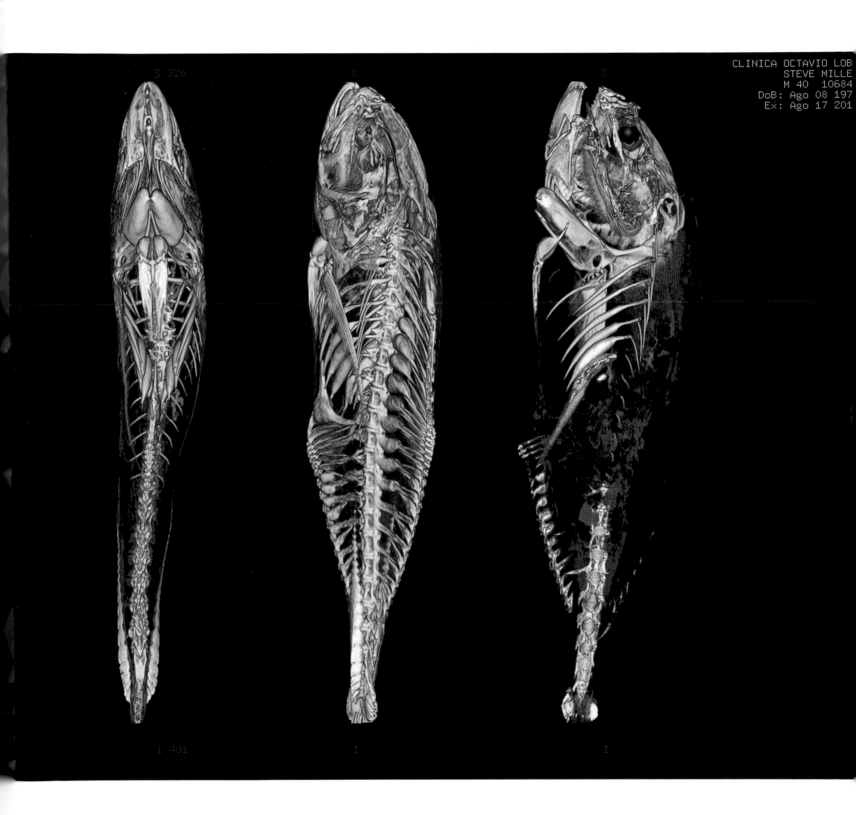

AUTHOR CHRONOLOGY

Personal Data

1951 Born October 12, Buffalo, New York

1970 University of Vermont, Burlington, VT

1973 Middlebury College, Middlebury, VT

1973 Skowhegan School of Painting and Sculpture,
New York, NY

Solo Exhibitions

1981 White Columns, New York

1982 Artists Space, New York

1985 Public Art Fund-Times Square Electronic Billboard
Jack Shainman Gallery, Washington, D.C.
Bette Stoler Gallery, New York

1986 Jack Shainman Gallery, Washington, D.C.
Josh Baer Gallery, New York

1987 Josh Baer Gallery, New York

1988 Josh Baer Gallery, New York
Galerie du Genie, Paris

1989 Fiction/nonfiction, New York
Carol Getz Gallery, Miami, Florida

1991 Galerie du Genie, Paris

1992 Elga Wimmer Gallery, New York

1993 Galerie Karin Sachs, Munich, Germany
Nina Freudenheim Gallery, Buffalo, New York
A.B. Galeries, Paris

1994 Espace D'Art Brenne, France

1996 Centre International d'Art Visuels CARGO, Marseilles
Espace d'Art Yvonamor Palix, Paris
CAPC Musée Bordeaux, Galerie Pour la Vie

1998 Sagpond Vineyards, Sagaponack, NY
Karin Sachs Gallery, Munich
Hong Kong Arts Center, China
Saks Fifth Avenue Project Art, Southampton, NY

2000 "Neomort," Universal Concepts Unlimited, New York
Raphael Rigassi Gallery, Bern, Switzerland
Galerie Lilian Andree, Basel, Switzerland

2005 Prudential Center, Hampton Classic, Bridgehampton, NY

2007 Rose Art Museum, Brandeis University, Waltham, MA

2009 Robin Rice Gallery, New York, NY

2010 Gallery Maya, London

2011 "Fashion Animal." Galleria Tempo, Rio de Janeiro, Brazil

2012 "Saude do Planeta," Harpers Books, East Hampton, NY

2013 National Academy of Sciences, Washington, D.C.
Gallerie Rigassi, Bern, Switzerland
The Four Seasons Restaurant, New York

2014 Arte Rio 2014, "Steve Miller with Galeria Tempo," Rio de
Janeiro, Brazil
Long House Reserve, East Hampton, NY
Bloomingdale's, "Health of the Planet Surfboards," New
York, NY

2015 Marsiaj Tempo Galeria, "Health of the Planet" Rio de
Janeiro, Brazil

2016 Robin Rice Gallery, New York, NY
Sara Nightingale Gallery, Watermill, NY
Bloomingindale's, "Health of the Panet Surfboards," New
York, NY

2017 National Academy of Sciences, Washington, DC
Second Street Gallery, Charlottesville, VA

Group Exhibitions

1974 "Member's Gallery," Albright-Knox Gallery, Buffalo, New York

1976 "Member's Gallery," Albright-Knox Gallery, Buffalo,
New York

1978 "Contemporary Reflections," Aldrich Museum, Aldrich,
Connecticut

1979 "Six Artists Under Thirty," Burchfield Center, Buffalo,
New York
"Dimensions Variable," The New Museum, New York

1981 "Selections Sixteen," The Drawing Center, New York
"The Positive Show," ABC NO RIO, New York

1982 "Nineteen in New York," Nina Freudenheim Gallery, Buffalo,
New York
"The Ritz Hotel," Washington Project For The Arts,
Washington, D.C.
"Visual Politics," Alternative Museum, New York
"New Drawing in America," The Drawing Center, New York
"The Crime Show," ABC NO RIO, New York

1983 "A More Store," Jack Tilton Gallery, New York City
"Hundreds of Drawings Benefit," Artists Space, New York
"Portrait For the 80's," Protech McNeil Gallery, New York
"Language, Drama, Source & Vision," New Museum,
New York
"Terminal New York," Brooklyn Army Terminal, Brooklyn,
New York

"Steve Miller & Brigid Kennedy," Burchfield Center, Buffalo, New York

"Shared Space," Bronx Museum of the Arts, Bronx, New York

"White Columns," New York

1984 "Bialobroda, Blair, Miller, Rosenberg," Baskerville & Watson Gallery, New York

"Between Here & Nowhere," Riverside Studios, London, England, traveling exhibition

"Group Show," International With Monument, New York

"The International Show," Baskerville & Watson, New York

"Behind Faces & Figures," Philadelphia College of Art, Philadelphia, Pennsylvania

"Ars Ex Machina," Bette Stoler Gallery, New York City

1985 "The Comet Show," Light Gallery, New York

"Dwyer, Spero, Majore, Miller, Lang," Josh Baer, New York

"Belcher, Jaffe, Majore, Miller, Pittu," Bette Stoler, New York

"Emerging Expressions: The Artist and the Computer," Bronx Museum of the Arts, Bronx, New York

"Past & Future Perfect," Hallwalls, Buffalo, New York

1986 "Physics," Colin De Land Fine Art, New York

"Layers of Vision," Bette Stoler Gallery, New York

"Dwyer, Lemieux, Majore, Miller, Nagy, Tim Rollins & KOS," Rhona Hoffman, Chicago, Illinois

"Spiritual America," curated by Collins & Milazzo, CIPA, Buffalo, New York

"The New York, New York Show," curated by MOMA Advisory Service for the Gannett Company

"Gold," curated by MOMA Advisory Service for American Express

"Brown, Miller, Nagy, Suzuki," Colin De Land Fine Art, New York

"New Drawing," Gallery Association of New York, traveling show

1987 "Computer Assisted; the Computer in Contemporary Art," Freedman Gallery, Albright College, Reading, Pennsylvania

"Computers and Art," Contemporary Arts Center, Cincinnati, Ohio

"Dwyer, Jackson, Miller," Nina Freudenheim, Buffalo, New York

"Digital Visions: Computers and Art," Everson Museum of Art, Syracuse, New York

"The 2nd Emerging Expression Biennial: The Artist and the Computer," Bronx Museum of the Arts, Bronx, New York

"Group Show," Jack Shainman Gallery, New York

"Paint/Film," Bess Cutler Gallery, New York

"Art Against AIDS," Baskerville & Watson Gallery, New York

"Dreams of the Alchemist," Carl Solway, Cincinnati, Ohio

"Group Show," Simard Holm Gallery, Los Angeles, California

"Group Show," Jack Shainman Gallery, Washington, D.C.

"New York: New Venue," The Mint Museum, Charlotte, North Carolina

"Monsters: The Phenomena of Dispassion," Barbara Toll, New York

"Art and the Computer," Gallery Casas Toledo Oosterom, New York

1988 "Twenty in New York," Nina Freudenheim, Buffalo, New York

"Digital Explorations: Emerging Visions In Art," Tibor de Nagy Gallery, New York

"New York," Josh Baer Gallery, New York

1989 "10 Gallery Artists," Nina Freudenheim, Buffalo, New York

"Chaos," The New Museum of Art, New York

"Invitational With Gallery Artists," fiction/nonfiction, New York

"Earth Remembered," Hook Gallery, Brooklyn, NY, curated by Richard Mock

"Science/Technology/Abstraction," Wright State Univ., Dayton, Ohio

1990 "V.I.P.-Video-Image(s)-Peinture," Galerie du Genie, Paris

"Gallery Artists," Carol Getz Gallery, Miami, Florida

"Hollywoodland," fiction/nonfiction Gallery, New York

"Not Painting: Goldstein, Miller, Paik, Richter," S. Bitter-Larkin Gallery, New York

"Komoski, Miller, Minter," Carol Getz Gallery, Miami, Florida

"White Columns 20th Anniversary Benefit Exhibition," White Columns, New York

1991 "Byron, French, Miller, Solomoukha," Elga Wimmer Gallery, New York

"Art, Science et Materiaux," at L'Institut des Materiaux, Nantes, France

1992 "Excess in the Techno-Mediacratic Society," Musee Sarret de Grozon, Arbois, France, organized by Joseph Nechvatal

1993 "Compkuenstlerg," Kunstlerwerkstatt Lothringer Strasse, Munich

"Gedanken Skizzen Entwurfe," Galerie Karin Sachs, Munich

"The Return Of The Cadavre Exquis," The Drawing Center, New York

"Excess in the Techno-Mediacratic Society," Shoshana Wayne Gallery, Santa Monica, California

"Excess in the Techno-Mediacratic Society," Galerie Krinzinger, Vienna, Austria, organized by Joseph Nechvatal

1994 "Gene Culture," Fordham College, New York City, organized by Suzanne Anker

"Logo non Logo," Threadwaxing Space, New York, organized by Robert Morgan and Pierre Restany

"Les Americains : 50 Annees de Peinture Americaine 1944–1994," Fecamp: Palais Benedictine

"Mauvaises Nouvelles De Chine," Galerie Philippe Gravier, Paris

"Inaugural Exhibition," Offshore Gallery, East Hampton, New York

"The Outside Inside Gertrude Stein," Elga Wimmer Gallery, New York

1995 "Morceau Choisis, du Fonds national d'art contemporain," Centre National d'Art Contemporain de Grenoble, France

"Imaging the Body, an Artistic Diagnosis," The New York Academy of Sciences

"Autour de Roger Vivier," Enrico Navarra Gallery, Paris

"In Corpus Machina, Keith Cottingham, Steve Miller, Joseph Nechvatal," Espace d'Art Yvonamor Palix, Paris

"The Portrait Now," Elga Wimmer Gallery, New York

"Humanism and Technology: the human figure in industrial society," National Museum of Contemporary Art, Seoul, Korea, organized by Pierre Restany

"Logo non Logo," University of South Florida, organized by Robert Morgan and Pierre Restany

"The Outside Inside Gertrude Stein," Dortmunder Kunstverein, Dortmund, Germany

1996 "Autour de Roger Vivier" China Club, Hong Kong

"5th Year Celebration" Elga Wimmer Gallery, New York

"Steve Miller & Joseph Nechvatal" Parsons Gallery, Paris

"Body, Trace, Memory" Eighth Floor, New York

1997 "Sous le Manteau" Galerie Thaddaeus Ropac, Paris

"Autour de Roger Vivier" Agnes b., Tokyo

1998 "Out of Portrait" Espace d'Art Yvonamor Palix, Paris

"Modular Composite"Central Fine Arts, New York

"Autour du Mondial" Galerie Enrico Navarra, Paris

1999 "DREAMS 1900-2000" Equitable Art Gallery, New York

"Shoes, Shoes, Shoes" Frederieke Taylor/TZ'ART, New York

"Provincetown, 100 Years an Arts Community," Fine Arts Work Center, Provincetown

"Paradise Now: Creating the Genetic Revolution," Marvin Heiferman and Carol Kismaric (curators), Exit Art, New York

"Foreign Bodies, an intersection between art and medicine," Untitled (space), New Haven, Connecticut

"R.E.D. (Remote Experience Dependency)" Universal Concepts Unlimited, New York

"13 Alumni Artists" Middlebury College Museum of Art, Middlebury, Vermont

"Medicine in Art" College of the Mainland Art Gallery, Texas City, Texas

"Rounders" Suzanne Anker, Frank Gillette, Ingo Gunther, Steve Miller, Josef Nechvatal, Michael Rees, Bradley Rubenstein and Michael Zansky. Universal Concepts Unlimited, New York

"CYBERARTS 2000," Prix Ars Electronica, Linz, Austria

2001 "Mondial," Le Grimaldi Forum, Monaco

"Digital Printmaking Now," Brooklyn Museum of Art

"The Collector," Universal Concepts Unlimited, New York

"Paradise Now: Picturing the Genetic Revolution," The Tang Museum, Skidmore College, Saratoga Springs, New York

"Paradise Now: Picturing the Genetic Revolution," University of Michigan Museum of Art, Ann Arbor.

2002 "25th Anniversary Exhibition," The Drawing Center, New York

"Dialogue Between Science & Art," Cultural Center Metropol, Ceske Budejoice, Czech Republic

2003 "Divining Fragments: Reconciling the Body," curator, Koan-Jeff Baysa, The Center for Photography at Woodstock, New York

"From Code to Commodity: Genetics and Visual Art," organized by Suzanne Anker, The New York Academy of Sciences, New York

"Genomic Issue(s): Art and Science," organized by Karin Sinscheimer and Marvin Heiferman, The Graduate Center of the City University of New York, New York

"Colecoes IV," curator Nessia Leonzini, Mercedes Viegas Arte Contemporanea, Rio de Janeiro, Brazil

"Reprotech: Building Better Babies," curator, Suzanne Anker, The New York Academy of Sciences, New York

"Touch and Temperature: Art in the Age of Cybernetic Totalism," Deborah Colton Gallery, Houston, TX

"Touch and Temperature: Art in the Age of Cybernetic Totalism" curated by Michael Rees, Bitforms Gallery, New York

"Reality Check," Spike Gallery, New York

"Abstraction with a Twist," curator Elga Wimmer & Lutz Rath, RVS Fine Art, Southampton, NY

2005 "Finders Keepers," curator Alicia Longwell, Parrish Art Museum, Southampton, NY

"Abstraction," Burchfield-Penney Art Center, Buffalo, NY

"Edge of Nature" Jameson Ellis and Steve Miller, curator Graham Leader, Hampton Road Gallery, Southampton, New York

"Colecoes IV," curator Nessia Leonzini, Luisa Strina Gallery, São Paulo, Brazil

"Le Cas du Sac," au Musée de la Mode et du Textile, Paris

"Collection 2," foundation pour l'art contemporain Claudine et Jean-Marc Salomon, Annency, France

2006 "Presentation D'ICONOfly," curated by Olivia Bransbourg, Christie's, Paris, France

"A Delicate Balance," curated by Victoria Anstead, General Electric Company headquarters, Fairfield , CT

"Summer Group Show," Holasek Weir Gallery, New York, NY

"Luxury Goods," curated by Beth Rudin DeWoody, Kathleen Cullen Fine Arts, New York, NY

"SUMMERTIME," Robin Rice Gallery, New York, NY

"Neuroculture: Visual Art and the Brain," curated by Suzanne Anker and Giovanni Frazetto, Westport ArtCenter, Westport, CT

"OCONOfly, Quand L'Accessoire Devient Muse," Chez Christie's, Paris, France

2007 "Coletiva 2007," Mercedes Viegas Arte Contemporanea, Rio de Janerio, Brazil

"Brasil Des Focus: o olho de fors," curated by Paulo Herkenhoff and Nessia Leonzini, Centro Cultural Banco do Brasil, Rio de Janeiro, Brazil

"Summer Time 2007" Robin Rice Gallery, New York, NY

"Small Work," Nina Freudenheim Gallery, Buffalo, NY

2008 "Imagination on Behalf of Our Planet," Organized by Art & Science Collaborations, Inc., A.S.C.I. 10th International Digital Print Exhibition, New York Hall of Science, NY, NY

"First Annual Hampton's Guerrilla Exhibition," Curated by Catamount Mayhugh, Artists's Secret Society, Easthampton, NY

"I Dream of Genomes" curated by Janet Goleas, Islip Art Museum, Islip, NY

"Container Exhibition" LongHouse Reserve, Easthampton, New York

"Summer Time 2008" Robin Rice Gallery, New York, NY

"10th International Digital Print Exhibition," New York Hall of Science, NY

2009 "Octet," curated by Suzanne Anker and Peter Hristoff, Pera Museum, Istanbul, Turkey

"Deviant Specimens: Amanda Means, Steve Miller and Gary Schnyder," Howard Yeserski Gallery, Boston, Mass

"Octet: Codes and Contexts in Recent Art," curated by Suzanne Anker and Peter Hristoff, Visual Arts Gallery, NY, NY

"Summertime," Robin Rice Gallery, NY, NY

"Up and Coming," curated by Kimberly Goff and Julie Keyes, Benson Keys Art, Southhampton, NY

"American Rendition," dance performance by Jane Comfort and Company, Duke Theater, NY, NY

"Artists Secret Society Guerrilla Exhibition," Christy's Art Center, Sag Harbor, NY

2010 "Pocket Calls to Nature," Sara Nightengale Gallery, Shelter Island, NY

"Arquivo Geral," Centro de Arte Helio Oiticica, Rio de Janero, Brazil

"Exposição Fotografias: da paisagem ao geometric," Galeria Mercedes Viegas, Rio de Janero, Brazil

"Art/Science Exhibition," Schneider Museum Of Art, Southern Oregon Univ.,OR.

"ExCentricA: 2010 Gala Benefit," Long House Reserve, East Hampton, NY

"Summer Time Salon 2010," Robin Rice Gallery, NY, NY

Group Exhibition, Glenn Horowitz Book Sellers, East Hampton, NY

"Moxie and Mayhem: Acquisitions for a New Museum," Burchfield Penney Art Center, Buffalo State College, NY

Group Exhibition, Nina Freudenheim Gallery, Buffalo, New York

"LREI 2010 Art Auction," Little Red School House & Elizabeth Irwin High School, NY, NY

2011 "50th Anniversary Exhibition," Rose Art Museum, Boston, Mass

"Paris Photo," John McWhinnie @ Glen Horowitz Booksellers, Paris, France

"Scope Miami," Keys Art, Miami, FL.

"Sao Paolo Art Fair," Galleria Tempo, Sao Paolo, Brazil

"EMERGE 1.0," Terrence Joyce Gallery, Greenport, New York

"Da Paisagem ao Geometrico," Galeria Mercedes Viegas, Rio de Janiero, Brazil

2012 "World Cup," MARCO, Monterrey, Mexico

"Bad For You," Shirazu Gallery, London, UK

"Dreams," Galerie Rigassi, Bern, Switzerland

"Emerging Art Long Island 1st Annual Juried Exhibition," The South Street Gallery, Greenport, NY

"Group Therapy," Harper's Books, East Hampton, NY

"Mind Over Matter," Hampton Hang, Watermill, NY

"Open For The Stones," Harper's Books, East Hampton, NY

"Summertime Salon," Robin Rice Gallery, NY, NY

2013 "Machinarium," Oi Futuro, Ipanema, Brazil

"Art Rio 13," Galeria Tempo, Rio de Janiero, Brazil, September

"Summertime Salon 2013," Robin Rice Gallery, New York, June 26–September 15

"Trees in Focus: Anne Fountain Foundation Auction," Sotheby's, NY, NY.

"The Big Show 8," Silas Marder Gallery, Bridgehamptom, NY May 19–June 24

"EMERGE.LI 1st Annual Juried Exhibition," The South Street Gallery, Greenport, NY

2014 Robin Rice Gallery, "Summertime Salon 2014,"
New York, NY

Sothampton Arts Center, "The Irrational Portrait Gallery,"
Southampton, NY

Sag Harbor Whaling Museum, "Under the Influence," Sag
Harbor, NY

SciArt Center, "What Lies Beneath," New York

Museo de Arte do Rio, Armadillo: Soccer, Adversity and the
Culture of the Caatinga, Rio

Sothebys Paris, "Objectif Arbres," Paris

Refinery Hotel, "Flora, Fauna, and Form," New York, NY

ArtRage Gallery, "Stone Canoe/Vein 8," Syracuse NY

Museo de Arte do Rio, "Slide," Rio de Janiero, Brazil

Art Rio, Fashion Mall, Rio de Janeiro, Brazil

2015 Lazypoint Gallery, Revealing the Parallel: Indian Tantric
Painting, Amagansett, NY

Robin Rice Gallery, "Summertime Salon 2015,"
New York, NY

Sara Nightingale Gallery, "Entitled," Water Mill, NY

TMC International, "An Exhibition of Works selected by Turid
Meeker," Sag Harbor, NY

Southampton Art Center, "East End Collected,"
Southampton, NY

2016 Melissa Morgan Fine Art, "Neo-Psychedelia," Palm Desert, CA

Robin Rice Gallery, "Summertime Salon 2016,"
New York, NY

Southampton Arts Center, "Water Bodies," Southampton, NY

Public Collections

Albright-Knox Art Gallery, Buffalo, NY

Bloomingdales, New York City

The Burchfield-Penney Art Center, Buffalo, NY

Chanel, Paris

JP Morgan, Chase Bank, New York

The Dow Jones & Co., Inc., New York

The Dunn & Bradstreet Corporation, New York

First Bank System, Minneapolis, MN

Fonds National D'Art Contemporain, French National Collection

Foundation Hahnloser, Bern, Switzerland

Foundation Salomon, Annency, France

Eli and Edythe Broad Museum, Michigan State University, East
Lansing, Michigan

High Museum, Atlanta, Georgia

Museo de Arte do Rio, Rio de Janeiro

Musée de la Mode, Paris

Progressive Corporation, Mayfield Heights, OH

Ralph Lauren, Polo, New York

Rose Art Museum, Brandeis University, Waltham, MA

Santa Barbara Museum, CA

Southeast Bank, Miami, FL

Bibliography

2000 Rush, Michael. "Steve Miller at Universal Concepts Unlimited." *Art in America*, July, ill.

Dahl, Renée. "Miller's Crossing." *Hamptons Magazine*,
September 1–7

Griffin, Tim. "Blinded with science: Exit Art unravels DNA's
double helix." *Time Out*, September 21–28.

Laber, Emily. "Variations on a Gene." *The SCIENCES*,
September/October.

Schjeldahl, Peter. "A Show Embraces Biomania." *The New
Yorker*, October 2.

Scully, James. "Sole Man." *Harper's Bazaar*, October, ill.

Blake, Judy. "Art, medicine meet in a curious new genre."
New Haven Register, November 5.

Hoffman, Hank. "Open your mind and say 'Aaahh'" *New
Haven Advocate*, November 30.

Travis, John. "Genes on Display: DNA becomes part
of the artist's palette." *Science News*, vol. 158, no. 25,
December 16.

Anker, Suzanne. "Gene Culture: Molecular Metaphor in
Visual Art." *Leonardo*, vol. 33, no. 5.

2001 Brown, Nancy Marie. "A Cabinet of Wonders." *Research/
Penn State*, vol. 22, no. 33, September, ill.

2003 MacNeil, John S. "Down DNA Memory Lane." *Genome Tech-
nology*, April, ill.

Baysa, Kóan-Jeff. "Divining Fragments: Reconciling the
Body." *NY ARTS*, December, ill.

2004 Anker, Suzanne. "Update." *New York Academy of Sciences
Magazine*, April/May 2004. REPROTECH: Building Better
Babies, (illustration "L,Origine duMonde" 1994, page 6)

Baysa, Kóan-Jeff. "Divining Fragments: Reconciling the
Body." *Photography Quarterly*, #88, vol. 21, no. 3, 2004.

2005 Hamptons Cottages and Gardens, August 15-31.

Baque, Dominique. "L'impossible visage, le visage comme
enigma." *Art Press*, November, ill.

Ernst, Eric. "Is Collecting Also Creating? Parrish show finds
works on eBay, not at Sotheby's." *The Southampton Press*,
November 24.

Landes, Jennifer. "Obsessions on Display." *The East
Hampton Star*, December 15.

Rogers, Pat. "Finding Link Between Art and Science,
Ancient Objects are Inspiration for Artist." *The Southampton
Press*, December 22–29.

2006 de Malherbe, Delphine. "Le Sac de Voyage/ The Traveller's Bag." *Icono Fly*, no. 1.

de Malherbe, Delphine. "Journal D'une Montre." *Icono Fly*, no. 2

2007 Coleman, David. "Acquiring Mind." *Elle Décor*, March, ill.

Rogers, Pat. "Pottery Tells of Chinese History." *The Southampton Press*, July 19.

Fasolino, Elizabeth. "Contemporary Lessons." *The East Hampton Star*, July 22.

Peterson, Oliver. "In a 'Funky Space,' a Movement is Born" *The Southampton Press*, July 22.

Velasco, Suzana. "Olhos de for a miran o Brasil." *O Globo*, July, 30.

Goleas, Janet. "Artist of X-Rays and Atoms." *The East Hampton Star*, November 13.

2008 Genocchio, Benjamin. "Looking into the World of Genomes and Seeing an Unreliable Future." *The New York Times*, March 2.

"Down to Earth Design." *Domino*, December 2008

2009 Gilbride, Jeff. "Students pick new rally cry for Rose." *Daily News Tribune*, February 11.

Newman, Hillary. "Interview: Steve Miller." *The Huffington Post*, March 3.

McQuaid, Cate. "A Botanical Bent." *Boston Globe*, August 5.

Graham, Colin M. "Miller Takes His Art For A Ride In The Surf." *The Hamptonian*, Aug. 13-26.

Deitz, Steven. "Brookhaven Facilities at the Frontiers of Science…and Art." *Brookhaven National Laboratory*, October, 26.

2010 Leros, (illustration page 28), April, 2010/Issue 223.

Jungle Drums, (illustration page 14-15), April 10, 2010/ Issue 79.

The Hill, (illustration page 19), April 10, 2010/Issue 306

2011 Gustavson, Jennifer. "Video: New art group launches contemporary exhibit in Greenport." *Suffolk Times*.

Lima, Paolo. "Vivo ou Morto." *Istoe'*, no. 2197, December 21.

2012 "Exposicoes." Vejo Rio, January 11.

Peterson, Oliver. "Inside the Amazon." *Long Island Pulse*, April, ill.

Holmes, Tula Cahoon. "Portfolio: X-Ray Visionary." *The Southhampton Review*, vol. 6, no. 1, Spring.

Goleas, Janet. "Open Book." blinnk.blogspot.com, July 15.

Museé Magazine, July, 2012

Huberty, Erica-Lynne. "Collective Benefit." *Long Island Pulse*, July/August.

YouTube, Steve Miller Transforms "Almost Green" into "Library Branch," 2012.

glave.com, Check Out What This Artist Did With My Book.

2013 Onabanjo, Remi. "Focusing on the Photographers: Steve Miller." Anne Fontaine Foundation, March 12.

Michaels, Levi. "Machinarium, Technological Art in Ipanema." *Rio Times*, July 16.

Tessler, Debra. "Raio X do Brasil: a arte de Steve Miller." DebraTessler.com, July 18.

Fard, Maggie Fazeli. "Art Exhibits Inspired by Science Fiction and Medicine." *Washington Post*, July 29.

Peterson, Oliver. "Work on Monday: 'Sloth Pieta' by Steve Miller." *Dan's Papers*, February 11.

Scott, Debra. "Hamptons Artist." *Hampton's Country Capitalist*, July, ill.

Buntain, Julia. "Steve Miller: Health of the Planet." *Art and Science Collaborations*, July, ill.

"DC Highlights the Art of the Ion Movement." *Sparked*, August 25.

"Sagaponack Artist Steve Miller featured in International Clothing Line." *Dan's Papers*, August, ill.

Gambino, Megan. "Crossing the Line Between Art and Science." *Smithsonian Magazine*, September 9.

"Fashion Animal: expo do artista Steve Miller chega ao Fashion Mall." *Vogue Brasil*, August 9.

Moss, Drew. "Watching the Wheels." *Long Island Pulse*, August, ill.

"X-Ray of Brazil: The Art of Steve Miller." *New York Spy*, August, ill.

Heiferman, Marvin. "Steve Miller: Crossing the Line." *Concatenations Forum*, August, ill.

Krementz, Jill. "Sagaponack Summer 2013 Part III." *New York Social Diary*, August, ill.

Gains, Steve. "The Art of the Hamptons." *Elliman*, Fall/Winter 2013-2014.

Blanch, Andrea. "Steve Miller: Fios Das Pessoas." *Musee Magazine*, no. 7, vol. 2, December, ill.

Buntaine, Julia. "Straight Talk with Steve Miller." *Sci-Art in America*, December, ill.

2014 "Steve Miller Reveals New Fine Art Surfboards." *Dan's Papers*, January 3.

"Sci Art in America." *Art and Science Collaborations, Inc.*, January 2014.

"Steve Miller: A Natural Visionary." *The East Hampton Press & The Southampton Press*, February 18.

"Steve Miller Rides Another Wave of Success." *Hampton's Party Girl*, April 17.

"Protein: by Steve Miller." *XSEAD*, April, ill.

"5 Must-See Art Shows on the East End this Weekend." *Dan's Paper*, June 13.

"Artspace comemora Copa com venda em parceria com a BrazilFoundation." *Vogue Brasil*, June 13.

"Under the Influence: A Dialogue in Art." *Hampton's ArtHub*, June 30.

"Cultured: Steve Miller Partners with Osken." *Beach Magazine*, July 16.

"The Floodlights: Fleeting Installations by East End Artists." *Hampton's ArtHub*, August 28.

"SciArt in America." 20th Anniversary Issue, August, ill.

"IN STUDIO – Steve Miller and X-Ray Art." *Hampton's ArtHub*, September 4.

"Not Another Blender." *The New York Times*, November 2.

Stone Canoe, *Art Journal*, Syracuse University, 2014

2015 "A Natural Progression." *New York Spaces Magazine*, August 2.

"Artist Spotlight: Steve Miller." *Hampton's Monthly*, August 15.

"Collecting the Collected." *The East Hampton Star*, April 30.

2016 *The Hastings Center Report*, January/February.

Hamptons Art Hub, April, ill.

Hamptons Art Hub: ART REVIEW, April, ill.

The Culture Trip, October, ill.

Catalogues and Books in Which Works Are Included

1979 Logan, Susan, Allan Schwartzman, and Kathleen Thomas. *Dimensions Variable*. New York: New Museum.

Lindeman, Edna. *Six Artists Under Thirty*. Buffalo: Burchfield Center.

1982 Goncharov, Kathleen, and Peters Lisa. *What I Do For Art*. New York: What I Do For Art, Exhibition Catalog, Just Above Midtown-Downtown.

Browning, Robert H. *Visual Politics*. New York: Alternative Museum.

Beck, Martha, and Marie Keller. *New Drawing In America*. New York: Drawing Center.

1983 Brooks, Rosetta. *Steve Miller: Five New Works*. Buffalo: Burchfield Center.

Verre, Phillip. *Shared Space*. Bronx: Bronx Museum.

1984 Brooks, Rosetta. *Between Here & Nowhere*. London: Riverside Studios, n.d.

1987 Saltz, Jerry, Roberta Smith, and Peter Halley. *Beyond Boundaries: New York's New Art*. New York: Alfred Van Der Marck Editions.

Phillips, Lisa. *New York, New Venue*. Charlotte, NC: Mint Museum.

Goodman, Cynthia, and Harry Abrams. *Digital Visions: Computers and Art*. New York: H.N. Abrams.

Prince, Patrick, and Shalom Gorewitz. *The Second Emerging Expression Biennia: The Artist And The Computer*. Bronx: Bronx Museum of Art.

Rubin, David S. *Computer Assisted: The Computer in Contemporary Art*. Reading: Albright College.

1988 *Steve Miller*. Paris: Galerie Du Génie.

1989 Trippi, Laura. *Strange Attractors: Signs Of Chaos*. New York: New Museum of Contemporary Art.

Rosenberg, Barry A. *Science/Technology/Abstraction: Art at the End of the Decade*. Dayton: U Art Galleries, Wright State U.

1990 Foresta, Don, and Stephen Sarrazin. V.I.P.: *Video, Images, Peinture*. Paris: Galerie Du Génie.

Mahoney, Robert. *Not Painting: Jack Goldstein, Steve Miller, Nam June Paik, Gerhard Richter*. New York: Nadalstein.

1991 Corey, David. *Steve Miller*. Paris: Galerie Du Génie.

Art, Science Et Materiaux. N.p.: Institut Des Materiaux De Nantes.

1992 Cameron, Dan. *Steve Miller*. New York: Elga Wimmer.

Nechvatal, Joseph, Tobey Crokett, and Robert C. Morgan. *Excess in the Techno Mediacratic Society*. Arbois: Conservation Départementale Des Musées Du Jura Nord.

1993 Wiedmann, Christoph. Munich: Kunstlerwerkstatt Lothringerstrasse.

Lane, Simon. *Steve Miller*. Paris: A.B. Galeries.

1994 Morgan, Robert C., and Pierre Restany. *Logo Non Logo*. New York: Thread Waxing Space.

Matthieussent, Brice. *Steve Miller: L'Origine Du Monde*. Prigny: Espace Art Brenne.

Tourneaux, Alain. Les Americains. Fécamp: Palais Benedictine, 1994. Print.

1995 *Morceaux Choisis Du Fonds National D'Art Contemporain*. N.p.: Centre National D'art Contemporain De Grenoble.

Lacroix, Christian, Michel Brodsky, and Charles Zalber. *Autour De Roger Vivier*. Paris: Galerie Enrico Navarra.

Ewers-Schultz, Ina. *The Outside Inside Gertrude Stein*. Dortmund: Dortmunder Kunstverein.

Anker, Suzanne. *Gene Culture: Molecular Metaphor in Visual Arts*. New York: Fordham College at Lincoln Center.

Restany, Pierre. *Humanism and Technology, The Human Figure in Industrial Society*. Seoul: National Museum of Contemporary Art.

1997 Kevles, Caroline Smulders, and Bettyann H. Kevles. *Sous Le Manteau*. Paris: Galerie Thaddaeus Ropac, n.d.

Kevles, Bettyann H. *Naked to the Bone: Medical Imaging in the Twentieth Century*. New Brunswick: Rutgers UP.

1998 Pringle, Colombe. *Mémoire De La Mode, Roger Vivier*. Paris: Editions Assouline.

Bourriaud, Nicolas, Giles De Bure, Henri-Francois Debailleux, Paul Lombard, Michel Nuridsany, and Pierre Restany. *80 Artistes Autour Du Mondial*. Paris: Galerie Enrico Navarra.

Gamwell, Lynn. *Dreams 1900-2000: Science, Art, and the Unconscious Mind*. Ithaca: Cornell UP.

2000 Heiferman, Marvin, and Carol Kismaric. *Paradise Now, Picturing the Genetic Revolution*. Saratoga Springs: Tang Art Museum.

Donadio, Emmie, ed. *13 Alumni Artists*. Middlebury: Middlebury College Museum of Art.

Bernstein, Marianne, and Thomas Duffy. *Foreign Bodies: Art, Medicine, Technology*. New Haven: Untitled (Space).

2001 *Notes for Neolithic Quark*. New York: UCU Gallery.

Kushner, Marilyn S. *Digital Printmaking Now*. Brooklyn: Brooklyn Museum of Art.

Mondial. Paris: Enrico Navarra Gallery.

2002 Wilson, Stephen. *Information Arts: Intersections of Art, Science, and Technology*. Cambridge: MIT.

Colacello, Bob, and Jonathan Becker. *Studios by the Sea: Artists of Long Island's East End*. New York, NY: Harry N. Abrams.

2003 Anker, Suzanne, and Dorothy Nelkin. *The Molecular Gaze: Art in the Genetic Age*. Cold Spring Harbor: Cold Spring Harbor Laboratory.

Genomic Issue(s): Art & Science. New York: Art Gallery of the Graduate Center.

Nelkin, Dorothy, and Suzanne Anker. *From Code to Commodity: Genetics and Visual Art*. N.p.: New York Academy of Sciences, n.d.

2004 *Reprotech: Building Better Babies*. New York: New York Academy of Sciences.

Baque, Dominique. *Photographie Plasticienne, L'Extreme Contemporain*. Paris: Editions Du Regard.

2005 Chenoune, Farid, Jean-Louis Dumas, and Helene David-Weill. *Carried Away: All About Bags*. New York: Vendome.

Baudrillard, Jean, and Sylvère Lotringer. *The Conspiracy of Art: Manifestos, Interviews, Essays*. New York: Semiotext(e).

Reichle, Ingeborg. *Kunst Aus Dem Labor: Zum Verhältnis Von Kunst Und Wissenschaft Im Zeitalter Der Tecnoscience*. New York: Springer.

Daubner, Ernestine, and Louise Poissant. *Art Et Biotechnologies*. Sainte-Foy: Presses DeL'Université Du Québec.

Piquet, Philippe. *Collection2*. Annency: La Fondation Pour L'art Contemporain Claudine Et Jean-Marc Salomon, n.d.

2006 Miller, Steve. *Eat Protein*. N.p.: Apple Book.

Anker, Suzanne, and Giovanni Fazetto. *Neuroculture: Visual Art and the Brain*. Westport: Westport Art Center.

2007 Rush, Michael, Mark Auslander, and Marvin Heiferman. *Steve Miller: Spiraling Inward*. Waltham: Rose Art Museum.

Herkenhoff, Paulo, and Nessia Leonzini. *Brasil Des Focos (o Olho De Fora)*. Rio De Janeiro: Centro Cultural Banco Do Brasil.

Popper, Frank. *From Technological to Virtual Art*. Cambridge: MIT.

2009 Reichle, Ingeborg. *Art in the Age of Technoscience: Genetic Engineering, Robotics, and Artificial Life in Contemporary Art*. New York: Springer.

Anker, Suzanne, and Peter Hristoff. *Octet: Selected Works from the School of Visual Arts*. Istanbul: Pera Müzesi.

2010 Wilson, Stephen. *Art Science Now*. New York: Thames & Hudson.

Chakrabarti, Nina. *My Wonderful World of Fashion*. London: Laurence King.

2011 Rooney, E. Ashley. *100 Artists of the Mid-Atlantic*. Atglen: Schiffer.

2012 *Art Inspired by Science: Imagining the Natural World*. Vol. 29. Ashland: AAAS Pacific Division.

Bad For You. London: Shirazu Mayfair Gallery.

Heinemann, Torsten. *Populäre Wissenschaft Hirnforschung Zwischen Labor Und Talkshow*. Dusseldorf: Wallstein Verlag.

2013 *Machinarium*. Rio De Janeiro: Binocular Editora.

Weibel, Peter, and Ljiljana Fruk. *Molecular Aesthetics*. Cambridge: MIT, *2013. Print*.

Heiferman, Marvin. *Steve Miller: Crossing the Line*. Washington, DC: National Academy of Sciences.

Silva, Marina. *Trees in Focus: Objectif Arbres*. New York: Assouline.

2014 Miller, Arthur I. *Colliding Worlds: How Cutting-Edge Science Is Redefining Contemporary Art*. New York: W.W. Norton.

Acknowledgments

The work in this book began during my first trip to Brazil, organized by Nessia Pope in 2005 to create artwork for an exhibition she curated for the Mercedes Viegas Gallery, in Rio de Janeiro. The enthusiasm I had for the exotic natural world, to which she introduced me, engendered this project. She became my tireless supporter, opening doors and including my work in numerous shows. Both Nessia, and my dear friends Simon Lane and Betsy Salles, led me to my Rio gallerists Carolina Dias Leite and Marcia Mello at Galeria Tempo. They exhibited the work from its early stages and eventually led me to the director, Nilson Gabas, of the Museu Paraense Emílio Goeldi in Belém, capital of the state of Pará.

The initial phase included finding a radiologist in São Paulo to x-ray the plants. My friend Jeff Matthews, through a barium investment, led me to the radiologist Dr. Henrique Lederman, who opened his hospital so I could begin taking X-rays, where I relied upon the language skills of Daniel Jatobá, the son of the collector Waldick Jatobá, to guide me through traffic and hospitals with effusive hospitality. Kim Esteve and Barbara Leary housed me and collected all the plants that we could fit in their car from the mammoth Cobal produce market in São Paulo. They hosted my plants in their greenhouse, which I parsed out nightly for an entire week as I made the X-rays in the hospital until midnight.

Kim led me to Octavio Lobo, my generous radiologist host in Belém. Octavio flew me in his plane over the vast Amazon delta and we cruised the river in his boat. We messed up his lab every night with smelly fish and live animals. The animals would not have been possible without the efforts of Messias Costa, the veterinarian at the Instituto Goeldi. The artist Fabricio Branco was my tireless and inventive guide who has led me on many Brazilian adventures from Belém to Salvador and Chapada Diamantina in the state of Bahia. Fabricio's efforts go well beyond the call of duty. That he survived some of the harrowing nights at the Clinica Lobo is testament to the strength of his stomach. Oskar Metsavaht promoted the project on a line of clothing for Osklen.

My team of studio assistants includes Becky Rosko, Henry Sanchez, Tohmi Shiroyama, Brendan Powel and Matej Vakula. For over 20 years, John Wilton has managed my digital archives, printing and Photoshop. He is responsible for helping me organize the visual material for this book. Maurice Berger gave sage counsel and edited my text.

Carl Safina can claim mission-driven enthusiasm in contributing an essay that connects the project to the world in which we live. Marvin Heiferman generously carved out time to add his writing to this effort.

And finally, this book started with the curiosity of Marta Hallett, who stumbled upon my work at the Bardin Palomo gallery in Hudson, New York. That the result would be her unflagging efforts to produce this book surprised no one more than me.

I thank them all for their invaluable contributions to bringing this book to life.

Anteater, 2016 | Carbon inkjet on cotton rag | 27 x 24 in.